ROY LICHTENSTEIN

OCTOBER FILES

George Baker, Yve-Alain Bois, Benjamin H. D. Buchloh, Leah Dickerman, Hal Foster, Denis Hollier, Rosalind Krauss, Annette Michelson, Mignon Nixon, and Malcolm Turvey, editors

ROY LICHTENSTEIN

edited by Graham Bader

essays, interviews, and a lecture transcript by Graham Bader, Yve-Alain Bois,
John Coplans, David Deitcher, Hal Foster, John Jones, Donald Judd, Max Kozloff,
Jean-Claude Lebensztejn, Roy Lichtenstein, and Michael Lobel

OCTOBER FILES 7

The MIT Press
Cambridge, Massachusetts
London, England

MIT Press books may be purchased at special quantity discounts for business or sales promotional use. For information, please email special_sales@mitpress.mit.edu or write to Special Sales Department, The MIT Press, 55 Hayward Street, Cambridge, MA 02142.

This book was set in Bembo and Stone Sans by Graphic Composition, Inc., and was printed and bound in the United States of America.

Library of Congress Cataloging-in-Publication Data

Roy Lichtenstein / edited by Graham Bader.
 p. cm. — (October files)
Includes bibliographical references and index.
ISBN 978-0-262-01258-4 (hardcover : alk. paper)—ISBN 978-0-262-51231-2 (pbk. : alk. paper)
1. Lichtenstein, Roy, 1923–1997—Criticism and interpretation. I. Bader, Graham.
N6537.L5R69 2009
709.2—dc22

2008027494

10 9 8 7 6 5 4 3 2 1

Contents

OCTOBER Files addresses individual bodies of work of the postwar period that meet two criteria: they have altered our understanding of art in significant ways, and they have prompted a critical literature that is serious, sophisticated, and sustained. Each book thus traces not only the development of an important oeuvre but also the construction of the critical discourse inspired by it. This discourse is theoretical by its very nature, which is not to say that it imposes theory abstractly or arbitrarily. Rather, it draws out the specific ways in which significant art is theoretical in its own right, on its own terms and with its own implications. To this end we feature essays, many first published in *OCTOBER* magazine, that elaborate different methods of criticism in order to elucidate different aspects of the art in question. The essays are often in dialogue with one another as they do so, but they are also as sensitive as the art to political context and historical change. These "files," then, are intended as primers in signal practices of art and criticism alike, and they are offered in resistance to the amnesiac and antitheoretical tendencies of our time.

The Editors of *OCTOBER*

Acknowledgments

Donald Judd's Lichtenstein reviews first appeared in *Arts Magazine* 36, no. 7 (April 1962); *Arts Magazine* 38, no. 2 (November 1963); and *Arts Magazine* 39, no. 3 (December 1964). Max Kozloff's "Lichtenstein at the Guggenheim" first appeared in *Artforum* 8, no. 3 (November 1969). John Jones's interview with Lichtenstein, an abridged version of which is included here, is previously unpublished; the full transcript is in the Archives of American Art. John Coplans's Lichtenstein interview first appeared in *Roy Lichtenstein: Graphics, Reliefs, and Sculpture, 1969–70* (Irvine, Calif.: University Gallery, 1970) and was reprinted in Coplans's edited volume *Roy Lichtenstein* (New York: Praeger, 1972). Jean-Claude Lebensztejn's discussion with Lichtenstein first appeared in *Art in America* 63, no. 4 (July/August 1975) as part of "Eight Statements," a series of conversations with contemporary artists on Matisse. The text of Roy Lichtenstein's 1995 Kyoto Prize lecture first appeared in *Kyoto Prizes and Inamori Grants* (Kyoto: Inamori Foundation, 1996); the abridged version included here is adapted from a transcript made from an audio recording of Lichtenstein's remarks. Both tape and transcript are in the archives of the Roy Lichtenstein Foundation. David Deitcher's "Unsentimental Education: The Professionalization of the American Artist" originally appeared in *Hand-Painted Pop: American Art in Transition 1955–1965* (Los Angeles: Museum of Contemporary Art, 1992), and has been abridged for this volume. Michael Lobel's "Lichtenstein's Monocularity" first appeared in the *Oxford Art Journal* 24, no. 1 (2001); an expanded version was included as the third chapter of his book *Image Duplicator: Roy Lichtenstein and the Emergence of Pop Art* (New Haven: Yale University Press, 2002). Yve-Alain Bois's essay "Slide Lecture" first appeared under the title "Roy Lichtenstein Perfect/Imperfect" in *Roy Lichtenstein Perfect/Imperfect* (Beverly Hills: Gagosian Gallery, 2002). Hal Foster's "Pop Pygmalion" was

originally published in *Roy Lichtenstein Sculpture* (New York: Gagosian Gallery, 2005). Graham Bader's "Donald's Numbness" was first published in the *Oxford Art Journal* 29, no. 3 (2006). In addition to the abridgements noted above, most essays have been edited slightly.

This book would not have been possible without the assistance and support of the Roy Lichtenstein Foundation. The many archivists who offered assistance with securing images and rights are warmly thanked. I am also grateful to Ryan Reineck, Rachel Churner, the authors, and the Mellon Foundation for its fellowship support during the preparation of this volume.

Arts Magazine, April 1962

The funny papers have again caused outrage among the respectable; this time it is not morals but art that is being corrupted. The premises of the status quo, which is multiple, being moribund at stages dating from recently back to the nineteenth century, have been ignored. Respectability comes quickly, is strong and can be shrewd. Lichtenstein's comics and advertisements destroy the necessity to which the usual definitions pretend. In part this social benefaction is aside from the gist of the work. Other than that aggravation there are few reasons for using comics. There may be reasons as to the social meaning of comics and the aesthetic meaning of enlarging them, but these would be minor. It is not so unusual to appreciate the directness of comics; they look like Léger, as do these versions of them. The commercial technique—non-art—is part of the jolt, but the schematic modeling, the black lines and the half-tones of Benday dots resemble Léger's localized modeling and black lines around flat colors. Lichtenstein is hardly as good as Léger, but is fairly good and has something on his own. He has added slightly to the ways of being open and raw. Ironically, the composition is expert, and some of it is quite traditional, as in one large panel of a pilot kissing his girl. The two heads, taking up most of the room, are undercut from the right by the ultramarine blue of the runway and the black shadows of the girl's blond hair. The coil of hair, spiral facing outward, concludes the sweep and provides a short, massive, central vertical at the lower edge. The pilot's red-dotted hand, clutching the girl's hair, repeats the vertical in the black. Her hands and his shoulder weave up the left edge. There are other panels and single figures from comics, and details, often single objects, from advertisements. The most unusual range of color is the red-black one, which is somewhat

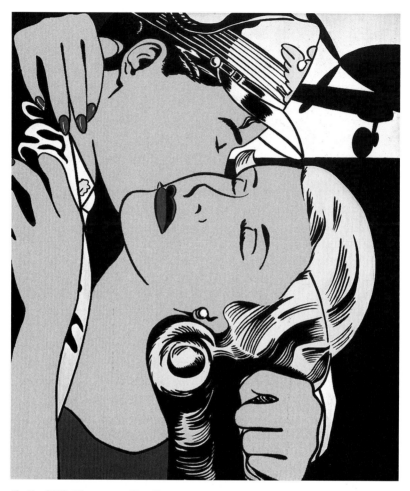

The Kiss, 1962. Oil on canvas, 80 × 68
inches. Paul G. Allen Collection.
© Estate of Roy Lichtenstein.

shrill. Perhaps a cadmium red medium is used. The distinctions are defi-
nite between red dots within a black line, the canvas or black dots within
a black line and areas of red or black. (Castelli, Feb. 10–Mar. 3.)

Arts Magazine, November 1963

For one thing, I like Lichtenstein's work better than before, and for another,
it has improved. The few drawings he had in a group show at the gallery last

spring were very good; so are the paintings in the present exhibition. The first time I saw Lichtenstein's paintings I was puzzled by their being comics and was disinterested in their obsolescent composition; all the same I was interested in their unusual quality. Generally in that case you revise your ideas of the meaningless or disagreeable elements. There are good reasons for the comics and the composition. Obviously, now, both are basic to the dominant quality. Perhaps the composition should somehow be less traditional, but how or why it should is pretty vague. Lichtenstein's spectacular ability in composition seems necessary; something has clearly to be art—that is, already developed and recognizable. The proficiency in composition, the evident art, is half of the idea. In addition, the traditional composition isn't all of the composition, all of the form. Mostly it involves the placement of the areas. In *Conversation* two large heads fill the upper corners. Between them and running to the bottom, and extending, although broken, to the lower corners, is a more or less single dark area, variously dark blue, black and red. The man's fingers, stenciled like the faces, are placed in the middle and at the bottom of the dark section. His thumb sticks up the center. The three-way arrangement, the hand in the lower center and the thumb dividing the dark section are forms that go back, through everything, to the early Renaissance. (It's funny, incidentally, that the best composition in years, in the word's ordinary sense, is seen only as a copy.) The comics are a form of representation themselves and a fairly cursory and schematic one. Lichtenstein is representing this representation—which is very different from simply representing an object or a view. The main quality of the work comes from the contrast between the comic panel, apparently copied, and the art, nevertheless present. The enlarged, commercial scheme has an unusual space, color and surface, and some other things. It does involve some novel ways of composing: the relationships of the areas as patterns of flat color, of two dark colors closely valued, and of differently colored and scaled Benday dots; the shapes made by the comic stylizations are odd, such as the concentric ones of an explosion or those of swirling water—waves and flames are similar—or lines of speed. The Ben Day patterns and their various juxtapositions I like a lot. *Conversation* has larger dots than usual in the two faces. In the girl's lips the dots are smaller and are paired; the stencil was moved slightly and the dots repeated. The repetition is also used, but with red and blue, in the shadow along the side of a cannonading fighter plane. The dots are obviously mechanical and have a curious brittleness and lightness, something of the surface quality of printed things generally. Lichtenstein's color is pretty

straight and unharmonized. The printed quality and the paintings' nature as a representation of a representation are part of the same idea. This idea is related to questioning, for example, the method, the general way you are dealing with certain problems, in contrast to considering those singly. The paintings are dealing with an idea of something, rather than with something itself. They are twice removed. Similarly, they suggest metalinguistics, in which the indications of reality that a word seems to possess are not accepted as a basis for thought, but rather a word's usage is examined. "Is" was once taken literally and discussed as if it were existence itself; now it is considered as a word, as a convention. *Wham!, Torpedo . . . LOS!, Conversation, In the Car* and *I Don't Care, I'd Rather Sink*, are all broad and powerful paintings. (Castelli, Sept. 28–Oct. 24.)

Arts Magazine, December 1964

A rich, memorable, and hugely satisfying new show by the author of *I Don't Care, I'd Rather Sink*. In an idyllic frame of mind he has painted sunsets, seascapes and the Temple of Apollo. These are different from the comics, aside from being painted differently. Lots of people hang up pictures of sunsets, the sea, noble buildings and other supposedly admirable subjects. These things are thought laudable, agreeable, without much thought. No one pays much attention to them; probably no one is enthusiastic about one; there isn't anything there to dislike. They are pleasant, bland and empty. A lot of visible things are like this; most modern commercial buildings, new Colonial stores, lobbies, most houses, most furniture, most clothing, sheet aluminum and plastic with leather texture, the formica like wood, the cute and modern patterns inside jets and drugstores. Who has decided that aluminum should be textured like leather? Not Alcoa, who make it; to them there is just a demand. It's not likely any of the buyers think much about it. The stuff just exists, not objectionably to many people, slightly agreeably to many. Basically, again, no one has thought about it. It's in limbo. Much political opinion is like this, much religion, much art, of which the chromos are an example, most opinion in fact, musicals, ice shows, graduation ceremonies. No one knows anything about Greek temples and everyone agrees they're great. Lichtenstein is working with this passive appreciation and opinion. It's part of these paintings and is an interesting and complex aspect there. It isn't adventitious, as social comment is supposed to be; it is social comment and it's visible. The paintings

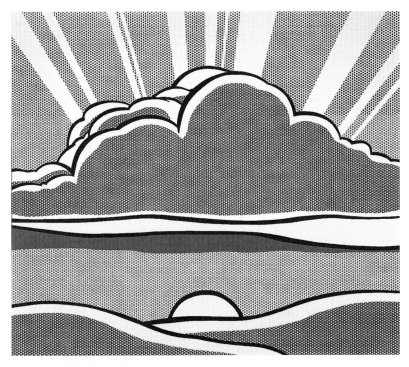

Sinking Sun, 1964. Oil and Magna
on canvas, 68 × 80 inches. Private
collection. © Estate of Roy Lichtenstein.

are very good as paintings. Lichtenstein's work is among the best there is. It isn't inferior to abstract painting; it isn't just social and literary. The scale, certainty and freedom of his work have been increasing steadily. These paintings have much less composition than the previous ones and more that is unusual. More is done with the dots and the flat patterns. Three seascapes, mostly sky, have blue dots stenciled on glass a few inches in front of a second field of blue dots. The sunsets have bands of flat areas, bands of dots, blowsy cumulus clouds, blank or dotted, the sun and great sundown rays. *The Temple of Apollo* is a large painting. The temple is bare canvas and black line and shadows. Half the painting is blue dots, the sky, and half, the distant land, has double the number of dots. The ground is yellow. There are two wide areas and a few verticals. A couple of the sunsets are baked enamel, which is syrupy and glossy, slightly raised. (Castelli, Oct. 24–Nov. 19.)

Lichtenstein at the Guggenheim

Max Kozloff

I can still remember Ivan Karp's "take-this-if-you-dare" look, as he hauled out, face backward, a number of canvases which were to be my first Lichtensteins. How was a guileless critic to know in that distant year (1962), that he would be confronted by what was quickly to become a grand trademark of '60s art? The subjects, the identities of those pictures have passed from my mind, but not their acid shock. To drink in those images was like glugging a quart of quinine water followed by a Listerine chaser. And there was, too, the fierce disbelief that anything so brazen as these commercial icons could have found their way on to prepared and stretched canvas. The very gallery seemed defiled by some quack churl who couldn't, or didn't, adhere to the idea of painting as an easel art. For this was a comic strip and mail-order world that unliveably refused to stay in place, one that would scream down any poor victim of an artifact, work of art, or person unluckily caught within its optical range. And now the Guggenheim Museum retrospects Lichtenstein at the end of the '60s before an audience who regards him as classic as well as contemporary, intellectual as well as risible. Long ago, what's more, his brand had entered thousands of homes, bannered and postered into our consciousness as the exhilarating paradigm of a "with it" generation. No less of the past, the chemistry of my own discontent had bubbled off, leaving the most sanguine appetite for his product. It's not that Lichtenstein had somewhere receded in to "art," but that art was redefined.

Doubtless, the stylistic mischief once raised by Pop, with Roy at its forefront, had much to do with this. There's no need to emphasize the importance of stylistic reversal and extension—even into the most unlikely realms—as a factor of the way we reeducate ourselves to everything innovating in art. And Pop art gave itself so completely to stylization that a new content was pressed out of its embrace with the media. Gone

are the symposia which thrashed about and wrangled over whether this work could be considered simply ... art!! Its mimicry of its sources, the Sunday supplement, the billboard, the teen romances, etc., short-armed quite a few who objected to the subjects ... who craved the expressive ... who demanded the transformed. And I should have thought it redundant, now, to espouse overmuch Lichtenstein's formalism. He talked form in the early days, possibly to calm down the flak. Today he's almost thought to be a composer in the vein of the emblematic abstractionists who developed concurrently, and shared certain devices, with him. A weird back-handed sort of honor. No, his redefining of art more likely located itself in his rewrite and scrambling of our perceptive habits, for which his subject and the style (most often they're the same thing) are translucent alibis.

For instance, there is something linguistically depraved about the behavior of his overused images, which flatten out with all their kinks and corruptions retained and magnified. He pays homage to the clichés of a visual argot ponied by all sorts of uncomprehending middle-men, whether they be art directors, product designers, or commercial illustrators. From this emerges such a rhetoric of error compounded by error, that Lichtenstein might be considered a specialist in impurities, an art-for-art's sake artist in reverse. Here, the notorious Benday dots are archetypal. At first they're stitched in daintily as a timid half-tone. Later they want to give different kinds of tactile and color information, and don't mind becoming bumptiously decorative in the process. Still later, they get clustered in differing ratios for the purpose of imitating grainy photo printing. Though Lichtenstein himself hardly misconstrues their purpose, his dot-screens are shot through with multifunctions and misalliances. This atomized matter magnetizes into cast shadows or measles, so that the illusionistic conventions at work in his art occasionally threaten to break down into a series of homeless blips. Sometimes I tend to think of them as punctuation marks migrating across sinuous diagrams, an obtuse counterpoint to the "action." Often, in his landscapes, they are mechanical jujubes sitting all over, as if they had taken out squatter's rights on the sky. In *We Rose Up Slowly*, an underwater scene, their crude veiling contrives only to look like several runs in stockings. A work called *Non-Objective Painting* blatantly coarsens with a dotted half-tone what otherwise passes for a reproduction of a Mondrian. By accepting the limitations of only the cheapest mechanical printing, Lichtenstein restricts himself to a kind of basic visual English. In an important sense, the schematic contrast between inarticulate and inflexible materials, and the implicitly more complex

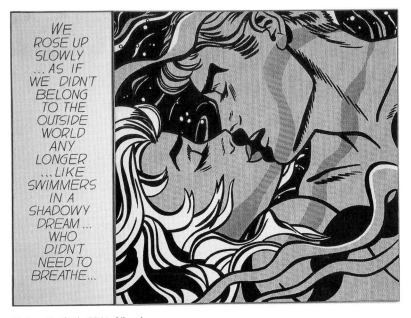

We Rose Up Slowly, 1964. Oil and
Magna on canvas, two panels; left,
68 × 24 inches; right, 68 × 68 inches.
Museum für Moderne Kunst, Frankfurt
am Main, Former Collection of Karl
Ströher, Darmstadt. © Estate of Roy
Lichtenstein.

passages, phenomena, and volumes they represent, is Lichtenstein's sub-
ject. Or rather, his stock in trade. From the inadequacies of rotogravure,
he mines a rich sensory confusion.

The same might be said about his attack on the linear manner-
isms of comic strip draftsmen. Tentacles of hair, leaves of fire, crevices of
shadow, these are but some of the unintended metaphors that sprout in
his scaled-up and hardened view of the funnies. It's curious that while on
one hand he particularizes the emotive handling in this kind of drawing,
on the other, he generalizes its perceptual capacities. A girl's tresses and the
pushed, bristled paint of a giant brushstroke, are executed with a similar
line. We know very well what a glint of metal looks like in the comics;
we're less accustomed to see the same linear motif appear in an area of a
"Picasso." In everything he does, Lichtenstein designs that we catch him
redhanded, the better to show the interchangeability of his elements. The

carapace of such degraded line freezes all possibility of personal touch and spontaneous pressure, one of the reasons for the acceptability of its hysterical subject. Hyped and hoked up on Roy's inflated terms, it comes alive as a slow, florid overgrowth of sensation. Though each object still conventionally reads as what it is, it tends to lose its symbolic leavening, and lifts off, freely created in its own right.

I used to think he was infatuated with violence. And I will not, even now, absolve him from an exquisite spite. Pop art would have yielded such aggression, in any event, if only because it absorbs into itself transcontinental kitsch, phallic dreams of national glory. And these are positively barbaric. But such violence can be attributed neither to individual taste nor a didactic intent. True, it exists for Oldenburg, as a kind of organic alarm which can only be exorcised by detumescing the whole environment. Lichtenstein is more removed. Along with, or even before Godard, he had been responsible for magnifying that lethal kid stuff into an obsessive talisman of the cold war. He may be less of an anarchist than the Frenchman, but he is as much a revolutionary technician. The baroque cinema of the comics, their combination of words and visuals, are mutually explored by the two men. In contrast, Warhol's is a literal transcription of the media, more sexual in surface than in energy, which numbly documents our disasters. In each of these men, violence is a declension of falsity (be it primitive or glamorous), sundered even from the reflecting mirrors of the real.

Lichtenstein's filter of this falsity is the most directed and consistent. That is why he can be the most nominally lurid of modern artists. Iconographically, the Guggenheim show is studded with belligerent themes sterilely processed. Air warfare, explosions, six-guns, that sort of thing. But it is equally replete with classical temples, kitchen items, sunsets. The Dionysiac motifs are corseted, tamed, and deflated, by the mechanistic form. But the "Apollonian" ones never looked so brutal. In other words, rigid though it seems, Lichtenstein's style is pliant enough to project something of the affective opposite upon that which it portrays. And this is due to a genius for displacement rather than any accommodation of technique. I wonder, in the end, if his simplifications don't convey an ultimate form of violence. The more tongue-tied and self-denying he is, the more sensational his revelations.

Much is known about Lichtenstein's ambivalence toward his content. Given the narrative aspects of his painting, this might almost have been expected. But his sculpture, whether on the wall or the floor, stands free as

self-contained imagery, an exclusive vehicle for style. In addition to being the most depoliticized area of his work, it's also the most paradoxical, for the reason, now, that illusion is left behind. What impresses is the extent to which normally very transient phenomena or very specific artifacts have become abstracted. However slim or flat the volume of his sculptures, it demanded the most craven or the most elliptical conventions to make sense out of the three-dimensional object. How do you make tangible an explosion, or study the components of blast, except by the most outrageous petrifications? In the sense that such sculptural images seem snipped out of his paintings, they offer the same solutions as in his pictorial work. But to the degree that their immobility is much more explicit, they're the most astonishing things he's ever done. A sculptured explosion is a contradiction in terms. Actually, Lichtenstein has never shrunk from depicting conditions for which his form was the least plausibly adapted. What use is linear clarity in rendering light? To make something solid out of the ethereal, something opaque out of the transparent: these moments when form and subject work most abrasively against each other are the dramatic points of his career. The subtitle of his Rouen cathedral series, "seen at three different times of day," is delightfully untrue. His two-color schemes for these pictures resemble infrared or ultraviolet versions of an Impressionism which they contravene almost on the level of being a "negative" of Monet. Similarly, the metal meshes in his explosions are negatives of the dots in his paintings. Nothing is more absurd than the way these tired, shiny plaques, centered by little scalloped bursts, permanize the split-second . . . and yet, nothing is more winning.

Equally playful, although in a quite different vein, are the "Modern Sculptures" of the last two years, pendants of his "Modern Paintings." They broach the problem of the take-off, the spoof, and the parody in Lichtenstein's art. Let's admit right away that for Lichtenstein, art within art is not a matter of deriving *sanction* from or *gaining access* to anything. It's just that the tradition of "fine art" is as wonderfully, woefully "there" as the traditions of commercial culture—and both are legitimate prey for a vision that considers such material . . . nature. In this context, Lichtenstein has always been a "revivalist." It means nothing and everything to say that he feeds off the given accoutrements of culture, high and low, old and new. Even when he invents a composition, he is not free from borrowing its style; and even when he is most derivative in style, he can be most authentic in thought. He gives as much as he gets, *feeding back* into the cultural mainstream, not so much comments, or précis or afterthoughts on his sources,

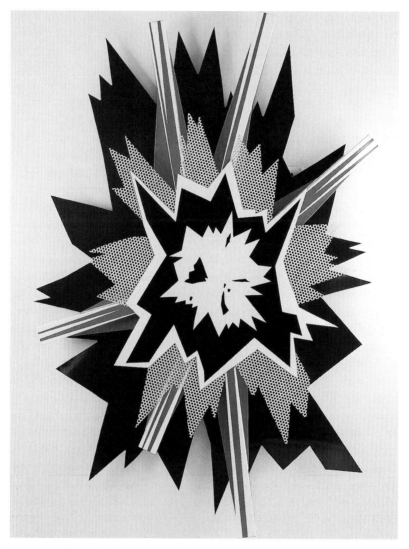

Explosion II, 1965. Enamel on
steel, 88 × 60 inches. Charles
Simonyi Collection. © Estate of Roy
Lichtenstein.

but witty alternatives of looking "through" them—and by extension, at ourselves. The Cézanne, the Picasso, the Radio City modern bannisters and railings, these are simultaneously present and absent camouflages, that define the originality of Lichtenstein's own historical moment. The latest of these allusions to '30s "Art Deco" purveys its own authority. Gilt and chromed trellises, circles, and ripples, welded to chevrons and stripes, stand stripped of their function, in pointless debonair pride. To see one of these long floor pieces in the foyer of the Guggenheim, however, is to realize how an ironic revival plays itself off as a foil against a "straight" one, within the same curvature of forms. "Modern Sculpture"... Guggenheim Museum ... they're no more modern than they are old. Their streamlining cuts through time as well as space, establishing our age as the empire of the *Moderne*. Just as he can metal-plate sheer outbreaking energy, so Lichtenstein typifies his "now" by grasping a past style's dream of the future.

Yet the principle of choice for his visual cribs is not tied in with anything so definite as recurring nostalgia. Diverse as they are, these images have in common the fact that they've been overused, exhausted of interest for every audience except the one which can't imagine them as the basis for making new art. Because current happenings are too "artistic," Lichtenstein predates his work. A time-gap operates to give his subjects a false period flavor of their own, and therefore exempts him from dependence on the topical. Not that he isn't responsive to, or analytic of, his present situation. *Preparedness*, for instance, rehabilitates the WPA mural style (and scale), molds it into a '40s subject, and executes it in comic strip technique, to afford an oblique, yet incisive glimpse of American Imperial society in 1969. Such is the chameleon-like sensibility behind the armorial schemata of this art. Oddly enough, his dedication to a final seriousness has kept Lichtenstein from essaying the combine painting or assemblage, as did practically every other Pop art colleague. Then too, an almost tender loyalty to the past, sparked by that urge for the permanent I've already mentioned, prevents him from indulging in the ritual gesture of self-destruction: ephemeral or disposable art.

In contrast to the slippery Oldenburg, and the mercurial passivity of Warhol, Lichtenstein looks to be a straight-laced type. The lack of nuance, the unwieldy public scale, and the often monumental theme (he has just completed a mammoth diagram of the pyramids) all contribute to the impression of a rather ponderous, if not a conservative attitude. Yet, what really kindles is the lightness of spirit within the discipline ... and

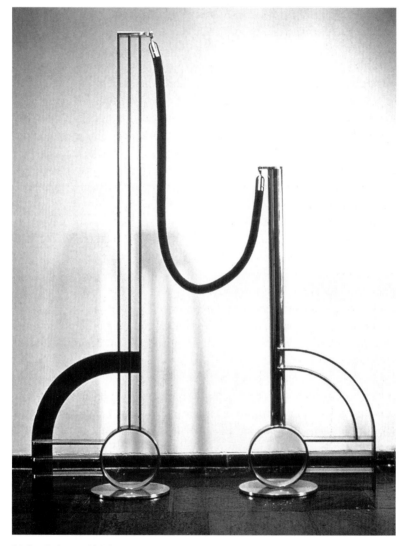

Modern Sculpture with Velvet Rope,
1968. Brass and velvet rope, two
parts, 83¼ × 26 × 15 inches and
59 × 25 × 15 inches. Edition of three.
©Estate of Roy Lichtenstein.

something else, a charming "who, me?" self-kidding that crops up with some regularity within his production. The man who asks us, "What do you know about my image duplicator?," with his fierce gaze, only welcomes exposure, and invites us to join in the joke. And Lichtenstein has responded to his own fame, at the very inception of Pop, by having one of his lovelies mouth "Why Brad darling, this painting is a masterpiece! My, soon you'll have all of New York clamoring for your work!" More abstractly coquettish now, as opposed to mock-deprecating, is *Stretcher Frame*, of 1968. For its facade pretends to be its back, and yet Lichtenstein shows that the dots alone are sufficient to "make" the picture. These are disarming games with the spectator, games whose content is the artist's open acknowledgment of his artifice. They're a reflection of Pop art's social notoriety drawn back into his work, as if he were saying, quite rightly, that he has nothing to hide, that his devices are only his devices.

But *Stretcher Frame*, despite its illusion, is quasi-abstract painting. By 1964, when he opened his art to full throttle, Lichtenstein must have understood something about the abstract potentialities of his vision. The zoned landscapes by themselves would have indicated the generalizing advantages of the dot technique stripped of imagery. If Dine, Rosenquist, Warhol, and Oldenburg had demonstrated all manner of compositional affinities with systemic abstraction, Lichtenstein alone, and inevitably, has "represented" it. In this matter, his mockery, if you will, is quite theoretical, but his aestheticism is quite practical. His affluent "Modern Sculptures" run laughably but not derisively abreast of Anthony Caro's, whose overlooked forbears in Neo-Cubism Lichtenstein would remember. And with face-slapping scholarship, Roy makes explicit, in *Modular Painting with Four Panels*, what Frank Stella owes to Delaunay. If it could be left at that, Lichtenstein would have to be accounted merely a frivolous scavenger. The trouble, the wonderful trouble, is that *Modular Painting* . . . is a masterpiece, of which Brad can be truly proud.

Tape-recorded Interview with Roy Lichtenstein, October 5, 1965, 11:00 AM

John Jones

This previously unpublished interview, focusing on the relationship of Lichtenstein's painting to European art, was part of a research project sponsored by the American Council of Learned Societies. It was conducted by John Jones, then a lecturer at the University of Leeds who, at the time of the project, was a visiting scholar at New York University. Other interviewees were Rudolf Arnheim, George Cohen, Helen Frankenthaler, Adolph Gottlieb, Robert Indiana, Richard Lindner, Sheldon Machlin, Robert Motherwell, Claes Oldenburg, Man Ray, James Rosenquist, George Segal, Theodoros Stamos, Saul Steinberg, and Jack Youngerman. The full interview transcript, which has been lightly edited for inclusion here, is in the Archives of American Art.

JOHN JONES: First of all I'd like you to talk about your own style.

ROY LICHTENSTEIN: In relationship to how I feel it fits into the tradition of . . . ?

JJ: Well, yes, that . . .

RL: Well, I really think, I guess, that most art fits into a European tradition in the sense that European tradition is based on perception and there are certain aspects of perception which remain constant. And the purpose of art I think is still unity and this is really the tradition of art. In a sense there's no real tradition of European art when you think of how a work of art looks, and when you've produced everything from Titian to Vermeer to Mondrian—there's very little similarity between these works. And I think that American art, although we like to think of it separately in a way, is no further away certainly than those painters are from one another. I think that what we're doing is something that maybe hasn't been done in Europe, but then those European artists also were doing things that

weren't done before in their own tradition. I think that even Oriental art fits into this tradition in the sense that there's a different stylistic aspect to it. It certainly looks different. But I think there's really very little difference between American art and what we think of as European art although we seem to be making a lot out of it. I think there's the apparent lack of subtlety and sort of make-believe anti-sensibility connected with American art. I think this is a style and it does relate to our culture and I think it would be anachronistic maybe to pretend to be involved with subtle changes and modulation and things like that because it's really not part of America. But I think you see these same things going on in Miró and Mondrian, also Arp—except that we're attaching (at least the so-called pop artists are attaching) this form to subject matter from our highly industrialized life. But I think there's really very little difference in the art. But then you can look at it either way. You can say there's a great deal of difference or you can say there's not much significant difference.

JJ: When you say that these differences somehow reflect American culture generally, in what respect . . .

RL: Well, I think that it's a matter of degree. I think that in America there's just more industrialization and it permeates everyday life—the way you make coffee instantly to the kind of furniture most people have, the kind of apartment most people may live in, the garage and the car and the transportation and the television, whereas I have the feeling it isn't true of Europe. Certainly England is highly industrialized and Germany is and France is to a certain degree, but somehow or other it doesn't—I'm not sure that it really permeates the everyday life of most people in those countries the way it does here. There's no real tradition here and things like antique furniture are specially imported and then really belong to only a few people, whereas I think most people in foreign countries are living in an old setting even though there are the same objects in their environment. And I suppose the Iron Curtain countries are concerned, let's say, with—it's a funny way to put it, "Iron Curtain countries," but we're so used to that language we use it—they probably have new things because most people had nothing to begin with so their objects are new. But I don't think that the full force of the tremendous traffic involved in highly industrialized civilization really reaches the people the way it does in America.

JJ: Of course it's true. How does this relate to your training?

RL: Well, a sudden realization I guess that it's a shift from Europe. I think we were all trying to do European painting in one sense. We were schooled to know about the tremendous tradition of painting in a European way and we tended to think of commercialism as a kind of intrusion and we would try to live in a way that would revoke ourselves from it. I think this is true even of the Abstract Expressionists. Their tradition seems to be much more European than the more recent painters because of the interest in paint and all of that. Even though they think of it as an American art it seems to be so close to Expressionism in Europe that it's very hard to tell the difference.

JJ: Yes. Two things come up. You talk about the kind of training that artists have. What sort of training did you have? What art schools did you go to?

RL: I went briefly to the Art Students League but most of the training I had was at Ohio State University, and of course you're studying European art most of the time because until very, very recently American art was definitely second-rate and would occur several years after the same movement occurred in Europe and would be, as you said earlier, watered down.

JJ: Yes.

RL: We had Realists and we had Impressionists but none of them could compare with the Europeans.

JJ: The second thing is you used the phrase "An interest in paint," a sense of concern for paint. Do you feel that this is somehow not a timeless quality that painting should have?

RL: Yes. I think it is not a timeless quality, I think that it's something that occurred—it's really Venetian I guess in origin and occurred in Italy. Of course in the northern countries you didn't have this concern with paint, even though for some reason or other oil painting began in the North. I don't quite understand how this occurred. But then it's really in Impressionist and Expressionist times that the concern with paint comes about again.

JJ: I think I meant it in a rather different way. I meant that the artist's concern in the past, or at any rate the kind of concern that one learns in art school, is a formal language, which has to do with material itself. The

language which you employ to express yourself, is this the language of what we might call the drama of materials?

RL: Well, I think there we're still involved in that way. We're still, I think, completely involved with it to the same degree really as it's always been except that I think you find other qualities in it. And whatever quality one generation has is boring to the next generation. And so you look for something else. And something that seems like amateur art school scratching becomes a way of painting in the next generation because you find something interesting in it.

JJ: Apart from the boredom that one generation feels for the past generation, did you consciously look around for themes which were different?

RL: Well, I think that's probably an after-the-fact kind of statement, you know. Once you happen upon something you like to think that you thought it up on purpose. I think that thought occurred to me after I did what I did rather than consciously looking around for something new. I don't think you can really do that. I don't think you can do it successfully.

[. . .]

JJ: Did you at first feel that you were forsaking some of these abstract qualities for the sake of the, you know, the intriguing impact of these [figurative themes]?

RL: Yes. It actually worried me because it's very hard to—because I've been out of art school now since '46, I got my Master's in '49, and I'd been painting a long time, and you begin to believe in the qualities that you're working in and suddenly the change is really kind of traumatic. I knew that there was something there that had great impact, and the importance of it I sort of felt but didn't know thoroughly, and I kept worrying about the other work. In fact I even tried to do both at the same time in a funny way. It didn't work.

JJ: I read something in this book *Pop Art* that's been published recently, where for a while you tried to paint from comic strip characters but in a looser kind of way.

RL: Well, that happened before I actually changed. I had a little session of that even a few years earlier. But the painting is really unsuccessful. I was working with things like Donald Duck and Mickey Mouse and you could

make them out but the paint was sort of a mess actually. [Interruption for phone.]

JJ: What you were saying was that for a while when you began to paint these things you tried to do both things at once, the kind of painting you were accustomed to painting and to introduce this new thematic subject matter. And then came a point when you in a sense abandoned the one for the sake of the other.

RL: Yes. And all of this was very quick too. I mean it absolutely happened within a period of a month or so. But it's just so hard to give up what you're used to that I really couldn't abandon it.

JJ: Would you say that since then it's been a process of assimilation, of bringing the two together? I mean you said just now that you were thinking of the pictures as abstract pictures.

RL: No. Well, I think I did that pretty much from the beginning. I thought of them as abstract. Just at the point of painting them I certainly knew that there was subject matter, but there was a process of selecting subject matter first and once it was selected and drawn on the canvas then it really became a process of painting in the traditional way but not with traditional means.

JJ: Yes, I see. Would you say that the process since then has moved away from the first sort of vulgar impact of the comic strip thing toward something more tasteful? Or is that unfair?

RL: No, I think it has. I think the subject matter has become abstract and I think it's partly the choice of subject matter and also a desire to pick subject matter which suited my feeling, but I think once the idea of the vulgar has been brought across you can't keep repeating the same thing all the time. The landscapes that I did are really vulgar landscapes, but because they're landscapes and the way I did them tends to be more abstract, they appear a little more tasteful I think. It's a word I really don't like but I'm afraid it applies.

JJ: Yes.

RL: I think that it probably is true and as you can see I'm doing brush-strokes and things now that look a little bit like Abstract Expressionism. But it's still humorous I think in the way that the landscapes were, it's

taking something that originally was supposed to mean immediacy and I'm tediously drawing something that looks like a brushstroke.

JJ: And you're actually applying this parody of commercial technique to the . . .

RL: To the brushstroke also.

JJ: Yes.

RL: People will love me for that.

JJ: Is there an element of not exactly Dada protest, but a kind of perverse desire not to do it—I mean in a sense what you're doing is a negation of the whole point of those brushstrokes.

RL: Yes.

JJ: Well, there is a kind of attitude that says art, acceptable art has these values. I will mock them and parody them.

RL: Yes, I would certainly think so in that they're done in almost completely the opposite spirit as the original paintings. Though even in the paintings of [Franz] Kline, for instance, it's not an immediate brushstroke, it's something I think he did on paper and even projected up, I've heard, on the canvas and certainly redid over and over again.

JJ: Wasn't there a concern that it should have the appearance, though, of . . .

RL: Of immediacy? Yes.

JJ: Yes. But there's no such concern in your treatment of it? I mean in fact just the reverse, you want it to look . . .

RL: I want it to look as though it were painstaking. It's a picture of a picture really and it's a misconstrued picture of a picture. Something like the feel in those Picassos I did, you know.

JJ: Yes.

RL: It looks more like an idiot painting of Picasso.

JJ: This comes back to the point I was trying to get at before: do you feel your painting stand or falls in these humorous terms or do you think that essentially—sorry to keep harping back to this—but one might say that

Woman with Flowered Hat, 1963. Oil
and Magna on canvas, 50 × 40 inches.
Private collection. ©Estate of Roy
Lichtenstein.

French painting stood or fell by the quality of the paint, the relationship of the parts and so on, the pictorial integrity of the work.

RL: Yes. That's the major concern. The fact that it's a concern doesn't necessarily mean that it's there of course, but that's what I think I'm doing anyway and . . .

JJ: You'll be sorry to abandon such a . . .

RL: No, I wouldn't abandon that. I mean I really don't think of it as anti-art, I think of the painting as holding together because very shortly the joke historically will disappear I think, and the joke is part of the immediacy; it's usually very shallow humor which will die in six minutes, you see. And if the painting doesn't hold up after that it's really a disposable painting which would tie in with the culture. But it's not really what I'm trying to do. And in that way I think it relates to the tradition of art as I see it. Of course we can all fool ourselves very easily but really the major work in the painting is not the idea, which could be done very quickly, but it's in trying to make the painting hold together and to use those elements to—I mean I don't use modulation, for instance, of color but I try to use the line and the form so that it will cause a sense of change within the color. This isn't far from the way Miró worked. And so . . .

JJ: Well, you've twice mentioned Miró. Is he a painter whom you greatly admire?

RL: Yes. I was thinking . . .

JJ: Are there any others?

RL: Well, I really admire almost all of them, you know. I think really the painter I like best is Picasso, just because of the variation and the insistence of his images. And, of course, Matisse also. It's very easy to like Picasso and Matisse. I think I like them better than painters since them. I like de Kooning's work very much and . . .

JJ: On the whole the Surrealist thing in a sense informs your work and yet . . .

RL: I really am not terribly interested in the Surrealists. Everyone thinks I should be tremendously interested in Léger, let's say, and the Surrealists. But the Surrealists really don't interest me very much. Léger only recently has interested me. In fact I never really liked his work at all but I saw

recently the Léger Museum and was really very impressed with it. But I think it's possible that they keep all the good paintings there.

JJ: Do you feel that he was doing things you are trying to do?

RL: Well, I didn't realize that at first but I can see that certainly the industrialization and standardization and all of that seem to be part of it. I really just looked at it as kind of clichéd art. I think I missed the point of it completely to begin with. No, I think that this is the reason for the kind of form that he uses. Still his paintings to me, many of them, seem as though the parts of each are individual rather than really put in context, but I'm learning to like it.

JJ: Putting aside the question of pictorial qualities for a minute, I'm curious about certain aspects of your comic strip things. I understand that you look through an enormous number of these before you select one. But having selected these frames from the cartoon strips, do you feel that they have some kind of universal significance? It seems to me that in one or two of the things that you've done—I haven't seen many, but a few in reproduction—you seem to take a figure and envelope it in some kind of timeless, almost archetypal situation. Or do you think this is pushing it too far?

RL: Well, I don't know if they have universal meaning, but I think they would have at least an American-European link, in that people would understand easily the hostility or romance or something. And I do take the ones that put forth the idea that we all frown at but we all do. We all at times talk like comic books to people and, you know, they're really the most potent situations of our lives but they're also laughable if you're not really in it.

JJ: Yes, It's funny. Somerset Maugham once said that man in extremity sounds like a cheap novel.

RL: That's right. And it's that kind of thing which seems to stimulate me. But you know, when you think of comic strips you think they're all like that but it isn't so. If you go through them you'll find that there are very few frames that you can really pick out that would be useful to you. Most of them are in transition, they don't really sum anything up and it's the ones that sum up the idea that I like best. But also I pick frames that I feel I could do something with aesthetically. Some of them are too mixed up or too disparate in some way to be able to be pulled together. And so I

may take an idea from one comic strip and the actual pictorial image from another, although sometimes they both occur at the same time.

JJ: And so when you're choosing you are concerned with their aesthetic possibilities as well as the idea.

RL: Yes. It's sort of total impact that I'm looking for.

JJ: I saw a poster the other day, "This Must Be The Place." Do you recall it?

RL: Yes.

JJ: It seemed to me that this is a very funny joke, this extraordinary place and this comment together are very witty but I only wondered if they are more than this. Do you see that arrangement of houses as an arrangement of forms?

RL: Yes.

JJ: And the placing of the letters in the balloon is all related in this way to this kind of . . .

RL: I really think they're almost academic in that sense, yes. I mean [my subjects] either get into a kind of Cubist composition, which that one does, or they're almost completely islanded, like *Roto-Broil* where it's a complete single statement and in that way is very much like a Noland or something but there's almost no ground. The figure just exists there and I think you have to make some kind of positive composition out of it.

JJ: That's interesting.

RL: They're really of two types I think if you look at my work. It's either one thing isolated or it involves the whole arrangement. It seems to work out best when I do that.

[. . .]

JJ: To put it very crudely, do you feel that your work makes some kind of social comment as well, that it's an observation about American culture?

RL: I think it does. It's not really a preoccupation of mine. I don't feel strongly about getting messages across but I think it reflects at least industrialized life and, by way of that, American life.

JJ: You don't feel that it reflects it with approval or disapproval?

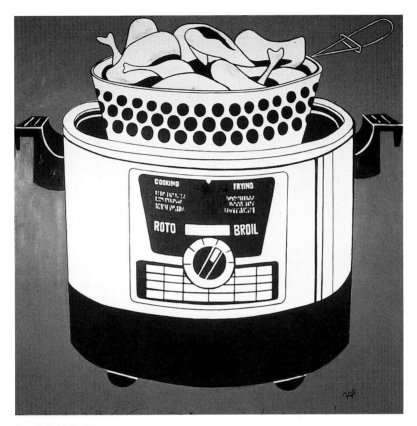

Roto-Broil, 1961. Oil on canvas,
68½ × 68½ inches. Museum of
Contemporary Art, Tehran, Iran.
© Estate of Roy Lichtenstein.

RL: No. No. But pretty much in the same way that when the Realists painted slums and garbage cans, they were not approving of these conditions. I mean I certainly don't think that popular life has a good social effect. In fact I think just the opposite. But there are certain strong and amazing and vital things about it. It's not the society that I really like to live in. I don't mind living in it now because in a way I'm seeing it through other eyes, having been schooled in what is essentially European art tradition. I really wouldn't want [pop culture] to be taken up in the culture seriously, but at the same time there is this tremendous vitality about it.

JJ: You're glad in a sense that you stand outside it?

RL: Yes, I think so. Yes. And stylistically as opposed to the Abstract Expressionists, you see, who really stood outside it, we're at least pretending not to be standing outside. We pretend to be a part of it and to be fostering it and be all for it and that sort of thing, which I think is really a pretense. But there are few people who will admit it. You have to have taught college for quite a while to be able to admit something like that. If I had only painted I think I would probably hide the fact, but I tend to be too constructive for that.

JJ: Yes. About this question of communication—you say message and so on—how concerned are you with the sort of attitude which prevailed for a while that the artist didn't care if people didn't see anything in his work? Is your painting just for you or is it about things which you want other people to share?

RL: I'm very, I think, involved in what other people would see in the painting.

JJ: Yes.

RL: And it is important for me when I'm working on it. I really think for other artists too. I think that the Abstract Expressionists not caring, this is part of policy probably because nobody *did* care, so you might as well go along with it. But I think they certainly cared whether their friends liked it. It's just that the audience at that time was so small for art. It's still small; there are more people who might buy art but I think the people who read art are still a very small group. There are more people who pretend to be interested or maybe are interested in it today, but I really think that artists are interested in how at least some other people see their work.

[. . .]

JJ: But there's a sort of paradox in this business now. I was at Larry Rivers' opening the other night and that must have been one of the biggest social occasions of the year.

RL: Yes. Well, here we have a lot of those, it's amazing. Are you going to be here for a while? A year?

JJ: I hope to be.

RL: You'll be amazed at the amount of connected social activity here with art. I hear in England it really isn't much.

JJ: No.

RL: Everybody comes to all these things. The calendar is so full of these things I don't know how I'm going to get any work done.

JJ: I'm interested in this whole thing about American paintings, the importance of American painting in the world. It's a kind of phenomenon too because it's not just about painting anymore in a way. There is such an interest and such universal awareness of what everybody is doing here which is probably unique in the history of painting. I don't think it has entirely to do with the painting, it has more to do with the speed of communication and this sort of thing.

RL: Yes.

JJ: Nevertheless, the tremendous success you people have had is probably unique in the history of art, that without being a bad painter you've had some success. Do you see what I mean? In the past there have been society painters in London and certain painters, portrait painters, who in their middle age have just automatically become successful. Funny enough, one feels that *so many* painters in New York are making a lot of money.

RL: The reason for the amount of interest in the work, as you suggested, is partly the buildup of communications. Someone can do a painting and five days later it can be reproduced in a magazine and seen in Japan or something, which of course couldn't happen before. But I think that a lot of it has to do with American collecting, which never was a factor before. Oh, there have always been collectors—they say that out of the five hundred known Corots two hundred are in America, of some sort or another. They have always been collecting, because there's been money, but rarely modern American art. They collected *modern* art—Picasso, Matisse and so forth—but not Americans. The Abstract Expressionists of course had a very difficult time but they did manage to establish this group of collectors, people who buy very small works to start with. And then there's so much written about collecting that more people collect and it builds up. We're in a very affluent period now and this combination of easy communication and affluence and the fact that American painters have come into their own has permitted a great deal of collecting. I think there's much less collecting, say, in France. There aren't too many French collectors of modern American works—probably four, or five, major collectors anyway. There are more in England, more in Germany, more in Italy than there are in France. Whereas we felt France to be the

center of art, now certainly London is much more important. But I think it's the presence of American collectors that's helped all of this art because they can afford to collect and they just didn't have the sensibility for it before. Now apparently they do. It's a good market worldwide really.

JJ: How did you come to achieve this sort of success? I mean how did it happen for you? Were you just suddenly taken up by a gallery, or did collectors seek out your stuff before you dealt with Castelli?

RL: No. I'd only done maybe a dozen paintings like this and Allan Kaprow who was teaching with me at Rutgers made an appointment for the Castelli Gallery to see it. I brought the work up and they liked it, and Ileana was in town and she came out—I was living in New Jersey at the time. A lot of people saw it at the gallery and came out and there seemed to be quite a bit of interest. It was a few collectors but they seemed to buy in quantities. That's another strange thing that I didn't realize, you know. I had always been with a gallery pretty much and maybe a collector would buy one. But now I find collectors buy five at a time or something like that. It's very gratifying. David Hayes was one of the first collectors that I had, and the Tremaines and so on.

JJ: Someone was telling me that someone by the name of Scull, is it? collects.

RL: The Sculls haven't collected a lot of my work but they have done a lot of collecting. They're now auctioning off I think Klines and de Koonings. They have a very big collection of Rothko and Kline and de Kooning and they're just auctioning some of the work.

JJ: I see.

RL: They're not unloading or anything, they just like to collect, to keep collecting and I think just so they can afford to do this they're auctioning some examples of each of those people's work. But I don't think they're really auctioning off young artists because they're still historically recent.

JJ: Now this can be off the record as you know, or not at all, if you like. There's an element of cynicism about the whole scene. Do you feel this strongly?

RL: Not really. I remember when I first went around to galleries in '49 or '48 I was never old enough and they wanted mature artists who had proved themselves and so forth. Now it seems that you can't be young enough and

there's nothing you can do that would be so daring that nobody would take it. So it's not a bad situation, it's a rather educated situation.

JJ: Does it depress you at all?

RL: No, it really doesn't. In fact I'm rather happy with it, except that the desire for the new could lead to the buying of almost anything no matter how bizarre. But that's not as bad as being reactionary and not taking it because it's bizarre.

[…]

JJ: This is a very optimistic point of view, I think. A critic like [Clement] Greenberg might say—I don't know, I'm just guessing from what I read— might say that innovation has taken over and the art bit is minimal in the scene now. […]

RL: I would never approach the problem that way and innovation really isn't what I'm looking for. I think that it's a product of keeping yourself interested within the context of art. I don't know how you would get into innovation, you see, any other way. I don't think you could look for it. You'd never find it. You couldn't just sit there thinking what should I do. Any outlandish thing you think of doing would probably again be just either a combination of others' work or some extension of it. I think it would look immediately banal.

JJ: You don't feel somehow that innovation in plastic concerns is possible?

RL: I don't really think that we've done this. I mean that hasn't been a major part of, say, Pop art. Or I don't think it's been a major part of geometric art going on today. There's not really much difference to me between Mondrian and, say, Albers except that Albers is symmetrical where Mondrian is asymmetrical, which is a sort of minor point because they're both good painters. But I think the only innovation in Pop plastically is that the painting doesn't have to be symbolic of the organizing act, you see. So in that sense it's a kind of sophisticated look, whereas Abstract Expressionism, Cubism, and so forth were all highly symbolic of plastic discovery. Pop is almost the opposite. In that way it is also a plastic innovation by its very oppositeness.

JJ: I've heard the view expressed that after Matisse there was a kind of interest in color and the artist might regard himself as some kind of

scientist whose obligation is to push the whole thing a little bit further. Someone like Rothko, for example, who takes further this kind of concern with color as if the boundaries of plastic art are somehow going to be pushed away. This kind of plastic innovation—would it be true to say that you feel that the plastic part takes care of itself?

RL: I think it is in our art and I would not say that no one will ever make another plastic innovation. But it does seem to me at this moment that every kind of direction—Realism, and all kinds of abstraction from the strictly geometric to automatic writing—has been explored, and that to make color work, which has always been my problem, just doesn't seem to be instructive enough, because although still very few people can do it and understand it, it isn't revelatory in any way any more.

JJ: Yes.

RL: I still think it's highly important. Otherwise you're not in the realm of art—which is all right too, but that's the realm that I want to be in. I'm doing other things with these cups, as you see: putting the two-dimensional symbol of three-dimensionality which you find in the newspaper ad for a cup onto the three-dimensional surface, which is some kind of plastic play anyway. I don't think it's a plastic innovation in the sense of your discussion of Cézanne at all. It really hasn't made that kind of a major step. But I think there have really only been two steps like that in the history of art. One, say, was Massacio and light and shade, and the other was Cézanne and color.

JJ: Yes.

RL: And of course it didn't only happen with those two people but around that time. So I think to expect a major plastic innovation is very nice and I'd love to do it for you sometime. But I don't think that really is part of . . . [Microphone turned off.] I'm sculpting this. It's the idea of doing sculpture of a ceramic in ceramic. So that it's strange because they appear at first to be real cups which in a sense they are, but they were all made by hand and they're not whole, so it's just really sculpture but, you know, different from the cup and saucer.

JOHN COPLANS: Most of the new prints seem to have direct references—at one level or another—to specific aspects of modern art.

ROY LICHTENSTEIN: Yes, the *Cathedrals* are meant to be manufactured Monets and so are the *Haystacks*. The modern prints—I mean the various ones of *Peace Through Chemistry*—are muralesque. They are a little like W.P.A. murals.

JC: They also seem to be very Léger-like.

RL: Yes, and they are a play on Cubist composition. Of course, the imagery has also to do with the '30s. The theme is hackneyed, which is part of the idea.

JC: Why?

RL: I thought something could be made out of these old images. I don't know exactly why they appeal to me. But I like the idea of a senseless Cubism. At first Cubism had significance. It was saying something about vision, about unity, especially the relationship of figure and ground. But following Cubism—particularly in '20s and '30s *art moderne*—the style lost the point of Cubism completely, especially in the decorative arts.

JC: Your sculpture also refers to decorative Cubism of the '30s.

RL: Yes. I think I make images that are purely Cubistic, but the Cubism doesn't really tell you anything.

JC: If you are using such Cubist-derived forms, is it only the image that is Cubist, or the composition as well?

RL: The subject is Cubism and the image therefore becomes Cubism, but this has nothing to do with the formal qualities of composition—its real

relationships. This is a matter of whether the relationships are seen and felt. No compositional devices really hold a work together.

JC: What then makes your '30s images look as if they are made in the '60s? The element of parody? Surely formal properties outside the question of parody link these images to the '60s?

RL: Of course parody and irony are not formal aspects. But these are probably the most obvious link to the '60s; but also the directness and the paint quality.

JC: But what I'm really getting at, I suppose, is what really differentiates one of your sculptures from those of the '30s, apart from the question of idiosyncratic placement of each element.

RL: I don't know, I guess it's hard to say. Maybe it's getting inside what the '30s style is really about that makes the difference. The artists or designers of the '30s didn't have the same remove as I have. I mean, they were more serious about it, and that results in a certain difference. It's not that I am not serious, but if they were serious in one way, I am in another. It's something like my Picasso or Mondrian paintings—mine are not *really* like either of these two artists. I also think there is a great similarity between '30s art and much present-day art. Both are conceptual and both do certain things which are so much alike in style. It's only that today most artists don't employ the more obvious aspects of the '30s look. But the fact that there is a sort of thought-out-beforehand, measurable, geometric, repeated and logical appearance to most current art is very close to the '30s thinking. There certainly are many differences, but it is very close in some ways, so I'm not only playing on the '30s, I'm also playing on present-day geometric art. Current art is frankly decorative, at least a lot of it.

JC: In what sense do you use the word decorative—do you mean it is pleasing, sensuously pleasing?

RL: Yes, it covers big walls with all kinds of glorious colors and shapes. I think it's a question of the level of relatedness and the level of meaning that distinguishes today's work from the '30s and the '30s work I'm working from and, say, the '30s work of Léger.

JC: How do you see your sculpture in the context of this notion? I mean your sculpture isn't in actual fact so much copied as invented.

RL: Even though my work is similar to some '30s sculpture, mine is really more derived from architectural details, for instance, railings; and railings

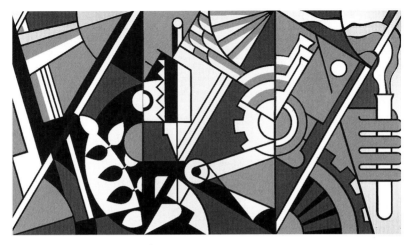

Peace Through Chemistry, 1970. Oil
and Magna on canvas, three panels,
100 × 60 inches each. Fondation
Beyeler, Riehen / Basel, Switzerland.
© Estate of Roy Lichtenstein.

have a certain similarity to a lot of the sculpture being done today. I think the same is true of my paintings. They also refer to architectural detail and decoration, but there wasn't much serious abstract painting that was this stylized. Mine are much more removed, even though I think one *could* have painted like this in the '20s and '30s. I've never seen any painting like the *Peace Through Chemistry* image. There should have been images like this; it's a mixture of a kind of W.P.A. mural painting and Cézanne or Grant Wood, mixed with American Precisionist use of city imagery.

JC: It also has overtones of the '30s poster style.

RL: Right, this is probably a more immediate source and brings in the simplicity of poster reproduction. I've combined a lot of images into what maybe '30s murals looked like. Then, of course, the dots I use make the image ersatz. And I think the dots also may mean data transmission. Previously they meant something more to do with printing, now I think they're decorative and they mean—I don't know if this is a correct rationalization or not—but I think they mean two things: one is simple data information, and the other is a way of making another value out of the same color—fifty percent red or fifty percent blue. Actually, in these prints the dot color had to be changed several times. The red dots are not the same ink color as the flat areas of inked red. In printing commercially, the

purpose of the dots is to get a free pink out of the deal. However, because red dots printed with the same ink as that of the flat areas don't look the same value, the printer changed the dot color to make them optically match the flat areas. Anyway, the dots can have a purely decorative meaning, or they can mean an industrial way of extending the color, or data information, or finally, that the image is a fake. A Mondrian with a set of dots is obviously a fake Mondrian. I think those are the meanings the dots have taken on, but I'm not really sure if I haven't made all this up.

JC: It also seems to me that in your *Cathedrals* and *Haystacks*, unlike the Impressionists who suspended color in a veil of choppy brushstrokes, you do the same with a veil of hard optical dots.

RL: Yes, it's an industrial way of making Impressionism—or something like it—by a machine-like technique. But it probably takes me ten times as long to do one of the *Cathedral* or *Haystack* paintings as it look Monet to do his.

JC: Unlike the painting, in the *Cathedral* prints the image is stabilized. I mean the view of Rouen cathedral is identical in each print.

RL: Yes, I think that changing the color to represent different times of the day is a mass-production way of using the printing process. On the other hand, the paintings in any one set are different from one another, and I'm not too sure why I did them this way, but I planned them as four sets consisting of three paintings in each set, although I may extend one set to five paintings. Each set has different images. I mean, there are no two images or colors the same in any one set. Identical images are dispersed in the various sets, but the colors are different.

JC: Then are you going to insist that the paintings be kept in sets and not be broken up by a purchaser?

RL: Yes.

JC: On the basis that the serial idea is more coherent with three images seen at once?

RL: I think it explains the serial idea much better, and a lot of the time the image of the cathedral is not very apparent. It is more apparent in one of the three than the others, and this gives coherence to the other two. But the other thing is that though Monet painted his *Cathedrals* as a series, which is a very modern idea, the image was painted slightly differently in

Cathedral nos. 1–6, 1969. Two-color
lithograph and silkscreen, 48½ × 32½
inches. Edition of seventy-five. © Estate
of Roy Lichtenstein.

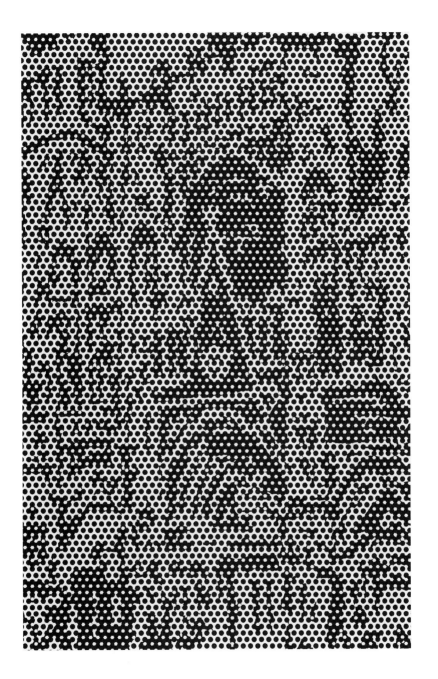

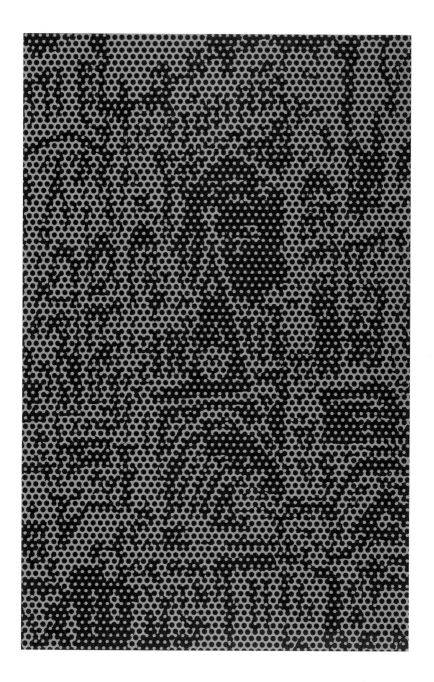

each painting. So, I thought using three slightly different images in three different colors as a play on different times of the day would be more interesting.

JC: Doesn't the very limited palette of colors you use ever bother you?

RL: No, it doesn't. Though once in a while I think, wouldn't it be great to extend my color range—but then it always seems it would be weaker and more artistic. I usually prefer an even more restricted range, and if I can do a thing in two colors, I do. I still use primary colors, but in these prints I try to get as many variations as I can.

JC: However, in the prints your colors are very mixed, very secondary.

RL: Well, they are the same colors and I try and get as wide a range as possible. It's not that I'm trying to get purple by using a mixture of red and blue—that's not what I mean—it's the range of combinations, such as using black and white and a small amount of a primary color in one painting or print, and in another, using a riotous combination of bright colors with graduated dots. I want to be blatant. I don't see that I gain anything by changing red to orange. The color range I use is perfect for the idea, which has always been about vulgarization. I've always used the same colors—red, yellow, blue, black and sometimes green on white—but I think my use of color varies considerably.

JC: In some paintings or prints the image as such doesn't seem to be terribly important to you in comparison to the overall color.

RL: Once I know what it's going to be, it isn't important. I want to give it whatever power I can as an image. I mean, I don't want to lose the quality of the image, but once I've decided on it, I don't allow it to be an issue.

JC: But the *Cathedral* prints are very abstract.

RL: Yes, that's the idea. I follow to a logical conclusion Monet's general idea in a much more mechanical way. Of course, they are different from Monet, but they do deal with the Impressionist cliché of not being able to read the image close up—it becomes clearer as you move away from it.

JC: I understand that for the *Cathedral* paintings you used an assistant quite extensively to cut the stencils.

RL: Yes, and to paint the dots in, too.

JC: But all the tedious work is done by your assistant?

RL: Yes.

JC: As a consequence, your productivity has increased? Or your leisure?

RL: Both.

JC: You mean, without an assistant, you wouldn't have been able to tackle them—they'd have been too boring to do?

RL: I don't think I thought of that. It wasn't too boring for Monet. I like to work. I even like the repetitive jobs—but it would have taken me years, and I would rather carry out my other ideas.

JC: In fact, using assistants gives you more freedom?

RL: I don't like to repeat myself, but if I get the idea of changing black dots on a white ground to white dots on a yellow ground, I tell an assistant to mask out the required areas and make the changes. I can then see what this change looks like and that saves me two days of work. I don't *have* to use an assistant, but it frees my energy for use elsewhere. Moreover, if I had to make the marble, brass, wood and glass sculptures myself, I would have to painstakingly learn all the required techniques and skills. I would turn out only one sculpture at the end of ten years, rather than several diverse sculptures in one year.

JC: But you like to do part of your painting?

RL: Yes, because the sculptures are done through drawing in the same way as the prints or the *Cathedral* paintings. The fact that someone cuts the stencil and paints on the dots exactly the way I would leaves no particular benefit for me to do it. I like to do a certain amount of tedious labor, though. I don't think it would be good to sit at a desk and just be a brain—I'd turn into a marshmallow in no time—so I always give myself some work to do on the paintings.

JC: Do you use masking tape on your paintings?

RL: I don't use tape because it masks out part of the painting. I like to let lines grow larger and smaller and to watch the whole painting while this is going on. I like the freedom of drawing a line in relationship to the whole painting; it's a hangover from my Abstract Expressionist days.

JC: I notice that the prints are much more abstract than the paintings, and instead of using the dots to delineate the cathedral, you use them to disrupt the surface.

RL: Yes, I do it in a couple of ways. In one, all the dots have the same centers, but some are darker than others, so the dots are divided into dark and light shaded areas. In the others, the dots in the darker areas are double shaded.

JC: The latter cluster to form the image?

RL: Yes, and the lighter areas are also dotted. The prints are done over a flat color such as red, yellow or blue, so it's possible to obtain a large range of color combinations, even though I'm only using four colors.

JC: But some of the *Cathedral* prints are monochromatic; for instance, the blue one.

RL: Well, of course I like to represent the complexities of Impressionism in one color. The blue represents the arrival of evening.

JC: The colors are all used logically to denote the time of day, like yellow for noon? What's morning?

RL: I'm not sure—I guess yellow. It's all a pretty abstract idea, but the purplish ones in red and blue are evening, too, of course.

JC: What's the black one?

RL: The black is on a flat blue color; that's midnight, it's almost invisible.

JC: You seem to have trouble indicating daylight.

RL: Well, just a little bit of trouble—red and yellow stands for daylight.

JC: I presume the various modern heads in the prints and the sculptures take off from the many Jawlensky Constructivist heads you once saw in the Pasadena Art Museum's collection?

RL: Yes, somewhat. I mean they get pretty far from Jawlensky, but the idea started with his paintings.

JC: Was it the '30s stylization inherent to these paintings of Jawlensky that interested you?

RL: I guess what interested me was—"what in the world a modern head could be about"—I mean to make a man look like a machine. It's the machine quality of the '20s and '30s that interests me. Picasso and Braque in Analytical and Synthetic Cubism weren't particularly interested in the machine aspect. It got consciously much more that way in Léger's painting

and with the Futurists and Constructivists, the people portrayed becoming dehumanized by being related to machines. This relates strongly to comic book images which are not machine-like but are largely the product of machine thinking. Then the fact that in the comics the rendition of a head, for instance, is so altered by the economics of printing. Dots, black lines, yellow hair, etc., are primarily the product of time-saving economies; thus the forms they take on are the product of the economics of printing. The *art moderne* idea of making a head into something that looks as if it's been made by an engineering draftsman deals with industrialization and manufacture, which is what my painting has dealt with since 1961 or so.

JC: Do you think the '30s style consciously arose out of the idea of combining man and machine?

RL: Yes. I really do. It's a concession to inevitable industrialization—the opposite of pre-Raphaelite thought.

JC: This may be a little offbeat, but has there been anything written on your iconography that really interests you?

RL: Yes. I'm intrigued by unusual insights—things I haven't thought of. I think of them as inventive but not necessarily true. I mean, I'm sure my own insights are just as askew as anyone else's. I have certain feelings which I try to put into words, but I really don't believe in the words. I think one tends to think up things that sound logical or insightful about one's work anyway.

JC: What do you think is the essential difference between your prints and paintings, apart from the obvious things such as medium, scale, etc.? Your *Haystack* paintings and prints are about the same size, I think?

RL: The prints are a little smaller, but that's not significant. The paintings are all different images. In terms of exactness in placement and register, the prints are better, because they can be better controlled in this medium. Working on canvas isn't controllable in the same way. The paintings bear the tracks of corrections of various things. The prints are all worked out beforehand and appear purer. Your question was, is there any basic difference—I really don't think there is. They're all done methodically, step by step. If a print doesn't work, I throw it away. In the case of the paintings, I can erase and change parts until I am satisfied—I can add things that weren't in the original stencils. With the prints, everything is done before the final printing, but the process is very much the same. I do

the dots first, then the colors and finally the black lines. That's not true of the *Cathedrals*, of course, which have no black lines. It's all only methodical up to a point and gets changed around whenever it is unsatisfactory. In fact, it's very hard to say.

JC: Well, it is always taken for granted that it's possible to work at a greater scale in paintings, and that there is more freedom to be impulsive, whereas printmaking is more systematic and has fewer possibilities for being impulsive. In retrospect, and from your own position and work, how do you now view the Pop style?

RL: That's really a tough question because there are lots of ways to get at this. I don't know if my current work is more or less Pop than before. The subject of my recent paintings and prints is still a vulgarization of Monet's *Cathedrals*. I mean, they're a vulgarization in the regular sense of the word in that I'm industrializing his images. Also, I think my imagery is taking on more subtle aspects than before, but I don't really think of my earlier work as lacking in subtlety. It may be that my early work is less "Pop" than people think, and that my recent work, though more subtle in appearance, is more "Pop." However, I have a feeling one shouldn't probe too closely into this thought.

JC: But your current work is very remote from your earlier images. I mean, previously you selected images that were about a decade old. Now you range back almost a hundred years. Of course, your early Cézanne paintings went back to the same time, but you seem to be focusing on a period about forty years or more in the past. Have you any idea why?

RL: The comics, and paintings of Picasso, Mondrian, Monet and W.P.A. murals, as well as the modern heads and designed objects, are all available to me as reproductions. The fact that the comic-book and advertising art was done more recently doesn't make it any more available to me than any other source of my images. I mean, it's still other people's graphic or three-dimensional works that I use, and that's what I was using in the early '60s. The fact that some of the images happened to be advertising art is almost incidental.

JC: You still deny there is any social comment in your work?

RL: I don't think I deliberately *put* it in, let's put it that way, but it's pretty hard not to read social comment in it. That is, I'm commenting on something, certainly. I don't think it's direct, and I don't think I'm saying that

society is bad. That's not the meaning of the *Cathedrals* or *Modern Heads* or *Peace Through Chemistry*. But obviously they comment on some aspects of our society. They observe society and come out of our society.

JC: But this is nothing to do with traditional Realism.

RL: Well, Realism has usually meant vulgarization. I think the idea of discussing ideas about art apart from the specific artists is silly. Maybe that's a fault of a certain type of abstract criticism which really deals in the philosophy of an idea, and it doesn't seem to matter so much which artists are discussed. It's a question of the strength of an artist as against the strength of an idea.

JC: Or style?

RL: Yes, because a style or a critical idea considered independently from the particular artist can be fairly meaningless.

JC: But you really don't see yourself as someone separate from the abstract artists in formal qualities, do you?

RL: No, not fundamentally. But my work isn't *about* form. It's about see-ing. I'm excited about seeing things, and I'm interested in the way I think other people saw things. I suppose seeing at its most profound level may be synonymous with form, or rather form is the result of unified seeing.

Roy Lichtenstein in Conversation on Matisse

Jean-Claude Lebensztejn

JEAN-CLAUDE LEBENSZTEJN: So, do you want to start?

ROY LICHTENSTEIN: No, I'll let you ask me something.

JCL: Why did you use Matisse's *Dance* in one of your *Studios*?

RL: When I started to do still lifes, I looked at other artists' still lifes and I thought of Matisse. Then I started to do still lifes that were much more directly based on Matisse. But I think maybe the contradiction in style is one of the things I'm interested in. Matisse was so interested in a certain kind of flavor that's almost completely antithetical to my own—his interest in the color quality. I don't really feel it's different basically, but I feel that in style—his sense of touch and materials, his sense of line—he's almost completely opposite.

JCL: Would you call your painting a derision of Matisse?

RL: No, no. Not at all. I think if anything I might have been dealing with the popular image of Matisse in the way I did with the popularized version of Picasso. I don't think I'm really dealing with a Matisse painting or with a Picasso painting when I use them. I realize there is a similarity, and people will recognize it's a Matisse. But I don't think that I was parodying a real Matisse.

JCL: You were more parodying a cheap reproduction of a Matisse?

RL: Yes, that would be more like it. I'm making a painting of my particular image of Matisse.

JCL: But in your previous works based on other painters, there were the Benday dots which allude to the dots of a printed photograph.

Artist's Studio: "The Dance," 1974. Oil
and Magna on canvas, 96⅛ × 128⅛
inches. The Museum of Modern
Art, New York, Gift of Mr. and Mrs.
S. I. Newhouse, Jr. © Estate of Roy
Lichtenstein.

RL: Yes. And the hash marks, the parallel lines and things that are in my
new paintings are supposed to do the same thing. It's supposed to look like
a fake, and it achieves that, I think.

[. . .]

JCL: Why were you interested in the commercial view on art?

RL: Well, I think that was a way of casting the work, in the same way
Matisse was able to put his work into the style, say, of Delacroix or the
Moroccan sense or whatever it was, which was a sort of fantasy. Commercial
art had all of the aspects that were needed to get across a new form of
painting which just seemed to be interesting. It had the direct printing
thing, it had the mass production, it wasn't Cubistic, it had color within
lines so that the print wouldn't bleed out the sides. It had created images
because of the convenience of the printing press—cartoons and things

printed on the side of cardboard boxes, things that would be roughly, crudely printed. It just presented everything I needed. [...]

A couple of years ago I started some paintings that had my own paintings in them, and which were similar to the Matisse studios. There was one difference that I think shows up mostly in the *Look Mickey*: When I reproduce one of my own paintings in my painting, it's different from Matisse reproducing one of his paintings in his painting, because even though in both paintings the depicted painting is submerged for the good of the whole work, it's much more so in Matisse. I wanted my paintings to read as individual paintings within the work, so that there would be some confusion. There's no remove in my work, no modulation or subtlety of line, so the painting-of-a-painting looks exactly like the painting it's of. This is not true, of course, of many early—including Renaissance—depictions of paintings on walls, where there's always a remove indicated through modulation, or some other way of showing that the depicted painting is not pasted on the picture or something like that.

I like the combination of a very separate quality that each of my paintings has within the painting, and the fact that everything works as one painting too. That's a big difference, I think, although Matisse might have been somewhat interested in the same thing because his were relatively blatant for his time. It's just that looking at his now, they seem very bold and energetic and bright, but they don't seem quite as—they don't seem crass, which they probably seemed at the time they were done. Some have obviously taken on a very museum quality, but others still haven't.

Even though we tend to think of Matisse as having every kind of painterly and European quality, he probably was trying to make as succinct and brash and forthright and direct a statement as he could make. In his own time, he must have been seen as a colorist. In a sense that meant eliminating light and shade, and related modulation. And the directness, which everybody looked at and saw in it, must have been just as shocking as our things when we think we're being direct.

[...]

JCL: In the painting by Matisse on which your *Artist's Studio, "The Dance"* seems to be based, Matisse used his first version of *The Dance*, the one that's in New York; you picked up the second version, the one in Leningrad.

RL: I did? Okay. I did it from a book, though.

JCL: But you combined then the actual *Dance* from a book, with Matisse's composition that includes *The Dance*. You didn't think of that?

RL: I saw it and knew that he did it, but I didn't refer to that picture. I think there are a number of Matisse paintings that have *The Dance* in the background.

JCL: But one of his is very close in composition to yours.

RL: Oh, really? I didn't really look at those paintings. Well, it may have come from seeing a lot of Matisse's paintings. Everyone is influenced by him to a certain extent. It's an influence that everybody also tries to get rid of. I think the same is true of Picasso, it's so pervasive it was necessary in the early 1960s to just rebel against that kind of painting. It goes without saying that Picasso and Matisse are different from one another in certain ways, but in a lot of ways they still represent European painting, a particular kind of touch or something that's very much like *painting*. They define painting in a certain way. And because of that I think that a great effort is made to get away from them. The Abstract Expressionists were trying to get away from them. Actually, I think maybe they got closer, which we all seem to do in trying to get away. Whereas Mondrian went to the more abstract Cubist elements partly to get away from a sense of touch. But Mondrian and Malevich and various people were also connecting with technology and modern thinking in their minds.

Anyhow, I like to parody the idea of getting away from painting. I see the sort of silly thinking involved in being modern, or the benefits of technology, because all of it's become a shambles by now. I still believe in technology in a kind of reactionary way, in that I think it will eventually solve the problems if it doesn't kill us, but I'm not serious about the relationship between painting and many of these ideas, which are banal by now anyway. There are problems either way: there are petit-bourgeois aspects of Matisse's painting which are a little annoying, but there are also the heavy-handed, almost Fascist aspects of abstract painting which might be read into it. So although I'm more sympathetic with painting as such than with strict abstract art, particularly when it's connected with an ideology of some kind, of some political kind, that may be why I end up parodying— although I'm not sure that's the right word—both of them somewhat. But I don't think that nihilism is the solution to anything, either.

JCL: The way that you seem to use Matisse and empty his work of its qualities seems somewhat nihilistic.

RL: Yes, I want it to have its own qualities but I don't want them to seem like qualities to anyone. I want it to seem as though I had divested it of quality. That's true, I think, of all the painting I've done—I've tried to take away anything that was beguiling.

I'd rather use the term "dealing with" than "parody." I'm sure there are certain aspects of irony, but I get really involved in making the paintings when I'm working on them, and I think just to make parodies or to be ironic about something in the past is much too much of a joke for that to carry your work as a work of art. I'm interested in all of the things you say—the divesting of the thing of qualities—but I'm still trying to maintain a set of other qualities which I'm giving it, but which I hope are not apparent. It's a case of building something that looks completely without thought, or senseless, and then of course trying to make it work. I mean, that's the hope . . .

[. . .]

JCL: Do you think the fact that Matisse was so interested in painting in his studio, which he did a lot of times, has a kind of connection with your series of studio paintings?

RL: No, because I think Matisse loved to look at things and paint them—flowers, girls, or whatever. The model being over there, him over here, the work over here, and it would be just a wonderful day for him to sit there, and he reveled in the beauty of the things that he saw. And he also reveled in doing his own work and he loved the model. He was a sensuous person. I like the way nature looks, but to me the idea of drawing nature just has nothing to do with art. It doesn't mean anything. I sometimes do it, but when I do I revert to a kind of Expressionist drawing that I learned to do in art school. I've never done a portrait of Dorothy [Lichtenstein's wife], I've never done a self-portrait. Almost always I draw something either that I think of or that I see in somebody else's work.

And the studio paintings that I do, while having absolutely nothing to do with my real studio—which, as you can see, has nothing in it but white walls—is a way of making collage out of some works that I've done and some Matisse works, with a kind of feeling about Matisse that I'm trying to develop—not *his* feeling, but my feeling about his work. It just doesn't have to do with his love of things. [. . .]

I'm very interested in color and involved in it, which no one thinks I am. I don't think I'm as removed from earlier artists as some people

think. I don't think that what I do is that much different. I realize there's a difference in style and so forth, but first of all, I think there isn't that big a difference between Romantic and Classical artists. There is obviously a dif ference in emphasis, and I would be more of a Classical artist than a Romantic, I suppose, but then the kind of unity that holds a painting together is really the same whether it's done by Rembrandt or David or Picasso or Oldenburg. There's really not that much difference, there never was. But new things always seem much more startling than they seem twenty years later or when they have sunk into the history of art. It takes art historians to realize that there are thousands of differences between every generation of artists. To the layman everything in the past looks like an old master. There's only one category, old master.

I can see the differences, but I also see great similarities. Because I think that there's something more basic.

JCL: Which is an idea of "art"?

RL: Yes. The way man would naturally perform in order to do art. I think there's obviously a tremendous cultural impingement upon our actions which makes each generation look a lot different. But we have a certain understanding of African art or Oriental art now, or other things that used to be "difficult." They communicate to us now, despite the fact that we're not familiar with their cultures.

JCL: Perhaps because of modern art?

RL: That introduced it; but modern art is even more foreign to us. I think people think of a Kandinsky, say, as being much more mysterious than a Hokusai or a Benin bronze.

There are certain basic things—sense of position, sense of contrast, the right amount of color—a certain basic physiological, psychological thing there. I don't know what it is, but I think that you know when you're right, or you think you do. And that's really more fundamental than what the art is about in one particular moment. While that is inter-esting and relevant, too, the more fundamental thing is the sense—it's just like a sense of time and rhythm in music. I mean one culture's art can seem to be vastly different from another culture's, but then you catch on rather quickly, and there is still a sense of rightness about it. [. . .]

I've always been interested in Matisse but maybe a little more inter-ested in Picasso. But they are both overwhelming influences on everyone, really. Whether one tries to be like them or tries not to be like them,

they're always there as presences that have to be dealt with. They're just too formidable to have no interest. I think that somebody who pretends he's not interested is not interested in art.

JCL: What about your relationship to Matisse in the early 1960s?

RL: I never thought of being related to Matisse and never thought that what I did had any relationship to him.

JCL: Why do you think you are using him now? For a particular reason?

RL: No, no particular reason. I just got into it through the still lifes. I think also he was doing what would be a modern form of still life in that his would look—when they were first done—very unconventional or like a new approach to still life. Even funny, not that he meant them to be funny but that they would be peculiar to the observer who would be used to nineteenth-century still lifes. It should be just as peculiar as my treatment of still lifes. I don't know, maybe not. It's very hard to judge how people see work.

A Review of My Work Since 1961—A Slide Presentation

Roy Lichtenstein

This lecture, delivered by Lichtenstein on November 11, 1995, to members of the Inamori Foundation on the occasion of being awarded the Kyoto Prize that year, provides a general overview of the artist's thinking on his post-1961 oeuvre. Edited slightly for inclusion here, it is reprinted in the hope that readers can imagine themselves in Lichtenstein's lecture-hall audience, listening as he moves step by step through three decades of practice.

In this slide presentation I hope to point out some of the progression of ideas in my work and show how one thing led to another, if one thing did, indeed, lead to another. Also I'd like to tell you of some of the meanings I intend to convey. [. . .]

By 1960 and 1961 I was working on Abstract Expressionist paintings using Mickey Mouse and Donald Duck and other cartoon figures as subjects. This drawing [*Donald Duck*, 1958], which was done earlier than my 1960 and 1961 paintings, is similar to these. It is a rendition of Donald Duck and it shows the degree of abstraction I was working in. The reason I'm showing drawings rather than a painting is because the paintings I did in this style no longer exist. In order to make the Donald Duck and Mickey Mouse paintings, I referred to cartoons, little comic images, so I would have some idea of how Donald Duck and Mickey Mouse might look. It occurred to me one day to do something that would appear to be just the same as a comic book illustration without employing the then current symbols of art: the thick and thin paint, the calligraphic line and all that had become the hallmark of painting in the 1940s and '50s. I would make marks that would remind one of a real comic strip.

The first Pop painting I did in 1961 is called *Look Mickey* [see page 166], and of course I realized that this was a marked change from prevailing

Donald Duck, 1958. India ink on
paper, 20¹⁄₁₆ × 26¹⁄₁₆ inches. Private
collection. © Estate of Roy Lichtenstein.

taste, because, although almost anything seemed to be fair subject matter
for art (there was a feeling that art could be made from almost any idea),
commercial art and particularly cartooning were not considered to be
among those possibilities. I adopted the idea of simulated cartoon print-
ing just to try out the idea. I hung this work up in my studio to think
about it, but I was unable to go back to abstraction, which had been my
intention, because this cartoon painting just seemed too demanding. I
understood some of the ramifications of these new cartoon paintings. I
realized afterward there were many influences on these paintings. The
work of Happenings people like Claes Oldenburg, Jim Dine, and Allan
Kaprow, for instance. In these artists' work there were American advertis-
ing and commercial objects and they were trying to escape the influence
of Cubism. There were still the remnants of Expressionism in their work
but there was a tendency toward American or vernacular commercial
representations of objects.

There are many other influences in my work, including Stuart Davis,
whose images incorporated gas station signs and other non-Parisian and

definitely American subjects. There were many examples of artists working with vernacular iconography. There was also the use of common objects in Cubism, like theater tickets, wallpaper and newspapers, real or simulated. There was the use of cut-out lips from a magazine in a de Kooning *Woman* painting. There were the famous Jasper Johns *Flag* paintings, and Robert Rauschenberg's use of Coke bottles. Then I understood that I was creating a style that mimicked a particular kind of commercial art, particularly that used in cartoons. Much of the way a cartoon is drawn had to do with the mechanics of reproductions. The black lines hid the difficulty printers had in registering different colors, which were printed one after the other. The use of dots to produce half-tones or 50 percent red or 50 percent blue, changed what is in art an aesthetic problem into a seemingly insensitive mathematical problem. So if somehow I could produce a work that had a unity of both drawing and tonality, but was done in a style which signaled the exact opposite of that, it would be just what I was looking for.

This painting of Popeye hitting Bluto [*Popeye*, 1961] used, besides the obvious cartoon elements, certain symbols for being hit, or seeing stars, or the movement of the arm. These signs for movement, which do not exist in nature, were of great interest to me. This related to the way the Futurists would have portrayed motion. There are certain marks, like these, that I am fond of using because they have no basis in reality, only in ideas.

I tried to cover as many subjects as I could, so I did war comics and love comics and single objects. There were many reasons for covering all this territory, but I was interested in using highly charged material, like *Men at War* and *love* comics (highly emotional subjects) in a very removed, technical, almost engineering drawing style. Comic books, themselves, are done this way. I also made several diptychs. It is a form reminiscent of religious painting and of course these paintings are anything but religious. [. . .]

What I was painting wasn't only from comic books, but was taken from any simply drawn commercial advertising, where the means of reproduction were highly limited. I was attracted to things printed on cardboard boxes or other material difficult to print on. It interested me if the original was done very small, so that when it was enlarged, it was crude. I wanted it to look not very skillful, and to have the colors be as simple as possible. At this time I think I was only using black and white, and yellow, red, blue, and sometimes green. The dots became more and

Popeye, 1961. Oil on canvas.
42¼ × 56 inches. Private collection.
© Estate of Roy Lichtenstein.

more perfected. You will see them become larger as things go on and I develop different means of painting the dots.

Golf Ball (1962), a painting of a single object, is intended to remind one of a Mondrian *Plus and Minus* painting. A single object unrelated to any ground was probably the antithesis of what was thought of as having "art meaning." If you think of these marks as a *golf ball*, you have formed this object in your mind. My emphasis was in forming the relationship of mark-to-mark.

Then I was interested in doing works where the painting itself can be thought of as an object, where the size and shape of the subject and the size and shape of the painting are the same. This phenomenon happens in various stages of my work where the subject of the painting is rectangular and occupies the entire canvas, so you can consider the painting to be an object. This was being done in the abstract painting of other artists as well, and in *shaped canvas* paintings, where the shape was not rectangular, like certain Frank Stella paintings of the period, where the canvases were filled with concentric bands of color.

I also started to use the work of modern masters as subject matter. This is Picasso's *Woman with Flowered Hat*, 1963 [see p. 23]. Instead of using subject matter that was considered vernacular, or everyday, I used subject matter that was celebrated as art. What I wanted to express wasn't that Picasso was known and therefore commonplace. Nobody thought of Picasso as common. What I am painting is a kind of Picasso done the way a cartoonist might do it, or the way it might be described to you, so it loses the subtleties of the Picasso, but it takes on other characteristics: the Picasso is converted to my pseudo-cartoon style and takes on a character of its own. Artists have often converted the work of other artists to their own style.

I started my *Landscapes* somewhat after the cartoons in 1964, overlapping in time with the last figurative cartoons I did. The landscapes I started doing were taken from the backgrounds of cartoons. Peripheral cartoon imagery also produced still lifes, cityscapes, and interiors. I also used a material called Rowlux, which is a trade name for lenticular plastic that has the characteristic that as you move it seems to move; and these pieces of plastic seemed perfect for sky and water, which seem to move or change their appearance constantly as you look at them. It seemed to be the perfect quotidian way of producing the appearance of a landscape that seemed, on one hand, to be more real because it moved, but obviously less real because you knew it was made of a material that produced this particular trick.

In 1965 I started to do *Brushstroke* paintings. The first *Brushstroke* painting [see p. 90] came from a cartoon of a man painting a fence. The cartoon in the comic book depicted a hand, a paintbrush, and paint stroked on a fence.[1] I did a painting from that and then decided to leave the hand and brush out of subsequent paintings and to focus on the brushstroke, because brushstrokes have such an important history in art. Brushstrokes are almost a symbol of art. The *Brushstroke* paintings also resembled Abstract Expressionism. Of course visible brushstrokes in a painting convey a sense of grand gesture; but in my hands, the brushstroke becomes a *depiction* of a grand gesture. So the contradiction between what I'm portraying and how I am portraying it is in sharp contrast. The brushstroke became very important for my work. I later did still lifes, portraits, and landscapes using cartoon brushstrokes, sometimes using a combination of cartoon and real brushstrokes. The brushstroke is also a favorite theme of my sculptures.

In 1967 I did a group of work based on Art Deco. I did sculptures of this theme at the same time. Art Deco was somewhat prevalent in

architecture and home decoration during my childhood in the 1920s and
'30s. But I think people were more familiar with it through elegant apart-
ments portrayed in Hollywood movies than they were in their own sur-
roundings. There were some Art Deco buildings in New York City. It
might be known to people more through magazine reproduction. Very
few people except for very stylish and rich people lived in Art Deco envi-
ronments, so I don't think it had an enormous influence. It looked a little
like *Cubism for the Home* to me. I saw in it a too-rational quality that had
an absurd twist. In my mind, the point of Cubism and even art seem to be
somewhat at odds with the kind of geometric logic of Art Deco, which
seemed too easily to fit the instruments, the T-squares and compasses, of
the designers and architects, and seemed to belie what Cubism was really
about.

In *Modular Painting with Four Panels no. 3* (1969), there are four sepa-
rate canvases that fit together. Each of the four is pretty much the same;
but I loved the problem of trying to make four almost identical paintings
into one painting. I remember that *repeated design* was a school art project
I had in the third or fourth grade, which related well to the Art Deco–like
work I was doing in 1970. I did a number of these paintings. The prob-
lem of whether these works represent one painting or four paintings is
largely a semantic problem. This situation is pretty much the same in the
subsequent *Paintings* series.

Stretcher Frame (1968) is another example of a painting that becomes
an object. This is a portrayal of the back of a canvas showing the stretcher
frame and the canvas from the back. Of course this would have to come
out to be the size and shape of a painting. It's a humorous answer to the
shaped canvas paintings of abstract artists of the 1960s. I did a number
of canvas backs in various sizes. The canvas-back series is related to my
trompe l'oeil works. Because of their cartoon style they don't fool anyone
into thinking they are real. I go on with that trompe l'oeil idea later. They
are meant to be a cartoon of a familiar genre that is supposed to fool the
eye into thinking the painting's subject matter is real.

Mirror no. 2 (1971) is another example of the painting becoming a
thing. This painting depicts a mirror. I got the idea for the *Mirror* paint-
ings from mirror sales catalogues, where most of the work was done in
air-brush. There is really no convincing way to portray a mirror, because a
mirror simply reflects what is in front of it. Cartoonists have used diagonal
lines and slash marks to tell us they are rendering a mirror and we have
come to accept these symbols. Making a painting that is also an object

*Modular Painting with Four Panels,
no. 3,* 1969. Oil and Magna on canvas,
four panels, 54 × 54 inches each.
Private collection. © Estate of Roy
Lichtenstein.

bridges, somewhat, the gap between painting and sculpture. I did a series
of mirrors around 1970. Many times I photographed a magnifying mir-
ror because a magnifying mirror, when it's out of focus, produces abstract
shadows and shapes which gave me ideas for the mirror paintings. I am
using graduated dots, maybe for the first time, in these works. In my mul-
tipanel mirrors I tried to vary the panels to represent reflections of various
things and to make a kind of geometric painting, one that could possibly
be thought of as a mirror, and to continue the idea of the painting as an
object. These paintings, in my mind, relate to Minimal art and might
remind one of an Ellsworth Kelly painting.

Mirror no. 2 (oval 6′ × 3′), 1971. Oil
and Magna on canvas, 72 × 36 inches.
Private collection. © Estate of Roy
Lichtenstein.

I also did a group of *Still Lifes* in the early '70s. *Still Life with Goldfish* (1972) has a Matisse fishbowl and it has my *Golf Ball* painting which I did in 1962. There are some Matisse leaves and lemons and grapefruit. *Cape Cod Still Life* (1973) is painted after a certain genre that Americans paint in Maine, Vermont, and out on Cape Cod, where the still lifes contain local boating and fishing materials like fish net, rope, lobsters, starfish, and seagulls. There are most likely thousands of these paintings being done in a somewhat expressionist or abstract style. It is almost a school of its own. They are often influenced by Picasso and Cubism. I'm interested in commenting on this school of painting which is so well intentioned and endearing but obvious and highly influenced. [. . .]

In 1974 I did a series of four large, about 8′ × 10′, paintings of interiors of artists' studios. They were inspired by Matisse's paintings of his studio, and this one [*Artist's Studio with Model*, 1974] features the Matisse philodendron, the Moroccan pitcher, and various other Matissian objects. But some objects are from my earlier work. There is a Europeanized Moroccan dancer that is part Matisse and part cartoon. There is also one of my *Entablature* paintings and an explosion, which I had done both as a painting and as a wall relief in porcelain enamel on steel. A kind of Matisse idea of the artist's hand drawing on the picture is at the lower right. And some other works of mine are on the right side above the hand. The Moroccan dancer is the nearest thing I had come to painting a nude or even a full figure until recently.

This painting [*Artist's Studio: "Look Mickey,"* 1973; see p. 179] is another example of the artist's studio series; this one includes *Look Mickey*, my first Pop painting. There is a mirror painting on the left and a Matisse sculpture-stand with a telephone. The telephone refers to one of my earlier paintings. Also included is a back-of-the-canvas painting of mine, a couch which I did as a drawing in 1961, a painting that only contains a balloon and words, and a still life. I like the idea of including in my paintings renditions of earlier paintings of mine because they are really identical or could be identical with the original paintings. In other words this *Look Mickey* is no different from my original *Look Mickey*. Most painters, when they depict their own earlier works in their new paintings, as Matisse did, minimize the clarity of these depicted works through modulation (which is read as atmosphere) and simplification to give you a sense that you are at a distance from the work. By painting these paintings within paintings just the way they were painted originally, there's no apparent difference

between the painting in the room and the painting itself, and that is something that interests me. These *Artist's Studio* paintings have, as you shall see, an influence on my later *Interior* paintings.

Another offshoot of Cubism was Futurism, and I did work of Futurist artists such as Carlo Carrà, Gino Severini, and Giacomo Balla. [...] This painting [*The Red Horseman*, 1974] was done from the *Red Horseman* by Carrà, done in 1913, which was a little gauche. Mine is a fairly large painting, it symbolizes the sense of motion Futurism develops from Cubism. But I think of Futurism as using Cubism for other purposes. I feel the same way about Art Deco or Purism or Vorticism. They all seem to be using a very important idea (an important perceptual change) for something a bit more trivial, only because the possibility was there to use it that way. Futurism does show motion, but it does not show motion very well; painting is not a *time* art. But I am interested in the quirky results of those derivatives of Cubism and like to push this quirkiness further toward the absurd. I am also interested in the relationship between depictions of movement in Futurism and in comic strips.

The *Entablature* series was done from 1971 to 1976. I started with black and white, very long entablatures, and progressed into these that have some color and metallic and textural fields in them. Once again these paintings can be seen as objects (rather than as pictures with objects in them), in that the entablature itself constitutes the whole painting. This series can also be seen to represent, in a humorous way, the *establishment*. By establishment I mean that the reference in these *Entablature* paintings was to the Greco-Roman tradition, which permeates our art and culture. The *Entablatures* represent my response to Minimalism and the art of Donald Judd and Kenneth Noland. It's my way of saying that the Greeks did repeated motifs very early on, and I am showing, in a humorous way, that Minimalism has a long history. In almost all these works there is a light source coming from the upper right and causing shadows on the lower left of everything; it is just a convention that I put into each painting for no particular reason, except that this uniformity would seem uncreative. My sources were photographs I took of neo-Classical buildings on Wall Street, and my use of repeated themes is capricious and has little to do with real entablatures. It was essentially a way of making a Minimalist painting that has a Classical reference.

Along with other still lifes, I did a series of paintings that I call *Office Furniture Still Lifes*, derived from ads for office equipment. File folders, metal chairs, mechanical lamps, and all kinds of uninteresting objects

Entablature, 1974. Oil, Magna, and
metallic paint with sand on canvas,
60 × 100 inches. Private collection.
© Estate of Roy Lichtenstein.

rendered in a mechanical, uninteresting way were the subjects of these still lifes. I used a slightly different color palette. I used grays and a different blue than my usual ultramarine. I tried to make the colors as uninteresting as the objects. Of course, I wanted the painting to be interesting in its uninterestingness.

In stark contrast to the *Office Still Lifes* were the *Surrealist* paintings, which were done in late 1976 to 1979. They were of no particular Surrealist artist, just Surrealism in general. I took certain elements from paintings I had done in the past: a man's suit, a shirt and tie from a dry-cleaning ad, the brushstroke—here [in *Reclining Nude*, 1977] being used as a cloud in the sky. I used parts of the cartoon heads and hair, a little part of an Alexander Calder scribble, which are those oval marks in the left. The beach ball is from Picasso's Surrealist period mixed with my *Girl with Ball*, and the mirror head on the man in the upper right is like a self-portrait I did in 1978. I used a flowing line to make a torso with holes through it like a slice through a Henry Moore sculpture. I used a mixture of improbable elements (there is even an early *Imperfect* painting and a Greek column) to give the feeling of a Surrealist painting.

This [*Razzmatazz*, 1978] is another example of my Surrealist work. It is in much the same spirit as *Reclining Nude*. The suit jacket at the left

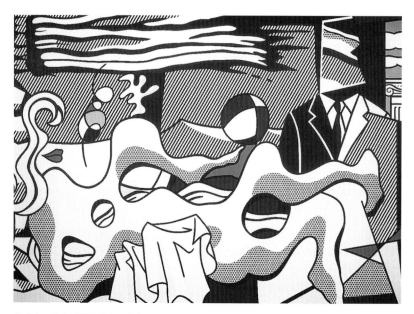

Reclining Nude, 1977. Oil and Magna
on canvas, 84 × 120 inches. Frederick
R. Weisman Art Foundation Collection.
© Estate of Roy Lichtenstein.

seems to have nothing in it, but then it has a wooden head coming out it. There appears to be a picture of Swiss cheese to the left of the wooden head. I did my first depiction of Swiss cheese in 1961; the way I draw it, it always reminds me of Jean Arp paintings or wall reliefs. A very stylized cartoon head occupies the upper center, and there is a dark figure in the middle of the right-hand side of the picture, which is somewhat like the *Reclining Nude*. The zig-zag triangles in the middle-bottom of the painting later become *Imperfect* paintings, a series that I will show you soon. There is a metal folding chair from the *Office Furniture Still Lifes* series. These works are something like the *Artist's Studio* paintings in that they are large compositions that include various images from various periods. [. . .]

Then I turned to *Indian Surrealism*, probably under the influence of Max Ernst, who did some Surrealist work that was related to the American West and featured certain Native American themes. I did a series in the 1950s that used Native American designs to make figures. These early paintings were more Expressionist in character. In the later paintings [such as *Indian Composition*, 1979] I used the patterns from Indian blankets or

pottery to represent figures of some kind. [. . .] Of course, there were many tribes and many different kinds of designs of Native Americans who had little contact with one another. These designs and motifs are all piled into one painting because they remind me of the *concept* of Native American work. [. . .]

We had hints before of what now became the *Imperfect Paintings*. I did both *Perfect Paintings* and *Imperfect Paintings*. In the *Imperfect Paintings* the line goes out beyond the rectangle of the painting, as though I missed the edges somehow. In the *Perfect Paintings* the line stops at the edge. The idea is that you can start with the line anywhere, and follow the line along, and draw all the shapes in the painting and return to the beginning. I was interested in this idea because it seemed to be the most meaningless way to make an abstraction. It is another way to make a painting that is a *thing*, and also a play on *shaped canvases*, a familiar genre of the 1960s. [. . .]

After this I did a series of paintings called *Reflections*. It started when I tried to photograph a print by Robert Rauschenberg that was under glass. But the light from a window reflected on the surface of the glass and prevented me from taking a good picture. But it gave me the idea of photographing fairly well-known works under glass, where the reflections would hide most of the work, but you could still make out what the subject was. Well, I tried to do a few photographs in this manner; but I am not much of a photographer. Later the idea occurred to me to do the same idea in painting; and I started this series of *Reflections* on various early works of mine. This [*Reflections: Wonder Woman*, 1989] is one of Wonder Woman, a work that I wished I had done earlier. It portrays a painting under glass. It is framed and the glass is preventing you from seeing the painting. Of course the reflections are just an excuse to make an abstract work, with the cartoon image being supposedly partly hidden by the reflections. [. . .]

After the *Reflections*, I did a series of *Interiors*, which were large paintings, 10 × 15 feet more or less. These come partly from my earlier series of *Artist's Studio* paintings from 1973. Many of the layouts for the *Interiors* come from advertisements in the yellow pages of the telephone book and similar sources. This painting [*Interior with Yves Klein Sculpture*, 1991] features a Hans Holbein portrait of Henry VIII. The idea really came from Jasper Johns who did his own version of the Holbein. There's an Yves Klein sponge sculpture which was done by impressing a sponge dipped in paint on the painting. There is the Discobolos, the disc thrower, leaving the painting on the upper right. It is a very unlikely group of things for the

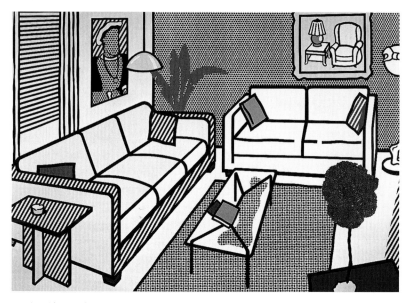

Interior with Yves Klein Sculpture,
1991. Oil and Magna on canvas,
120 × 170¼ inches. Private collection.
© Estate of Roy Lichtenstein.

same collector to collect, particularly with the painting of the armchair, lamp, and table. These *Interior* paintings, because of their size, give you the feeling that you might be able to walk into them. On the other hand, the painting is so artificial in style that you know it's impossible. I think this is the reason one feels strange standing in front of the actual work.

This painting [*Bedroom at Arles*, 1992] was done after a postcard of the famous Van Gogh, *The Artist's Room at Arles*, 1888–89. I've cleaned his room up a little bit for him; and he'll be very happy when he gets home from the hospital to see that I've straightened his shirts and bought some new furniture. Mine is a rather large painting and his is rather small (29″ × 36″). His is much better, but mine is much bigger. Of course my work is an entirely different endeavor. This is the only interior I have done from another painting. I think the contrast between my intention and Van Gogh's is so enormous that there is humor in that difference. My principal interest is the extreme difference in style. Where the Van Gogh is so emotional, and feverish, and spontaneous, my work is planned and premeditated, and painfully worked out. To translate an artist's work into a cartoon style says something. It seems to degrade the work by associating

it with cheap reproduction. But from my point of view I am translating the Van Gogh into *my* style, which imitates cheap reproduction. I think the process is not so far from Picasso's translations of Velásquez, which at the time they were done must have been seen as debasing the master.

Note

1. Lichtenstein here remembers incorrectly: the comic-book source of his first *Brushstroke* painting—a panel from *Strange Suspense Stories* no. 72—depicts an artist in his studio crossing out a completed figure painting on his easel. For details and a discussion, see Michael Lobel, *Image Duplicator: Roy Lichtenstein and the Emergence of Pop Art* (New Haven: Yale University Press, 2002), pp. 159ff.

Unsentimental Education: The Professionalization of the American Artist

David Deitcher

As art critic for *The Nation* at the end of World War II, Clement Greenberg surveyed American art and found it promising but imperiled. At the dawn of the cold war, he saw "serious" art jeopardized much as he had at the outbreak of the war in Europe. In 1939, in his essay "Avant-Garde and Kitsch," Greenberg had indicated the threat to art posed by the ersatz seductions and gross simplifications of mass culture by summoning the twin specters of Fascist art and Soviet Socialist Realism. In 1946, the dangers centered on the seemingly more benign contents of the *New Yorker* and *Harper's Bazaar*, as well as the safe modern art "derived from impressionism and its immediate aftermath" promoted by arbiters of American cultural propriety such as Henry Luce and his magazine *Life*. Greenberg pinpointed the object of his postwar misgivings in a review of the Whitney Annual:

> The middle class ... is now surging toward culture under the pressure of anxiety, high taxes, and a shrinking industrial frontier. All this expresses itself in a market demand for cultural goods that are up to date and yet not too hard to consume ... and compels the serious and ambitious artist ... to meet this demand by softening, sweetening, and simplifying his product.... This state of affairs constitutes a much greater threat to high art than Kitsch itself.[1]

High culture in the postwar United States was threatened, then, by a vast market for "middlebrow" art, music, and literature, which filled the gap between the challenging innovations of Greenberg's "avant-garde" and the fraudulent appeal of old-fashioned kitsch.[2]

A year later, Greenberg offered further insights into the social preconditions for middlebrow culture in "The Present Prospects for American Painting and Sculpture," an essay he published in *Horizon*. He wrote:

A society as completely capitalized and industrialized as our American one, seeks relentlessly to organize every possible field of activity and consumption in the direction of profit, regardless of whatever immunity from commercialization any particular activity may have once enjoyed. It is this kind of rationalization that has made life more and more boring and tasteless in our country, particularly since 1940, flattening and emptying all those vessels which are supposed to nourish us daily.[3]

Greenberg's belief that American society was "completely capitalized and industrialized" foreshadows the economist Ernest Mandel's observation, made a quarter of a century later, that the immediate postwar period signaled the onset of the distinctive economic and social forms associated with "late capitalism." For Mandel, late capitalism "constitutes *generalized universal industrialization* for the first time in history. Mechanization, standardization, over-specialization and parcellization of labour, which in the past determined only the realm of commodity production in actual industry, now penetrate into all sectors of social life."[4]

 Greenberg's understanding of middlebrow culture was not limited to a vision of inexorable commodification and rationalization; it also encompassed the liberal democratizing goals of American public education. His suspicion of the middlebrow recalls Theodor Adorno's critique of culture's "totalization"—its systematization and subordination within a condition of total control. This was the context against which the supposedly spontaneous creativity of the Abstract Expressionists stood in such high relief in the late 1940s, and was so admired by critics such as Greenberg. It was also the context in which the Pop artists of the early 1960s were raised and educated. An examination of the dialectical imperatives driving artistic production and education in the period is thus essential to understanding the differences—and most crucially, continuities—between these successive generations of artists.

If a grain of ambivalence can be detected anywhere in Greenberg's analysis, it is in his understanding that the national ethos of democratization was fueled by the unprecedented industrial productivity achieved by the United States during World War II. He was impressed that Americans possessed the wealth to "think it possible to cultivate the masses." But he was doubtful about that productivity's social and cultural effects:

It was to be expected that sooner or later the American "common man" would aspire to self-cultivation as something that belonged as inevitably to a high standard of living as personal hygiene. In any event the bitter status struggle that goes on in a thoroughly democratic country would of itself have served by now to put self-cultivation on the order of the day—once it became clear, to the commonality, as it has by now, that cultivation not only makes one's life more interesting but—even more important in a society that is becoming more and more closed—defines social position.[5]

The vast middle-class consensus about the desirability of "cultivation" could only have grown from longstanding and complex historical processes. Yet Greenberg focused his analysis on these processes' cultural consequences because his ultimate goal was to suggest a hostile context for the "virile," radically anti-domestic and anti-middlebrow art of Jackson Pollock and David Smith, which contrasted with the engulfing "femininity" of its middlebrow counterpart.[6] Given the cultural situation he described, Greenberg considered it necessary to deploy this rigidly gendered rhetorical arsenal to win the turf war on behalf of "his" artists. A decade later this same rhetoric of binary antagonism would help conceal the more complex, truly dialectical relationship of Abstract Expressionism and the Pop art that followed it.

Greenberg could not have foreseen the impact of the cultural transformations he traced on the younger American artists, many of them returning from war to study with federal support through the G.I. Bill, who would constitute the post–Abstract Expressionist generations. Not that the matter of artistic education lay outside Greenberg's interests; far from it, for he knew that in education lay the future. Thus he concluded "The Present Prospects of American Painting and Sculpture" with high praise for the teachings of Hans Hofmann, the German-born artist and educator whom he had also applauded in 1939 in "Avant-Garde and Kitsch."[7] Hofmann's lectures at his school on West Eighth Street had helped Greenberg to arrive at his conception of modernist art as an essentially positivistic, self-critical endeavor that was rigorously opposed to the instrumentality of everyday life. Hofmann had insisted, for example, that it was "the tragedy of the Bauhaus" to have "confused the concepts of the fine and applied arts."[8] Such statements take on special significance in the context of the changes then taking place in American visual culture,

since these developments were informed in a variety of ways by a tendency to erode the boundaries between art and design, or art and life, that Hofmann and Greenberg were determined to reinforce.

To a greater or lesser extent, the fine and applied arts have been perceived to be in conflict with each another throughout modern times. From the second third of the nineteenth century through the middle of the twentieth, the history of art and design instruction has consisted of institutional negotiations between aesthetic and utilitarian forms: between handicraft and assembly line; between originals and copies; between imagination and convention; between the cultivation of unified perception or of the resources of involuntary memory and the miseries of rote learning. This is not to deny that there were occasions of synthesis. But even the most utopian "sublations" of art into life—William Morris, Russian Constructivism and Productivism, the Bauhaus, De Stijl—can be understood as historically contingent reconfigurations of these dialectical terms.

These elements came into a peculiar alignment within American art and design instruction between 1935, when the Federal Art Project was launched, and 1945, when the war in Europe ended. It is within the context of this distinctly American rapprochement that the complex social determination of Pop art and the postmodernist art it portended can best be appreciated. The American Pop artists aestheticized commodities at the same time that they commodified aesthetics. That is to say, they could slide back and forth with unprecedented ease along an axis extending between the structures of "high" art and those of industrial production. This new facility cannot be explained solely in aesthetic terms—as a side effect of the artists' anti-Romantic repudiation of Abstract Expressionism, say, or of their putatively "realist" response to the image-saturated life of postwar America. To consider this axis and its implications by examining the way these artists were trained is to consider the social construction of the artist who navigates its path so comfortably.

As conceived by Holger Cahill, the Federal Art Project provided relief for unemployed artists and designers during the Depression and encouraged the production of variously anti-elitist and "public" art forms. It is well known that the project commissioned thousands of murals, graphics, and posters. Less familiar is the fact that it instituted nationwide educational programs to construct a vast and socially diversified American public for art. From Spokane to Harlem, over one hundred community art centers were established across the country.

Cahill based this national art agenda on the model of John Dewey's plan for progressive education, reflexive democracy, and the social integration of aesthetic experience. As such, its ultimate goal was to incorporate art into the everyday lives of Americans and to undermine the hierarchical distinction between fine and applied arts—in short, to overturn the notion of art for art's sake by proposing art as a tool for forging a sense of both national and regional identity and assisting in productive self-fulfillment.[9] The domination of Federal Art Project art by social realist and regionalist styles may denote the failure of a naively populist approach to address the problem of shaping a cohesive national culture, but the program's educational goals were more successful. They helped to confer a sense of cultural entitlement and reverence for art on a whole generation of middle-class and soon-to-be-middle-class Americans who came of age during and after World War II. It was this generation that Greenberg would picture "surging towards culture" in such numbers and with such avidity that he considered it "a greater threat to high art than *Kitsch* itself."

Not until the end of Dewey's book *Art as Experience* (published in 1934, one year before the inauguration of the Federal Art Project) did the author observe that in order to overcome the disparity between art and life it would be necessary first to eliminate, in his words, "the economic system of production for private gain."[10] In the absence of such revolutionary social change, however, the individual work of art might still serve as an aesthetic model of experience to be emulated in other areas of life, maintaining its traditional bourgeois function as a symbolic repository of harmony and resolution that provided imaginary shelter in the midst of an ever more discordant and fragmented society. Despite the radical implications of Dewey's metaphysics of experience, then, his theory paradoxically ensured that discrete works of art would retain or actually intensify their exalted status. Given the long-term effects of establishing art teaching more securely within general education, and of the assimilation of art within an increasingly spectacular mass culture, works of art and the people who make them were fated to become mythic presences within American society.

By the time the Works Project Administration was liquidated in 1943, the government had helped return American art to a private base of patronage: not to its original patrician base, but to the middle class. A whole new public now wanted to buy "original" works of art to furnish their houses, as prescribed by *Life*. This was the purpose of the "Buy American Art Weeks" that were held in 1941 and 1942 to sell off

thousands of government-commissioned and government-warehoused works of art.[11] But such domestic consumption was not the full extent of the private support for art that began to develop between 1935 and 1945. There was corporate support as well: since the mid-1930s, companies had been buying art for their own collections. In addition, many more were employing artists and designers in various ways. It was to fine and commercial artists, in fact, and to the burgeoning group of American artists practicing industrial design, that companies turned during the Depression to try to restore the public's lost confidence in American business, and to lure consumers back to the marketplace.[12]

In 1930, the Westinghouse Electric Company of East Pittsburgh hired Donald Dohner, a graphic artist on the faculty of the College of Fine Arts at Carnegie Tech, Pittsburgh, to redesign their products and develop plans for new ones. Five years later, Carnegie introduced a BFA degree with a major in industrial design—the first such program in the United States. It was Dohner who designed the new course of instruction, and without his experience at Westinghouse, he and his colleague, the artist Alexander Kostellow, could not have conceived it either when or as they did. The industrial-design curriculum devised by Dohner and Kostellow prepared its graduates to understand the material requirements of mass production, anticipate the desires of consumers, and employ the logic of aesthetic structure in their work. In a paper commemorating the introduction of this immensely influential program, Robert Lepper—Warhol's most important teacher at Carnegie Tech—coined the hyphenated term "artist-designer" to describe the new breed the faculty had hoped to engineer.[13]

The field of industrial design grew and became more prestigious throughout the 1940s, spawning a variety of institutional and pedagogical manifestations. After the war, the usual competition for students among university art departments—always eager to increase enrollment—was heightened as returning veterans (Lichtenstein among them) armed with federal education funds turned in unprecedented numbers to careers in art. Art department administrators and faculty members refashioned their curricula to suit the widest possible range of students.

At the same time, the increasing correlation of the artist's and the designer's education was furthered by the conception of "organic" curriculum planning, which blossomed in the 1940s. In 1942, the College of Fine Arts at Carnegie Tech implemented a "Fine Arts Academic Program" that required students in all of all its divisions (painting and design, industrial design, and art education) to take new courses, including "Thought

and Expression," "The Arts and Civilization," and "Individual and Social Psychology." This academic program was intended, in the words of Dean Keeble,

> to exploit the capacities . . . and correct the limitations of the typical art student . . . to provide a complement to his particular kind of professional training . . . to widen the horizon of our young artists, to reduce their prejudices and multiply their enthusiasms, to link intellectual and practical interests with their creative endeavors and, finally, to integrate them with society and equip them to take an effective part in the difficult world which this generation must face.[14]

As a response to the threat of an overly technical education, organic curriculum planning advanced the erosion of hierarchical distinctions between the education of the artist and that of the designer. In this sense it extended a century-old tradition of liberal educational reform. But it also emerged at a historically specific moment, when university administrators, educators, intellectuals, and more than a few entrepreneurs shared a widespread sense that this continent alone was likely to survive the war intact. It was incumbent upon Americans, then, to rescue Western culture—a task that was pursued by the contradictory means of recasting this culture in the guise of popular humanism.

Many of the art and design instructors of the 1940s came of age during the 1930s, and identified themselves as pragmatic modernists. They might have sprung from backgrounds in fine art and illustration, as did Lepper, or in engineering, like Hoyt Sherman, an art professor at Ohio State University whom Lichtenstein credited with the formation of his aesthetic frame of reference.[15] These enthusiastic if little-known modernists responded to the challenge of increased enrollment, and to the demand for more adaptable forms of practical training, by codifying the principles of what they regarded as a universal aesthetic. To achieve greater efficiency—and authority—they invariably turned to science to guide them and support their ideas. Sociology, anthropology, and psychoanalysis, for example, informed Lepper's two-year course "Pictorial Design," which instilled juniors and seniors in the Carnegie design program—Warhol among them (1947–48)—with an awareness of what Lepper called the "social flux"; that is, of their ever-changing relationship to the community in which they lived and worked.

Students in the "Pictorial Design" course were asked to scrutinize the Oakland community around Carnegie Tech "with the general viewpoint

of a cultural anthropologist." They were to study "people, shelter, exchange of goods and services, means of communication, ceremonial observances, the nature of governmental activity and public services, and community spectacle (i.e. topography, weather, light, movement of people in groups)." This focus recalls the overall outlook of Thomas Hart Benton who, as an instructor at the Art Students League early in the 1930s, had encouraged the young Jackson Pollock to sketch from life. In this way Pollock could distill the essence of the American scene into carefully observed, yet largely imaginary, compositions based on cross-country travels. Lepper clearly intended a more scientific attitude than this. As a combination of social concern and commercial interest, his course stopped at the threshold of market research.

As a final assignment, Lepper's students were to employ the knowledge they had acquired in their fieldwork and the organizational skills they had developed in foundation and studio courses to create "pictorial interpretations" of a novel that Lepper selected for them (in Warhol's class it was Robert Penn Warren's *All the King's Men*).[16] Perhaps the fulfillment of Lepper's course would only be achieved fifteen years later, however, in the anthropologist's blend of complicity and detachment, indifference and incisiveness, that characterized Warhol's Pop art. Considering how Warhol's work helped reconcile people to the conditions of life in an advanced consumer culture, it is not difficult to understand how Lepper could have supported him. Warhol's teacher and his colleagues had hoped that the new breed of artist-designer would help to bring about what he, echoing Kostellow, called "stability" or "equilibrium" within the "social organism."[17]

It was experimental psychology, particularly Gestalt, that inspired Lichtenstein's mentor, Sherman, to create an innovative—not to say eccentric—introductory course in drawing and pictorial structure at the beginning of the 1940s. Sharing with the founders of Gestalt their belief that "good form" was suited to the psychic and social "task of integration," Sherman sought not just the preservation of high aesthetic experience but the improvement of virtually all processes of production through their assimilation to aesthetic structures.[18] It had long been part of the modernist agenda to reshape consumer products according to modernist aesthetics. Sherman went farther, arguing that his course would benefit not just students of art and design but people in any walk of life, be they factory workers, football quarterbacks, dentists, or soldiers.[19]

Hardly your run-of-the-mill drawing instruction, Sherman's was actually a course in perceptual training. Like many proto-modernists and

modernists before him, Sherman imagined the persistence of "fundamental structures" as the transhistorical constant of all aesthetic experience. But he supplemented to this belief his own theory that the artist's approximation of such structures was the result of an "organized perception," and that this organized perception could be taught. Artists were not necessarily born, but could be made: Sherman could educate them to perceive, organize, and register materially the hitherto disordered data of sense perception in a continuous, undifferentiated process. As if to fulfill Dewey's belief that all productive processes are potentially aesthetic and that aesthetic structure should therefore inform all productive processes, Sherman determined to find a way to teach organized perception and make it as widely available as possible through the standardization and publication of his method.[20]

How does one impart the fluent patterns of organized perception? Sherman's course took place in a specially equipped studio, a former artillery shed that stood beside Ohio State's fine arts building, Hayes Hall, and that was remodeled in 1945 to Sherman's detailed designs. Perhaps the studio's most striking aspect was its lack of light. Not only were all the windows in the seventy-foot-long building sealed, but every other form of illumination was tightly controlled. So, for that matter, was the entire host of scientifically freighted and orchestrated variables that together constituted the course. Sherman hinted at the baroque scientificity of his program, and at its central device as well, by referring to his black box of a studio as the "flash lab."[21]

The students met six times a week for six weeks, never for more than twenty-five minutes a session. They spent the first ten minutes of each session getting used to the gloom. As recorded music (often jazz) filled the studio, they were encouraged to relax—to whistle and tap pencils—but also to feel for the limits of the drawing table in front of them, and for the outer edges of the newsprint on which they would soon draw with thick crayons or charcoal. These tables were arranged on four terraces facing projection screens far away at the studio's opposite end. As the course progressed, the tables were moved closer to the screens, to challenge the students' perceptual abilities. Above and slightly behind the terraced section of the space was a "bridge" containing a massive slide projector. Sherman had fitted this device with a "tachitoscope," a mechanical shutter, first devised by late-nineteenth-century psychologists, that made it possible for him to control the duration of a slide projection to within a fraction of a second. Also on the bridge were assorted strobes and spotlights, a gramophone and record collection, and a slide library containing four

Students in the flash lab, Ohio State
University, 1949. Photo: Ohio State
University Archives.

hundred mostly "abstract" designs that Sherman conceived especially for
his course.

After the ten minutes of relaxation and preparation had passed,
Sherman would show the first of the twenty slides he would use in each
class; or rather he would "flash" it, since it appeared on screen for a tenth
of a second or less. Cast again in darkness for the remainder of a min-
ute, the students would draw the configuration they had barely glimpsed,
depending mainly on its afterimage. At the end of the minute, another,
slightly more complex configuration would pulse before them, and again
they would draw in darkness from the afterimage. Later in the course,
Sherman would keep the lights on in the studio for longer intervals until,
at the end, students were encouraged to test their skills against the ambi-
ent light of landscape study.

Much of this program Sherman based on the theory—expounded by
experimental psychologists—that when an object is visible for a tenth of
a second or less, the human eye cannot perform the saccadic movements
that enable perception in depth. By "flashing" slides as he did, Sherman

was trying to promote a mode of visual perception that he interchangeably called "monocular" or "aesthetic" vision, in which, he believed, images and objects are likely to be grasped in terms of relative position, size, and brightness. For Sherman, "monocular" vision was "aesthetic" because it facilitated the apprehension of images or objects as "wholes," intensified the student's appreciation for the constitutive role that negative space plays in forming an image, and assisted in the process of transposing objects seen in three-dimensional space into the two-dimensional terms of a picture surface.

Sherman designed and classified his slides according to "optical cues" (relative position, size, and brightness) that he learned about in psychology texts such as Max Wertheimer's "Laws of Organization in Perceptual Forms."[22] He further organized each category of slides in a progression from simple to complex. There is a link here—implausibly enough—between Sherman's proto-high-tech course and the old and tradition-bound drawing instruction of the Beaux-Arts academies. This linkage is established more securely by the sequence that Sherman adopted for his course in its entirety.

According to that venerable Beaux-Arts sequence, one begins to draw "from the flat"—just as, in Sherman's course, one began with slides projected onto a single screen, effectively substituting for the aspiring academician's slavish studies after engravings. Next, where plaster casts of geometrical figures and organic forms introduced the nineteenth-century art student to the problem of transcribing three-dimensional objects into the two dimensions of the drawing surface, Sherman flashed specially devised slides onto three screens, two of which flanked the third, which was set slightly deeper in the space. Finally, with the transition to three-dimensional studies completed, the nineteenth-century student might turn to the classical statue, the live model, or the traditional still life. Sherman gave his students unconventional arrangements of studio props, trash bins, and cutout letters and numbers that he inverted to prevent recognition. In the early part of the course, he illuminated these studies only momentarily, using a strobe, except for a pinpoint of light that would isolate part of one object in order to establish a planar point of reference. As he replaced simple images with more complex ones, and as the course progressed from two to three dimensions, his goal remained the same: "to establish conditions which foster and, in so far as possible, require an organic type of integration ... unity in seeing, unity in the process of seeing-and-drawing, unity in the total creative act."[23]

There could be no room in such a course for reflection or conceptualization. Sherman argued that "any self-conscious effort that separates the aesthetic into its verbal components, such as composition, perspective, and tonality, is a sure way of destroying the desired end." Insofar as the flash lab was conceived to promote an explicitly undivided experience ("seeing-and-drawing") that would determine, and be inscribed within, the resulting work of art, any incursion into this protected zone of indivisibility from the inherently differentiating field of language had to be kept at bay. In this sense, training in the flash lab must be understood as a pedagogical formula for preserving the transcendental essence of modernist aesthetic experience.

This transcendentalism was defined with ever greater precision in the phenomenologically oriented critical discourse on Minimalist art in the mid- to late 1960s, and nowhere more lucidly than in Michael Fried's essay "Art and Objecthood." Fried distinguished modernist art from Minimalism (or "literalism"), which he found alarming in its "theatricality," its prioritizing of temporal duration and the circumstances of display in establishing aesthetic meaning. When, at the end of his essay, Fried rhapsodized over the modernist art that he considered at war with "theater," he might just as well have been describing the conditions of the flash lab:

> It is this continuous and entire presentness, amounting, as it were, to the perpetual creation of itself, that one experiences as a kind of *instantaneousness: as though if only one were infinitely more acute, a single infinitely brief instant would be long enough to see everything, to experience the work in all its depth and fullness*, to be forever convinced by it.[24] (Emphasis added)

Each and every variable in Sherman's course was determined scientifically to secure the availability of transcendent artworks that could bear witness to, and supply instantaneous experiences of, subjective indivisibility and perceptual fullness of being. But at a simpler, more patently instrumental level, the program was intended to increase the student's perceptual and organizational power. In an account of his course published in 1947, Sherman used charts and graphs to support the claim that his instruction enhanced a range of perceptual faculties—from the ability to see in the dark to that of quickly surveying an extensive visual field—while simultaneously fostering the efficient organization of frequently chaotic perceptual data. It cultivated, in other words, grace under pressure.[25]

At the same time that Sherman followed the transcendentalist impulse familiar from the discourse of Abstract Expressionist and other modernist art, he was also determined to supply his students with the means to function more efficiently and with a greater sense of "integration." In short, his course acknowledged the productive imperative that dominated American life more than ever at the dawn of late-capitalist consumer culture. Further, it presumed that the world had become a more challenging—not to say hostile—and subjectively shattering place. In this context, it may come as less than a surprise to learn that soon after the United States entered World War II, Sherman offered to train naval cadets in "organized perception" in order to help them more efficiently blast the enemy from seas and skies, by day or night. Sherman himself observed that his discovery of a method to teach drawing and pictorial structure coincided with the Japanese attack on Pearl Harbor.[26] But the birth of his project during wartime cannot explain the curious combination of aggression and defensiveness, technologism and conservatism, that characterizes his approach to art and its instruction, and that found its artistic complement in the work of Roy Lichtenstein.

In its presumption of an environment in which one is likely to be bombarded with perceptual stimuli to the point of abuse, Sherman's method recalls the conditions of industrialized urban life that Walter Benjamin evoked in his study "On Some Motifs in Baudelaire." For Benjamin, the bustling metropolis had become the site of countless minor shocks and potentially major traumas, which, he suggested, had worked with other historical processes to splinter subjective experience.[27] The context of modernity outlined by Benjamin is suggestive in understanding the transcendentalist underpinnings of Sherman's program, and of so much modernist art. But to understand why drawing for Sherman had become an explicitly "*aggressive* seeing-and-drawing act" (emphasis added), it is necessary to look to the more recent past: to Mandel's account of the conditions that emerged—like Sherman's course—in the United States in the midst of World War II, given the forms of production introduced under late capitalism and the "third technological revolution."[28] One would be hard pressed to imagine a form of instruction more directly geared to prepare individuals for life and work under these greatly accelerated conditions than Sherman's.

That this course could indeed help its students to create aesthetic unities while performing "the supervisory and preparatory functions" that Mandel explicitly identifies with late capitalism is evident not just in Lichtenstein's mature Pop designs but in the work he created as a graduate

student and instructor at Ohio State between 1946 and 1949. Though he could not have used the flash lab when he first attended the school as an undergraduate, between 1940 and 1942 (an early version of the lab was only constructed later in 1942, after he had left), Lichtenstein did learn Sherman's method when he returned to Ohio after the war and used it and its suppositions both to create his own art and to teach his younger pupils. His art from the period revised images of medieval damsels and knights from such familiar sources as the Bayeux Tapestry and, beginning around 1950, refurbished nineteenth-century American potboilers such as Emanuel Leutze's *Washington Crossing the Delaware* and William Rayney's *Emigrant Train*. On all this imagery, he imposed a gently comic modernist style derived from Picasso, Klee, and Miró.

Implicit in Lichtenstein's longstanding will-to-form is an abiding belief in the positive effect of such transcendentalist pictorial organization. This faith in the virtue, if not the sanctity, of modernist aesthetics suggests an important link between his art and that of the Abstract Expressionists. Indeed, the students of Hans Hofmann were joined by those of teachers like Lepper and Sherman in their common understanding of the modernist picture surface as a symbolic "pictorial space" in which the tensions and contradictions of late-capitalist social life could be resolved. Despite the metaphysical rhetoric and masculinist negational conceits that framed Abstract Expressionism, this art also incorporated structural features of late-capitalist social life. Pop artists may have taken to these structures more willingly, not to say ostentatiously—but not without subjecting them to aesthetic (and in Warhol's case, anti-aesthetic) processes that concealed evidence of formal and ontological differences within these signs of commercial equivalence. If Warhol's anti-aesthetic isolates his art within Pop, this should be taken not just as proof of his early success within the field of commercial design, but as evidence of the more deeply felt cultural antagonism of this working-class artist who was also, not incidentally, the only "out" gay man among his post–Abstract Expressionist peers.

By the late 1940s, when Lichtenstein was creating his variations on previous images, such re-presentational tactics were not his alone. Shortly after the 1962 death of Franz Kline, the painter Elaine de Kooning wrote a catalogue essay for a memorial exhibition of his work. In it she told of a day, late in 1948, when Kline visited her and her husband at the latter's Fourth Avenue studio. Kline was anxious to find a way out of an impasse

in his work. Two years had passed since Pollock had created the first of his epochal "poured" paintings, and Willem had attracted critical acclaim for the black-and-white enamel abstractions he had exhibited in April 1948 at Charles Egan's gallery. In this climate of expansive innovation, Kline was still creating sensitive drawings and modest easel paintings, some figurative and others in an abstract style that was somewhat too reminiscent of Willem's own. De Kooning suggested to his friend that he put one of the ink sketches he had brought along into the studio's Bell-Opticon opaque projector, which de Kooning himself had borrowed to enlarge his own diminutive sketches onto large canvas supports. Kline's epiphany occurred when he saw the image of his little India ink drawing projected onto the studio wall: "A 4 by 5-inch brush drawing of the rocking chair . . . loomed in gigantic black strokes which eradicated the image, the strokes expanding as entities in themselves, unrelated to any reality but that of their own existence."[29] From this procedure, which Kline would continue to use for the rest of his life, there evolved the monumental paintings that he exhibited at Egan's gallery in 1950, which established his international reputation as a significant Abstract Expressionist.

It was two years after Kline's show that Harold Rosenberg published his essay "The American Action Painters," in which he described this art as a "revolution against the given in the self and the world."[30] Rosenberg followed the artists' own order of priorities in underscoring the importance of their negation—their "constant No"—in determining the meaning of their improvisational method. Yet he admitted that some of the action painters made what amounted to preliminary sketches—"skirmishes," he called them, for the main event that would take place in the larger canvas arena. And in light of such sketches, and particularly of the reproductive procedures that Kline and de Kooning are known to have used, to what extent can their work be described in Rosenberg's terms? Motivated by and to some extent reproducing something already in the world, such paintings constitute a "revolution against the given" in only the most qualified sense.

That no one has allowed knowledge of this reproductive procedure to interfere in any way with the conventional interpretation of the action painters' art as Abstract and Expressionist attests to the enduring appeal of these spectacularly staged manifestations of an embattled American postwar humanism. Similarly, the success of Pop art had to take place before the Abstract Expressionists' affection for American mass culture— for cartoons, comic strips, and movies—could be considered important

Franz Kline, *Merce C.*, 1961. Oil
on canvas, 93 × 74½ inches.
Smithsonian American Art Museum,
Washington, D.C. © 2007 The Franz
Kline Estate/Artists Rights Society
(ARS), New York. Photo: Smithsonian
American Art Museum, Washington,
D.C./Art Resource, New York.

in looking at works such as de Kooning's *Women*.[31] A greater openness to the significance of Abstract Expressionist re-presentation would lead to a more complex understanding of art from the late 1940s through the early 1960s, and would provoke a healthy skepticism toward the commonplaces of both Abstract Expressionist and Pop ideologies. For example, art critics and historians ordinarily describe the relationship between Abstract Expressionist practice and everyday American life as one of more or less rigorous antagonism. Yet keeping in mind the totality of Kline and de Kooning's method, would it not be more accurate to say that these artists internalized the mechanical, repetitive structures that dominated postwar American life in order all the more dramatically to stage their resistance to them? The idea that action painters might resort to mechanical reproduction to assist in transcriptions that they then disguised beneath the painterly ciphers of an emphatic originality makes it possible to describe such works not just as "originals" but as *dissimulated copies* as well.

This less familiar—indeed repressed—aspect of the action painters' method also suggests that the relationship between Abstract Expressionism and the Pop art that followed it is more complex and ambiguous—more truly dialectical—than the familiar binary that critics and art historians have devised and reinforced to keep them apart. When Elaine de Kooning described Kline's revelation on seeing his figurative drawing transformed through gigantism and inversion into heroic abstraction, she might just as well have been describing a similar epiphany experienced by the young James Rosenquist. An unmistakable New York School swagger informs Rosenquist's tale of how he learned to see "abstraction everywhere" while employed as a commercial sign painter. Working on a scaffold high above Times Square, he was so close to the image that it was transformed—again through gigantism—into abstraction. Rosenquist was able to endow his montage-like Pop compositions with the push–pull spatial hydraulics that Hofmann had prescribed as a means of establishing maximum pictorial tension in non-illusionistic painting. However, this skill was due less to Rosenquist's experience as a commercial sign painter than to his having studied with Cameron Booth (1952–54) at the University of Minnesota. Booth had studied with Andre Lhote for a year in Paris (1927) before studying with Hofmann for two years in Munich (1928–30).[32]

If Kline and de Kooning dissimulated by producing copies that looked like originals, the Pop artists dissimulated by producing originals that masqueraded as copies. Where the Abstract Expressionist dissimulation was almost wholly overlooked, the Pop equivalent was picked up in the first

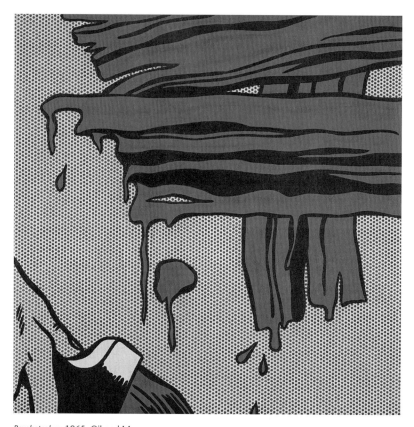

Brushstrokes, 1965. Oil and Magna
on canvas, 48 × 48 inches. Private
collection. © Estate of Roy Lichtenstein.

critical responses to the new art. The contradictory character of the Pop
object was central to an unusually lively and revealing debate late in 1963.
It was Lichtenstein's earliest Pop paintings that provoked this controversy,
which led critic Brian O'Doherty (also an artist, under the name Patrick
Ireland) to identify a completely new class of object: the "handmade ready-
made." Reviewing the artist's second Pop show in the *New York Times*,
O'Doherty labeled him "one of the worst artists in America." Nonetheless,
he also credited him with creating paintings that "raised some of the most
difficult problems in art."[33]

O'Doherty took note of an argument that had just erupted in the art
press: the September issues both of *Art News* and *Artforum* had run angry
features about Pop art in general and Lichtenstein's work in particular.

Both were written by an esteemed California art teacher, Erle Loran, who had targeted two paintings by Lichtenstein, *Portrait of Mme. Cézanne* and *Man with Folded Arms* (both 1962), in order to excoriate some of the salient features of the new art.[34] Each painting was a characteristically brazen blowup of a diagram from Loran's book *Cézanne's Composition*, then twenty years old. As a manifestation of the far-reaching attempt before and after World War II to extend the benefits of cultural activity and modernist art to larger and more socially diverse numbers of Americans, Loran's diagrammatic analysis of Cézanne's art was itself something of a vintage '40s object. Lichtenstein's pedagogical pastiches join Warhol's *Do It Yourself* and *Dance Diagram* paintings, also from 1962, to form a distinct Pop genre, one that suggests these artists' ambivalent awareness of the middlebrow culture that Greenberg had considered so threatening to art when Loran published his book.[35]

Both Loran and O'Doherty thought it absurd that so many supporters of Pop were defending Lichtenstein by insisting that he "transformed" rather than "copied" his sources. Claiming that only an expert could discern the difference, O'Doherty found this hairsplitting quite beside the point. After all, it had been possible to classify *direct* appropriation as art since 1913, when that "old master of innovation," Duchamp, had "started it all by setting up his readymades . . . and calling them art, leaving on us the burden of proof that they were not." Both Loran and O'Doherty found the transformation alibi doubly annoying since it clinched the matter of Pop's high-cultural status by resorting to an altogether academic and contradictory dual defense. On the one hand, Pop was art because it "put a frame of consciousness around a major part of American life . . . we take for granted." On the other, Pop was art because an artist like Lichtenstein transformed his sources "like a good artist should"—a clichéd view of fine-art production. Dismissing both defenses, O'Doherty despaired of this "triumph of the banal" and demurred, "Mr. Lichtenstein's art is in the category, I suppose, of the handmade readymade."

Loran wrote his two articles after Lichtenstein's first Pop exhibition in Los Angeles, which included the artist's life-sized versions of images from Loran's book. These articles may well have marked a historical first: there is reason to believe that they supplanted Loran's intention to sue the artist and his dealer for copyright infringement. Such litigious impulses have peppered the history of American art ever since. The angrier of the two tracts appeared in *Art News*, where Loran openly expressed his contempt for Lichtenstein's work and hinted at his desire to sue.

Portrait of Madame Cézanne, 1962.
Magna on canvas, 68 × 56 inches.
Museum of Contemporary Art,
Los Angeles, The Panza Collection.
©Estate of Roy Lichtenstein.

In a recent sell-out exhibition at the Ferus Gallery, Los Angeles, he [Lichtenstein] gave the title of *Portrait of Mme. Cézanne* to the black and white line drawing on bare canvas reproduced here. Sale price: $2,000, or more. I suppose I should be flattered that a diagrammatic sketch of mine should be worth so much. But then, no one has paid me anything—so far.[36]

One does not have to read past the rhetorical question that served as Loran's title ("Pop Artists or Copycats?") to detect what was most provocative about Pop. Like many others, Loran saw Abstract Expressionism as the quintessentially American humanist art: a "monument to the human spirit," an emblem of the "depth and richness of human experience and intuition," and a demonstration of the "true meaning of free democracy . . . in America." The Abstract Expressionists had opened up new and unprecedented avenues for aesthetic exploration, which Loran considered on a par with the "most advanced products of the human mind, comparable in some ways to achievements in physics and chemistry."[37] As an art educator, he was incensed that any self-respecting artist would want to undermine so precious a cultural resource. That such an artist would then be remunerated handsomely for advancing a culture of copies over one of originals was simply more than he could endure in silence.

For Loran, the "transformation" or "copy" debate was spurious: since the Abstract Expressionists had ventured "far beyond the process of transforming nature" to produce paintings that presupposed "no conscious source but have an identity and imagery that is autonomous," transformation—even were it detectable in Lichtenstein's art—could only constitute aesthetic regression.[38] For different reasons, Lichtenstein himself shunned the transformation defense. During the first year of Pop's reception, critics so insistently and so often said that the artist transformed his sources that he was compelled to offer his own characteristically laconic corrective. Shortly after the publication of Loran's two articles (the second of which was entitled, significantly, "Cézanne and Lichtenstein: Problems of Transformation"), Lichtenstein remarked in an interview with Gene Swenson that "transformation is a strange word to use. It implies that art transforms. It doesn't, it just plain forms."[39]

Among the critics who joined Loran's assault was Max Kozloff, who worried in *The Nation* that art like Lichtenstein's might signal "a rejection of the deepest values of modern art." When Kozloff noted that for six or seven years in New York "we have been witnessing an attack upon the

notion of originality in painting," he pinpointed the central feature of the Loran controversy, and the crucial normative term within the modernist system of aesthetic evaluation that Pop had placed in jeopardy.[40] Kozloff was concerned about the implications of Pop's attack on artistic invention for "the ethic of most twentieth-century art." He condemned art like Lichtenstein's and Warhol's for depending on the high art "context" for its effect; without that context, he argued, their works would revert back to their status as non-art. Pop, in Kozloff's words, was "as contextual as it is conceptual," an observation that would seem to situate this art within the tradition of what has been called the "historical avant-garde" to the extent that it exposes the institutional framework of art. Kozloff's observation, however, fails to take into account the singularly contradictory character of the "handmade readymade," without which the entire debate about transformation could not have taken place.[41]

The handmade readymade may well have been limited in its critique of earlier aesthetic practices, but it did enable Pop artists to deflate Abstract Expressionist solemnity. Warhol, for example, indirectly addressed the abstract designs of Barnett Newman in paintings of greatly enlarged commercial illustrations (*Telephone*, 1961) and banal everyday objects (*Close Cover Before Striking*, 1962); and Lichtenstein, in 1964, was sufficiently inspired by the sight of a single comic panel (in which a hand in tight close-up slathers paint on an easel-bound canvas) to inaugurate a career-long series of paintings and sculptures that show Abstract Expressionist art as neither abstract nor expressionist.[42] The sensational appearance in galleries, museums, and the popular press of Pop's monumental hand-painted and silk-screened ads, headlines, and comic book images forced observers to reflect upon the erosion of Abstract Expressionist belief systems.

Actually, as Kozloff observed, this erosion dated from a full decade earlier. The viability of Abstract Expressionism depended upon the interrelated concepts of stylistic authenticity, metaphoric structure, and the mythic notion of autonomous creativity. That these preconditions had become at best contestable and at worst discredited by the early 1950s is suggested by Kozloff's observation that during this period "there grew a cleavage between the motivating idea and its embodiment, the fusion of which had been the guiding premise of Abstract Expressionism.[43] This is another way of saying that a fissure had opened up between artistic form and content. Abstract Expressionism had depended upon a supposed fusion of the two, not just for its metaphoric conception of style as transparent to the artist who creates it, but for its claim to descend

from an aesthetic tradition that arguably could be traced to the birth of humanism.

In a related observation, Kozloff asserted that the once crucial distinction between abstraction and representation was "no longer relevant." In a sense this was already true at the height of Abstract Expressionism, for when Kline and de Kooning used opaque projectors to transfer images from one medium and scale to another, they transformed abstraction into representation. Kozloff's point, however, is that even for action painters who had never resorted to the devices of mechanical reproduction, abstract imagery had become encoded, conventional. "It is quite as possible to put comic strips through their mechanistic paces as it is concentric circles. In fact, as conventionalized icons they ultimately have about equivalent non-meanings."[44] One cannot very well sustain a view of a modernist-vanguard artwork as the last resolutely unique object in the midst of a commodity culture once such a work has joined all others in its failure to establish the illusory union between form and content that would testify to its transcendent status. In this sense, all images have acquired an equivalence with one another in their capacity to yield "non-meaning."

Kozloff's reference to "concentric circles" and "conventionalized icons" recalls Johns's paintings of targets, stenciled numbers, flags, and other "things the mind already knows." These painterly adaptations of the readymade contradicted the humanistic and Abstract Expressionist conception of the artistic image as the unforeseen and therefore authentic result of an organic painting process in which every brushstroke testified (seismographically, as it were) to the presence of the artist-creator. That conception was nowhere more suggestively and concisely contested than in Robert Rauschenberg's two paintings *Factum I* and *Factum II* (both 1957): *Factum II* is an exacting replica of *Factum I*, right down to the vivid pseudo-expressionist drips and slashes of red, gold, black, and white paint. In each work these signifiers of spontaneity are juxtaposed with printed matter that includes a calendar of the year 1956, doubled headshots of President Eisenhower, newspaper clippings containing paired pictures of a burning tenement, and color photos of a lakeside landscape. The casual coexistence on the same pictorial surfaces of the hand- and the machine-made, the "unique" and the reproducible, establishes the terms of an equation in which the painterly rhetorics of existentialism and abstraction are given parity with other, less highly regarded forms of representation.

Factum I and *Factum II* crystallized the emergent logic of the hand-made readymade. It only remained for the Pop artists to find their own

ways of exploiting the gulf that had opened up between pictorial form
and content during the 1950s. Concerning style's increasing dislocation
from authorship, Warhol could exult, "I think that would be so great, to
be able to change styles. And I think that's what's going to happen, that's
going to be the whole new scene."[45] Neither metaphoric nor metonymic,
the handmade readymade depleted painting of its symbolic function.
It had no "depth." As Roland Barthes observed, no artist can be found
"behind" this obdurate object. Confronted by it, the French critic was
moved to recall a "true revolution of language."[46]

To the extent that Pop (and earlier works by Rauschenberg and
Johns) can be described in terms of such a dissolution of metaphor, it is
not surprising that it heralded the corresponding return to prominence
of "allegory"—a term in this case referring to the appropriation of pre-
existing images (or objects) in a seemingly arbitrary fashion that resituates
them within a new chain of signifying relations. The signifier, its original
signified now bracketed, generates new meanings potentially antithetical
to the old. As Benjamin wrote, "This meaning with that image, that image
with this meaning."[47] This structural feature of allegory enabled Pop artists
to deploy images that function on the one hand at the level of the most
commonplace mass-cultural signs (the comic strip referent) while on the
other registering the more rarefied concerns of high art (the comic strip
panel of a jet plane exploding, for example, functions—to some—as a
critical reference to Abstract Expressionism). It was precisely this allegori-
cal structure that led Barthes to describe Pop as follows: "There are two
voices, as in a fugue—one says, 'This is not Art'; the other says, at the same
time: 'I am Art.'"[48]

Yet the handmade readymade also resulted in oddly conciliatory cul-
tural effects. As early as 1962, when Donald Judd reviewed Lichtenstein's
first Pop show, critics recognized that what they most disliked about
Lichtenstein's work—its proximity to the stylistic codes and contents of
mass culture—was tempered by the "traditional" and "quite expert" com-
position of paintings like *The Kiss* (1962). Judd wrote, "Respectability
comes quickly, is strong and can be shrewd. Lichtenstein's comics and
advertisements *destroy the necessity to which the usual definitions pretend*."[49]
(Emphasis added.) He was referring to Lichtenstein's ability to navigate
his way successfully through the "high and low" minefield of normative
terms in modernist visual culture—to effectively suspend the dialectical
antagonisms upon which high modernism had ostensibly been built. By
representing the mass-cultural artifact while re-forming it to suggest an

abundance of traditional aesthetic rewards, Lichtenstein eliminated the "necessity" of enforcing the boundaries between high and low, original and copy.

By testing the categorical limits of modern art, Pop also exposed the arbitrariness by which exclusionary cultural hierarchies were established and maintained. In 1964, Claes Oldenburg noted that he had always been "bothered by distinctions—that this is good and this is bad and this is better. I am especially bothered by the distinction between commercial and fine art, or between fine painting and accidental effects. I think we have made a deliberate attempt to explore this area."[50] Parody, dissimulation, and the defamiliarizing effect of enlargement enabled Oldenburg to stage his aesthetic investigation into the similarities and differences between (to cite his example) a sculpture by Arp and the gravity-induced biomorphism of spilled ketchup. By summoning at once the most exalted and the most debased cultural registers, he foregrounded his "arbitrary act of the artist." Lichtenstein was just as interested in the flip side of this problematic. Responding to a comment about the "impersonality" of his and Warhol's art, he criticized the widespread tendency—born of the numbing effects of life in an advanced consumer culture—to assume that "similar things are identical."[51]

By drawing the spectator's attention to familiar imagery, the hand-made readymade taps into the resources of what Benjamin, after Proust, calls "voluntary" memory: the most commonplace form of recognition, essential to functioning in everyday life, and instrumental throughout the history of capitalism. However, this art exploits voluntary or instrumental memory only to expose its inadequacies. Direct examination of the Pop object prompts awareness not just of the institutional circumstances that separate high art from mass culture, but of ontological differences between a Lichtenstein painting of a comic strip panel and the original image, or between piles of Warhol Brillo boxes and Brillo's own. The Pop artists turned Abstract Expressionist logic on its head when they gave up "invention" (in the traditional sense of that term); but by fashioning objects that also insisted that similar things are, indeed, not identical, they salvaged a vestige of the action painter's resistance to "the given in the self and in the world."[52]

The American art instructors of the 1940s introduced many of the artists we associate with Pop to the technical skills and belief systems that they considered indispensable to modern art and design. Of Pop artists it can truly be said that they were among the first generation of American

artists to be professionally educated in university art departments, or in fully accredited, degree-granting art schools. They experienced a unique, transitional moment in the history of American art instruction, when a singularly rational approach to teaching unprecedented numbers of students the skills of pictorial organization and commercial design was united with a still romantic belief in the inherent beneficence of art and science. The efficient, now remote, pedagogical methods by which Warhol and Lichtenstein were taught endowed both artists with the mastery of form and contradiction that so completely characterizes their work. This odd conjunction of a demystifying, often positivistic approach to art training with a romantic belief in art's conciliatory and restorative powers provided both engine and analogue for the Pop artist's contradictory aesthetic procedure, and for its ultimate product: the "handmade readymade."

Notes

1. Clement Greenberg, "Review of the Water-Color Drawing and Sculpture Sections of the Whitney Annual," 1946, in *Clement Greenberg: The Collected Essays and Criticism*, vol. 2, ed. John O'Brian (Chicago: University of Chicago Press, 1986), pp 57–58.

2. "As Kurt List, the music critic, says, we may be witnessing the emergence of a new, middlebrow form of popular art that, while it exploits many of the innovations of avant-garde art, lowers their intensity and dilutes their seriousness in order to convert them into something calendars and magazines can digest—as if in answer to a public that is making new and higher demands on the art offered to it." Ibid., p. 57.

3. Greenberg, "The Present Prospects of American Painting and Sculpture," 1947, *Collected Essays*, p. 163.

4. Mandel divides the history of capitalism into a sequence of "long waves" in which rates of profit rise and fall, and along with them rates of capital accumulation. One such long wave—the "long wave of the third technological revolution"—begins in 1940–45, as the rate of profit increases due to the "weakening (and partial atomization) of the working class by fascism and the Second World War." This prompts a "massive rise in the rate of profit, which promotes the accumulation of capital. This is first thrown into armaments production, then into the innovations of the third technological revolution," which is marked by "generalized control of machines by means of electronic apparatuses (as well as by the gradual introduction of nuclear energy)." This, in turn, promotes a long-term rise in the rate of profit, which Mandel sees extending through 1966. Ernest Mandel, *Late Capitalism*, trans. Joris De Bres (London: Verso Edition, 1978), pp. 121, 131, 387.

5. Greenberg, "Present Prospects," p. 163.

6. Even when Greenberg is not excoriating middlebrow art per se, the terms of his critique remain rigidly gendered: "[David] Smith's art is more enlightened, optimistic and broader than Pollock's, and makes up for its lesser force by a virile elegance that is without example in a country where elegance is otherwise obtained only by femininity or by [a] wistful, playful, derivative kind of decorativeness." Discussing the art writing of his day, Greenberg's use of disparaging gendered terms gives way to open ridicule: "The discussion of American

art, even in the most exalted circles, is a kind of travelogue patter—this is what fills the three or four art magazines that live an endowed existence in New York and whose copy is supplied by permanent college girls, male and female." "Present Prospects," pp. 167, 162.

7. After claiming that "Picasso, Braque, Mondrian, Miró, Kandinsky, Brancusi, even Klee, Matisse and Cézanne derive their chief inspiration from the medium they work in," Greenberg adds the following footnote: "I owe this formulation to a remark made by Hans Hofmann, the art teacher, in one of his lectures. From the point of view of this formulation, Surrealism in plastic art is a reactionary tendency which is attempting to restore 'outside' subject matter. The chief concern of a painter like Dali is to represent the processes and concepts of his consciousness, not the processes of his medium." It is no exaggeration to state that Hofmann's "remark" remained central to Greenberg's criticism through the 1960s, informing such later essays as the seminal "Modernist Painting" (1960). See "Avant-Garde and Kitsch," *Collected Essays*, vol. 1, p. 9.

8. Hans Hofmann, "Search for the Real," in *Search for the Real and Other Essays*, ed. Sara T. Weeks and Bartlett H. Hayes, Jr. (Cambridge, Mass. MIT Press, 1967), p. 47.

9. See Francis V. O'Connor, ed., *Art For the Millions* (Boston: New York Graphic Society, 1973), pp. 13ff.

10. John Dewey, *Art as Experience* (New York: Paragon Books, 1979), pp. 326–27.

11. See Serge Guilbaut, *How New York Stole the Idea of Modern Art*, trans. Arthur Goldhammer (Chicago: University of Chicago Press, 1983), pp. 55–59.

12. See James Sloan Allen, *The Romance of Commerce and Culture* (Chicago: University of Chicago Press, 1983). In 1946, Greenberg noted "the increasing practice on the part of commercial firms of having what in popular estimation are high-art artists illustrate their advertisements." "Review of the Whitney Annual," *Collected Essays*, p. 57.

13. On the development of the industrial-design program at the Carnegie Institute of Technology, see Arthur J. Pulos, *The American Design Adventure* (Cambridge, Mass.: MIT Press, 1988), p. 165. For Robert Lepper's paper commemorating the introduction of this program, see an untitled manuscript in Lepper materials, Carnegie Mellon University Archives.

14. Dean Keeble, quoted in Glen U. Cleeton, *The Story of Carnegie Tech: The Doherty Administration (1936–1950)*, vol. 2 (Pittsburgh: The Carnegie Press, 1965), pp. 136–137.

15. "*Gene Swenson*: Where did your ideas about art begin? *Roy Lichtenstein*: The ideas of Professor Hoyt Sherman on perception were my earliest important influence and still affect my ideas of visual unity." Gene Swenson, "What Is Pop Art? Answers from Eight Painters, Part I," *Art News* 62, no. 7 (November 1963); reprinted in *Roy Lichtenstein*, ed. John Coplans (New York: Praeger Publishers, 1972), p. 53.

16. See Robert Lepper, "Processes in Professor Lepper's Courses in Pictorial Design, August 1948," Lepper materials, Carnegie Mellon University Archives, pp. 1–6.

17. In a 1963 symposium about Pop organized by Peter Selz at the Museum of Modern Art, Hilton Kramer—never a fan—made the following statement: "Pop art does not tell us what it feels like to be living through the present moment of civilization; it is merely part of the evidence of that civilization. Its social effect is simply to *reconcile us to a world of commodities, banalities and vulgarities, which is to say, an effect indistinguishable from advertising art.*" (Emphasis added.) See Peter Selz, "Symposium on Pop Art," *Arts Magazine* 37, no. 7 (April 1963), pp. 38–39.

18. "The writer was pursued by the notion that underlying pictorial organization there was a key idea which had not yet been fully clarified, and that if this idea could be clarified, great

improvements in teaching art might be possible, and perhaps the relation of art to modern life might be more clearly apparent." See Hoyt L. Sherman, *Perceptualism: The Artist's Vision* (Columbus: Ohio State University Press, 1944), p. 1. "Could we then claim that psychology is particularly fitted for the task of integration? I think we can, for in psychology we are at the point where the three great provinces of our world intersect, the provinces which we call inanimate nature, life, and mind." See Kurt Koftka, *Principles of Gestalt Psychology* (New York: Harcourt, Brace, 1935), p. 10.

19. Sherman recommended the "flash drawing course" for "reading, athletics, architecture, engineering design, landscape architecture, floriculture, photography, interior decorating, window trimming, advertising, music, optometry, dentistry, newspaper and scientific reporting" and for waging war. He trained the perceptual and kinesthetic capacities of the Ohio State football team quarterback in 1948, claiming to have improved his performance. See Sherman, *Perceptualism*, pp. 69–75, and Sherman, *Drawing by Seeing* (New York: Hinds, Hayden and Eldridge, 1947), p. 51.

20. "I have leaned heavily, and naively probably, on John Dewey's *Art in Experience* [*sic*]. I've never forgotten it." Sherman, quoted in David Ecker and Stanley S. Medeja, *Pioneers in Perception: A Study of Aesthetic Perception: Conversations with Rudolf Arnheim, James L. Gibson, Nelson Goodman, Henry Schaefer-Simmern, and Hoyt Sherman* (St. Louis: Cemrel, 1979), p. 309.

21. The "flash lab" was in fact the second of two studios that were built in the shed adjacent to Hayes Hall. The first, altogether more provisional, dates from 1942. This description of Sherman's studio and his course derives from Sherman's *Drawing by Seeing*.

22. "I became acquainted with Gestalt theory and figure-ground about 1939 and knew that ground was a critical factor over the figure, aesthetically. The ground always influences the figure. That was Helmholtz's demonstration; and I used the other cues of Wertheimer. . . . " Sherman, quoted in Ecker and Medeja, *Pioneers in Perception*, pp. 259, 267.

23. Sherman, *Drawing by Seeing*, p. 3. The tachitoscope had been used to remarkably similar effect at Ohio State University since the mid-1930s in the long-term investigations of Samuel Renshaw, professor of psychology, into "the effects of practice on the development of superior methods to yield enhancement of performance, or to discover the means of making effective use of such methods in training people to see more accurately and more rapidly." Though Sherman admitted to no such influence, it is hard to say how much he relied on Renshaw's work to formulate his own ideas. Renshaw's study, which was published in 1945, includes statements closely parallel to Sherman's own. In relation to Sherman's comments quoted above, consider Renshaw's statement: "Seeing, to be effective, must be unitary, coherent, and fluent. Perceptual training by tachitoscopic methods enforces from the first this theoretically sound procedure." The fact that a patently instrumental study by a university psychologist should be indistinguishable from the methods of an art instructor underscores yet again the strange confluence of utility and aesthetics that informed the education of the artist on American university campuses during this period. See Samuel Renshaw, "The Visual Perception and Reproduction of Forms by Tachitoscopic Methods," *Journal of Psychology* 20 (October 1945), p. 218.

24. Michael Fried, "Art and Objecthood," in *Minimal Art: A Critical Anthology*, ed. Gregory Battock (New York: E. P. Dutton, 1968), p. 146.

25. Sherman, *Drawing by Seeing*, pp. 18–19.

26. Sherman claims that he and an unnamed colleague from the psychology department "sold" the idea of a flash-based "aircraft identification program" to the United States Navy early in the American involvement in World War II. See Ecker and Medeja, *Pioneers in Perception*, p. 251.

27. See Walter Benjamin, "On Some Motifs in Baudelaire," in *Illuminations*, ed. Hannah Arendt, trans. Harry Zohn (New York: Schocken Books, 1969), pp. 155–201.

28. "The inception of the use of electronic data-processing machines in the private sector of the American economy in 1954 finally opened up, for numerous if not all branches of production, the field of accelerated technological innovation and the hunt for technological surplus-profits which characterizes late capitalism. Incidentally, we can thus date the end of the reconstruction period after the Second World War and the start of the boom unleased by the third technological revolution from that year." Mandel, *Late Capitalism*, pp. 194–195.

29. Elaine de Kooning, "Franz Kline: Painter of His Own Life," *Art News* 61, no. 7 (November 1962), pp. 67–68. Reprinted from *Franz Kline* (Washington, D.C.: Gallery of Modern Art, 1962).

30. Rosenberg, "The American Action Painters," reprinted in *The Tradition of the New* (Chicago: University of Chicago Press, 1959), p. 32.

31. For an example of the increased receptivity of critics after Pop to the importance of mass-cultural interests among Abstract Expressionists, see Thomas B. Hess's text in the exhibition catalogue *Willem de Kooning* (New York: The Museum of Modern Art, 1968), especially pp. 76ff. There Hess notes the artist's complaint that nobody had ever noticed how funny the "Women" really were. Resorting to a traditional art-historical reflex, Hess then claims these and other paintings (*Attic*, 1949, *Gotham News*, 1955–56) as a "direct influence" on Pop artists. For an analysis of Kline's involvement with popular culture, see Albert Boime, "Franz Kline and the Figurative Tradition," in *Franz Kline: The Early Work as Signals* (Binghamton: SUNY Press, 1977). There Boime cites Elaine de Kooning's story of Kline's self-discovery through opaque projection, and he continues as follows (p. 17): "The process of magnification had a double meaning for Kline: it monumentalized his work and simultaneously legitimized it in his eyes through its analogy with the movies' primitive ancestor, the comic strip." In keeping with the image of the Abstract Expressionists as cultural descendants of Prometheus, Boime understands this to "foreshadow Lichtenstein's and the photorealists' more mechanical amplification of images."

32. See Marcia Tucker, "James Rosenquist," in *James Rosenquist* (New York: Whitney Museum of American Art, 1972), especially pp. 14–15.

33. Brian O'Doherty, "Doubtful but Definite Triumph of the Banal," *New York Times*, 27 October 1963, sec. 2, p. 21.

34. Erle Loran, "Cézanne and Lichtenstein: Problems of Transformation," *Artforum* 2, no. 3 (September 1963), pp. 34–35; "Pop Artists or Copycats?," *Art News* 62, no. 5 (September 1963), pp. 48–49, 61.

35. Be that as it may, Loran's book managed to unite Alfred Barr, Thomas Craven, and Clement Greenberg in their regard for what the last described as a "more essential" understanding of Cézanne's art than any other he had encountered in print. See Greenberg, "Cézanne's Composition by Earle [*sic*] Loran," *The Nation*, 29 December 1945, reprinted in *Collected Essays*, vol. 2, p. 47.

36. Loran, "Pop Artists or Copycats?," p. 49. Lichtenstein remembered that the Castelli Gallery was approached by the publishers of Loran's book. A new edition, printed in 1963, would have been in preparation at the time the controversy took place. Unpublished interview with the author, 27 June 1983.

37. Loran, "Cézanne and Lichtenstein," p. 53.

38. Ibid.

39. Swenson, "Interviews with Eight Painters," p. 53.

40. Max Kozloff, "Art," *The Nation*, 2 November 1963, p. 284.

41. Ibid., p. 285. On the concept of the historical avant-garde, and the "neo avant-garde" into which Pop may fit more comfortably, see Peter Bürger, *Theory of the Avant-Garde*, trans. Michael Shaw (Minneapolis: University of Minnesota Press, 1984), esp. pp. 57–58.

42. See David Deitcher, "Lichtenstein's Expressionist Takes," *Art in America* 71, no. 1 (January 1983), pp. 84–89.

43. Kozloff, "Art," p. 285.

44. Ibid.

45. Andy Warhol, quoted in Swenson, "What Is Pop Art?," reprinted in *Pop Art Redefined*, ed. John Russell and Suzi Gablik (London: Thames and Hudson, 1969), p. 117.

46. Roland Barthes, "That Old Thing, Art . . . ," in *The Responsibility of Forms*, trans. Richard Howard (New York: Hill and Wang, 1985), p. 205. The manifesto of the "true revolution in language" that Barthes refers to in this essay was Barthes's own "The Death of the Author" (1968). See Barthes, *Image-Music-Text*, ed. and trans. Stephen Heath (New York: Hill and Wang, 1977), pp. 142ff.

47. Benjamin, quoted in Benjamin H. D. Buchloh, "Allegorical Procedures: Appropriation and Montage in Contemporary Art," *Artforum* 21, no. 1 (September 1982), p. 46.

48. Ronald Barthes, "That Old Thing, Art . . . ," p. 198.

49. Donald Judd, "Roy Lichtenstein," *Arts Magazine* 36, no. 7 (April 1962), p. 52. Reprinted in the present volume.

50. Bruce Glaser, "Oldenburg, Lichtenstein, Warhol: A Discussion," *Artforum* 4, no. 6 (February 1966); reprinted in Coplans, *Roy Lichtenstein*, pp. 62–63.

51. Ibid.

52. Warhol's work is usually described as if it were the fulfillment of his frequently quoted observation that "everybody should be a machine." Yet there is a considerable difference between a Warhol image (or object) and the thing it represents, and that difference is aesthetic. The difference between Warhol's aesthetic (trans)formations and Lichtenstein's is that the latter's are consistent with a conventional modernist understanding of "fundamental structure." Warhol's art can be considered "anti-aesthetic" insofar as his repertory of expressive devices—his deliberately off-register silkscreen method, garish color, and employment of seriality in place of more traditional methods of composition—consists of distillations of the aesthetic procedures of advertising and other forms of commercial design.

Technology Envisioned: Lichtenstein's Monocularity

Michael Lobel

Sometime in the summer of 1961, soon after initiating a mode of painting that would come to be more widely known as Pop, Roy Lichtenstein executed a large canvas entitled *I Can See the Whole Room! . . . And There's Nobody In It!* In the painting an outstretched finger pushes aside the cover of a circular peephole, revealing the face of a male figure; a word balloon above displays the lines of text that make up the painting's title. Lichtenstein derived the format of the painting from a preexisting image: a panel from a Sunday installment of the *Steve Roper* newspaper comic strip that had shown a figure inspecting a locked room through a peephole. Although he rendered the composition primarily in black and white he added some notes of color, such as the field of monochrome yellow behind the figure. He applied additional color—the flesh tone in the figure's face and hand, and the blue of the pupil—in passages of regularized red and blue dots, respectively. Those dots, of course, make reference to the mechanically printed medium from which Lichtenstein had borrowed his imagery. It is not difficult to understand the appeal this particular image may have held for the artist. Removed from its narrative context and presented as an easel painting it reads as a visual pun on abstraction, for if one imagines that peephole swinging closed the painting is read projectively as a monochrome canvas. In this way Lichtenstein offers a scene in which abstraction has been quite literally punctured by both figuration and language: a fitting image for an artist who had recently discarded an abstract mode for a figurative one.

Already I have begun to identify the general set of issues that has defined the critical debate about Lichtenstein's work: a formal vocabulary that mimics the look of mechanical printing; the use of imagery appropriated from printed sources such as advertisements and comic strips; the tension between figurative reference and the impulse to abstraction.

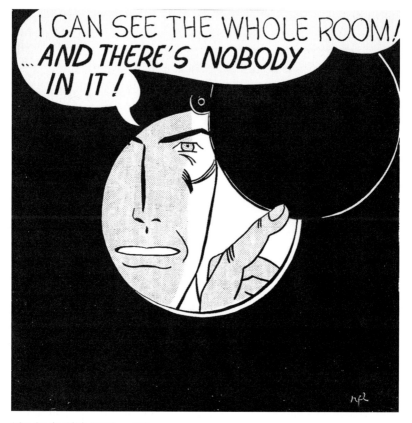

*I Can See the Whole Room! . . . And
There's Nobody In It!*, 1961. Oil and
graphite on canvas, 48 ⅜ × 48 inches.
Private collection. © Estate of Roy
Lichtenstein.

Those involved in that critical dialogue have most often been concerned
with determining if these strategies, taken together, constitute a critique
of consumer culture, or whether such gestures, relegated to the realm of
fine art, are too circumscribed to fully confront the powerful effects of
the mass media.[1] It is undeniable that these questions lie at the heart of
Lichtenstein's practice, and Pop art in general. Yet such a concentrated
focus on the ostensibly strategic nature of Lichtenstein's Pop art *vis-à-vis*
mass culture has left unexamined other aspects of the artist's work that
might provide further insight into the critical nature of his project. For
example, it has been widely overlooked that Lichtenstein's work from

the early 1960s consistently confronts issues of vision and visuality. This is evident from even the most cursory inspection of a work like *I Can See the Whole Room!*; the act of looking is foregrounded not only in the image itself, with that figure staring out at us from the very center of the painting, but also in the title (displayed in the word balloon above) with its reference to seeing. In this essay I will analyze the thematic of vision in Lichtenstein's work by calling attention to the artist's confrontation, not merely with the act of looking, but more specifically with the interrelation between machines and visual perception. When analyzed closely and in a sustained way, Lichtenstein's practice from the early 1960s reveals a veritably theoretical investigation of the conflicted relation between vision and technology. In order to better understand the basis for such concerns in the artist's work, we must first turn to accounts of his immersion in a unique program of art instruction through training in vision.

Monocularity: Body as Machine

According to Lichtenstein his first prolonged, intensive training in art came when he began his undergraduate studies at Ohio State University and came under the tutelage of Professor Hoyt Sherman.[2] By all accounts Sherman seems to have cut a striking figure of authority, one who was engaged in developing a sweeping program for testing and training visual acuity. What his project lacked in theoretical rigor it made up for in sheer spectacle; in addition to various published texts Sherman instituted his program in two veritable laboratories for testing and training visual perception. His "Visual Demonstration Center" was a room-size collection of fifteen models and displays that demonstrated various principles of visual perception, particularly optical illusions.[3] Its format had been appropriated from a similar set of demonstrations built by Adelbert Ames Jr. at Princeton University and at the Hanover Eye Institute in New Hampshire. One representative display was the so-called Distorted Room, which was built in forced perspective so that the room appeared square even though its back wall stood at a marked angle. An illustration from Sherman's handbook for the Visual Demonstration Center shows the effect of that illusion when two people were posed behind the windows on that angled wall; the room and back wall looked square, yet one of the figures appeared inexplicably smaller than the other.

In other words, the display was meant to show how past experience (in this case, that rooms are square) infringed on the viewer's ability to

Illustration from Hoyt Sherman, *The
Visual Demonstration Center,* 1951.
Photo: Ohio State University Archives.

perceive the true nature of this particular room. While its name would
seem to indicate that the Visual Demonstration Center was a series of
mechanisms for demonstrating essential properties of visual perception,
it would be more accurate to describe it as a series of tests that demon-
strated the *failures* or deficiencies of vision. Sherman intended to show the
viewer how various components of the perceptual process (such as bin-
ocular vision or the individual's prior knowledge of objects in the world)
infringed on the possibility of a "pure"—that is to say, unmediated—
perception of the visual field.

 In contrast, the dream of access to an idealized mode of aesthetic
vision was embodied in another segment of Sherman's grand project, in
which he utilized a device called the tachitoscope to create a unique pro-
gram of instruction in drawing. That program took place in a specially
constructed seventy-foot-long studio (converted from a former artillery
shed on OSU's campus) from which all exterior light sources had been

sealed off. Inside, students sat in front of drawing tables on four terraces facing a series of projection screens:

> Above and slightly behind the terraced section of the space was a "bridge" containing a massive slide projector. Sherman had fitted this device with a "tachitoscope," a mechanical shutter, first devised by late-nineteenth-century psychologists, that made it possible for him to control the duration of a slide projection to within a fraction of a second.... After ten minutes of relaxation and preparation [at the beginning of class] had passed, Sherman would show the first of the twenty slides he would use in each class; or rather he would "flash" it, since it appeared on screen for a tenth of a second or less. Cast again in darkness for the remainder of a minute, the students would draw the configuration they had barely glimpsed, depending mainly on the afterimage.[4]

The course continued on over the semester, with the duration of the flash eventually lengthening, and the subjects of study moving from Sherman's own two-dimensional abstract configurations (projected onto a screen) to complex three-dimensional still-life groupings. According to Sherman's theoretical program, the speed of the flash prevented the student from exercising any power of composition or intellection; this was intended to help the student see the image with "perceptual unity," that is, as pure form (a concept Sherman derived largely from Gestalt theory). Moreover, he called this process "drawing by seeing" in order to emphasize the automatic nature of the act: the drawing would be a kinaesthetic trace of the afterimage that had been left—in a flash—on the student's retina.[5]

It is clear that Sherman's systematic approach to artistic instruction had a significant impact on Roy Lichtenstein. Although the artist never took a full course of training in the flash lab, he did teach in the lab as an instructor at Ohio State between 1946 and 1949. Significantly, after leaving OSU Lichtenstein attempted to reconstruct the flash lab on two separate occasions: during a teaching stint at the State University of New York at Oswego, and as an assistant professor of art at Douglass College, the women's college of Rutgers. Bruce Breland, a colleague of Lichtenstein's at Oswego, has recounted: "Roy and I taught the freshman design course. Roy did the two-dimensional part which he called painting and drawing. I did the three-dimensional part which I called sculpture. Roy immediately installed the Hoyt Sherman flashroom technique."[6]

Likewise, Allan Kaprow recalled that "Roy continued Sherman's work in his courses at Rutgers. He built a small strobe projector for that purpose."[7] In an interview with the author, Lichtenstein confirmed Kaprow's recollections. When asked "Had you constructed [a flash lab set-up] yourself?," Lichtenstein responded:

> Yes, but I mean it was really primitive, because in the flash room they really got rid of light altogether. It's almost impossible to get rid of light in a room by pulling the shades down or something. So, a lot of it was . . . I would flash the thing, but of course you can also see what you're doing, which you couldn't do in the flash room. And I would flash set-ups of people and tables and things like that, of that nature. But even though it didn't have the same effect, it was something anyway, and I tried to explain that if you . . . actually, if you show a series of flashes you go kind of blind to the stuff in between because the flash changes the aperture of your retina . . . I mean your eye. So it's a little effective, you know, but I wish that I could build one—they're quite hard to do, because it's rare that you can really cut all the light out.[8]

It is telling that Lichtenstein's aside in that last sentence—"I wish that I could build one"—was formulated in the present tense, despite the span of almost fifty years that had elapsed between his undergraduate training and the time of the interview.

Sherman's influence on Lichtenstein has been cited repeatedly in treatments of the artist's work, in part because of Lichtenstein's own assertion (when interviewed in 1963 by Gene Swenson) that "the ideas of Professor Hoyt Sherman [at Ohio State University] on perception were my earliest important influence and still affect my ideas of visual unity."[9] Yet the literature on the artist has generally taken this statement at face value, as if Sherman's effect on his pupil was somehow direct and unmediated. If Lichtenstein's work was "influenced" by his training, that influence was by no means uncomplicated, for it was embedded in a profoundly ambivalent project. David Deitcher has pointed to the tension in Sherman's program:

> At the same time that Sherman followed the transcendentalist impulse familiar from the discourse of Abstract Expressionist and other modernist art, he was also determined to supply his students with the means to function more efficiently and with a greater sense

of "integration." In short, his course acknowledged the productive imperative that dominated American life more than ever at the dawn of the late-capitalist consumer culture.[10]

Although I might differ with Deitcher's historical conclusions, his account does make clear the aporia at the heart of Sherman's project. While Sherman's goal was to impart the means to an aesthetic way of seeing, the idealist premise of his project was undercut by—or at least in profound tension with—its mechanistic means.

It is Roy Lichtenstein himself who provides us with further insight into this particular problematic, one located in the flash lab's imbrication of body and machine. Reminiscing in 1987 about his training at Ohio State, Lichtenstein recalled that in the flash lab

> you'd get a very strong afterimage, a total impression, and then you'd draw it in the dark—the point being that you'd have to sense where the parts were in relation to the whole. The images became progressively more complex, and eventually you would go out and try to work the same way elsewhere—would try to bring the same kind of sensing to your drawing without the mechanical aid of the flash room.[11]

There was a tension in Sherman's project between its humanistic rhetoric about the individual's capacities for aesthetic vision, and its attempt to ground those capacities in mechanical processes. Sherman had developed his drawing-by-seeing program in order to provide students with access to the perceptual powers ostensibly possessed by "great masters" like Cézanne. Yet the means to that end was for the student to become—through the shock of a flash of light—a machine that recorded the visual field without the intrusion of intellection. As Lichtenstein points out in the above quote, the flash lab was intended to increase the individual's visual acuity. It was designed to help the student repress the prior knowledge that prods us to differentiate elements in the perceptual field and read them as things, objects, or bodies in space; in other words, it was intended to transform the subject into a machine that might record nothing but pure visual form. There is of course a name for a device like this, one that records the play of forms in the visual field "perfectly," without the intrusion of a human subjectivity that might muddy the visual record: the camera.

For all its rhetoric of imparting "aesthetic vision," Sherman's instruc-
tional program in the flash lab more or less placed the student in the
position of the photographic apparatus. Students were placed in a com-
pletely darkened chamber (*camera obscura*); exposed to a flash of light; led
to believe that an afterimage had been left on their retinas by that flash (as
if on a photographic plate); and expected to draw that image automati-
cally (in Sherman's own words, "kinaesthetically") on the sheets of paper
in front of them. The flash lab even incorporated elements from the pho-
tographic developing process, as described in a passage in Sherman's book
Drawing by Seeing devoted to describing the lab's equipment:

> For illumination during the dark-adaptation period, a red light is
> set in the ceiling over the drawing stands. This light is the regular
> darkroom lamp used in photography. It proves to be a convenience
> when students drop their chalk, run out of paper, or otherwise need
> to locate an object during the blackout period.[12]

Did Lichtenstein recognize the extent to which Sherman's program
pushed the student's body toward the condition of the photographic
apparatus? An answer to that question may be found, in part, by looking
back to *I Can See the Whole Room!* Note that the work presents a scenario
in which the viewing subject is located in a darkened room with a hole in
one wall, in other words a camera obscura.[13] Yet on reflection this descrip-
tion is not entirely accurate. For one, the camera obscura generally uses a
smaller hole—even at times a pinhole—to produce its image, quite unlike
the large opening depicted in the painting. More significantly, that open-
ing has been outfitted with a circular cover that swivels back and forth;
another name for that device would be a shutter. Lichtenstein's paint-
ing thus constructs for us a schematic view of a primitive photographic
mechanism.[14] *I Can See the Whole Room!*, then, provided the artist with a
vehicle through which to confront certain problems raised by Sherman's
program of training in modernist aesthetic vision. Sherman certainly
recognized that the drawings of each student would have a personal or
individual style (in *Drawing by Seeing* he expressed his belief that these
differences should in fact be encouraged).[15] Nevertheless, Lichtenstein
seems to have responded most strongly to the extreme technologization
of vision presented in his teacher's project. This instrumentalization of
the body suggested not that individuality was being prized, but rather that
in the shock of the flash the student's subjectivity was effectively erased

as he or she became a machine for recording visual stimuli. Perhaps this explains why, in addition to placing the viewer in the position of the photographic apparatus, Lichtenstein's painting also constructs a textual narrative in which the viewer's corporeality has been effaced (as implied by the figure's observation that "*THERE'S NOBODY IN IT!*").[16]

In *I Can See the Whole Room!* the relation between machine and embodied vision is condensed into one particularly charged element: the motif of monocularity.[17] For one, monocular vision stands for the photographic apparatus itself: this much is clear in the artist's depiction of the central peephole, which pierces the darkened chamber of that primitive photographic mechanism. The single exposed eye of the figure peering through that hole rhymes with the monocular format of the camera lens. This was not the first time a monocular presentation of the human body had been used to imply a rhyming (or competition) with the lens of the camera; take, for example, Paul Strand's 1916 photograph *Blind Woman, New York*. Strand's blind woman stands as an ironic commentary on photography, in that she embodies the same monocular mode as the camera that snaps her picture (one of her eyes is open, the other closed shut). Her very sightlessness (and the sign around her neck that reads "BLIND") comments on the essential blindness of the photographic apparatus itself.[18] An earlier example provides an even more useful model; in an essay on Jean-Martin Charcot's late-nineteenth-century photographs of hysterics, Ulrich Baer has called our attention to an image of Hortense J., one of Charcot's patients. As Baer points out, "Hortense's symptom imitates the photographic apparatus: her light sensitivity, the squinted eye, catalepsy—the hysteric's face mimics the camera and the cameraman."[19] Baer's essay on Charcot is of use to us in detailing a precedent for Sherman's scientistic attempt at pushing the human body toward the condition of photography. Baer outlines what he calls a "poetics of the flash" through an analysis of Charcot's 1880s photographs of hysterics at the Salpêtrière hospital in Paris. Charcot had attempted to use photography, in conjunction with the mechanism of the flash, as an aid to the diagnosis of hysteria. Placed in a darkened room, his patients were exposed to a flash of light that froze them in a pose (to be later categorized as "hysterical") that could be photographed by one of his assistants. Although there are marked differences (historical, cultural, theoretical) between Charcot's and Sherman's projects, the two are linked inasmuch as both employed the flash to forge a conjunction between the camera and the body. On Charcot's cataleptic patients, Baer writes:

Catalepsy retains by way of the body what photography retains by way of the camera: it freeze-frames and *retains* the body in an isolated position that can be viewed and theorized outside of a sequence of motion. . . . the "dark chamber" into which [Charcot"s patients] were led, and where their bodies froze into immobile statues, may thus be said to allegorize the photographic process itself. The technical process suddenly becomes visible as a human body that has been frozen by a flash in a *cabinet noir* that translates, as if by accident, into the "chambre obscure" of photography—the *camera obscura*.[20]

If, as Baer argues, the frozen positions of Charcot's patients mimicked the photographic process, Sherman's students were, in a sense, prodded to approach the condition of photography even more closely. The flash was meant to invoke not paralysis but rather motion: an automatic movement through which their hands were to trace the afterimages ostensibly imprinted on their perceptual systems.

This automatism—in which the movement of the hand is taken as a direct response to the reception of a visual stimulus in the eye—is expressed in Sherman's project on a number of levels. While the use of the flash was intended to heighten the intensity of the image's reception, it also prevented the students from seeing their drawings while working on them. Sherman explained:

As a matter of emphasis, one does not try to *draw* with unity; rather one tries to *see* with unity and to let the image thus seen become the dominating force in organizing the drawing. If the student consciously works at getting unity in his drawing, the effect will be stilted. . . . The discipline of creative work in the visual arts, in other words, consists more in ruling out extraneous stimulations to muscular action than in aggressively forcing the charcoal or paintbrush here and there on the paper. The body "knows how" to draw, so to speak, if it is but permitted to draw in accordance with the full dictates of the creating image. This means taking the emphasis off the manual manipulations so that the act of drawing can be instrumental rather than primary.[21]

This passage points out the extent to which Sherman's rhetoric tends to repress the presence of any cognition in the act of drawing, and concurrently emphasizes a strange kind of automatism (as embodied in his reference to the act of drawing as "instrumental"). In the initial stages of

instruction the student is prohibited from seeing the drawing in process and thus prevented from making any visual corrections; rather, he or she is expected to depend on a "kinaesthetic" (in this context perhaps a more accurate term would be "mechanical") response in rendering the image. This is precisely why Sherman referred to it as the "seeing-and-drawing" act, in that the work of the eye and that of the hand are linked by one unified action: an automatic one like that of a machine. Sherman's project, then, embeds the modernist practice of automatism (such as that pioneered by the Surrealists) in a thoroughly mechanical paradigm.[22] Hence we might suggest that for Lichtenstein it was no longer tenable to link such automatism to the unconscious or the primitive (as had been done so readily by the preceding generation of Abstract Expressionist painters), since for him it had become so fully aligned with the machine. Sherman also makes mention, in the above passage, of the body reacting automatically if "permitted to draw in accordance with the full dictates of the creating image." This idea of the image or motif determining its reception by the body was another major component of his theoretical project. He asserted that the capacity to draw aesthetically would be achieved by effectively repressing past experience and returning the individual to the state of what John Ruskin called the "innocent eye."[23] In his text on Cézanne, Sherman repeatedly argues that the artist's work was "non-volitional," that Cézanne had to forget his experience with the perceptual world and return to a state of pure perception in which he could recognize the order already imposed on vision: "Paradoxically, Cézanne's struggle was essentially, therefore, to 'unlearn' the customary appearance of objects in order to achieve that which was fundamental to vision."[24] This concept was not new to modernist discourse, yet by directly inserting the machine into the equation Sherman's program pushed the technological instrumentalization of vision to an extreme.

If monocularity seems to have been linked in Lichtenstein's work to the structure of the photographic camera with its single lens, it would have had even further meaning for him in the context of his teacher's project. For Sherman had utilized the adjective "monocular" to refer to that very mode of vision he had located in the work of Cézanne, and which he attempted to impart to his students in the flash lab. Cézanne's importance lay in his consistent use of compositions centered concentrically around a single focal point, which Sherman argued was the key component of aesthetic vision. Cézanne's work thus provided the foundation for his project; he used the term "monocular" in part because he believed that

seeing with "perceptual unity" required that the individual relate all points or elements in a field to a single focal point:

> Teaching students to draw with satisfactory pictorial organization is to a major degree a process of teaching them to see with perceptual unity—that is, to see all points in a motif with relation to a focal point. The artist needs to be able to see the whole field at which he is looking and to see it in such a way as to place the parts in the whole through referral of the parts to a focal point.[25]

In addition, he maintained the assertion—as demonstrated by certain models in his Visual Demonstration Center—that binocular stereopsis was irrelevant to aesthetic perception. He believed that binocular vision impinged on the subject's perception of pure form—in this case, that of tonal or color contrast—because "in binocular viewing, contrast is instrumental to distance, whereas in monocular viewing, contrast tends to be an end in itself."[26]

It is in this dialectic between monocular and binocular modes that we may begin to locate the tension (even pathos) in Sherman's theoretical project, which is then confronted in Lichtenstein's work. The human body is seen as fundamentally deficient or flawed; the very corporeality of vision must be overcome—or perhaps more accurately, repressed—in order to reach the transcendent ideal of aesthetic vision.[27] As Lichtenstein said years later, Sherman's project "was a mixture of science and aesthetics, and it became the center of what I was interested in."[28] Yet the mixture of science and aesthetics resulted in this case in an instrumentalization of the body, in which hand and eye were understood to be connected automatically as in a machine. I do not mean to suggest that Lichtenstein's working process was photographic, or that he thought—to any extent—that his project involved a kind of mute transcription of preexisting imagery. Nevertheless, he made consistent reference in interviews to his ability to "unify" an image, a skill he had learned through Sherman's program. In short, if he maintained the conviction that the artist's aesthetic faculty interposed itself somewhere between eye and hand, his training would only have lent the gnawing suspicion that such a mysterious ability might be attributed as much to a mechanical source as to any creative, human capacity.

Considering the polysemic charge monocularity held for Lichtenstein (it represented an aesthetic ideal that could be achieved only through the

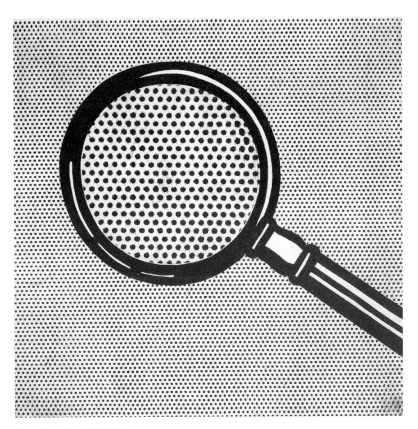

Magnifying Glass, 1963. Oil on canvas.
16 × 16 inches. Permanent loan to the
Kunstmuseum Liechtenstein, Vaduz.
© Estate of Roy Lichtenstein.

repression of vision's corporeality), it comes as no surprise that he would return to the monocular again and again in his work. For one, there is the case of the 1963 canvas *Magnifying Glass*, which provides the viewer the direct experience of monocular viewing. Note that the perceptual illusion proffered by the image—namely, that the large dots within the circular boundary of the magnifying glass are actual enlargements of the smaller dots in the background—is of the same type utilized by Sherman in his Visual Demonstration Center. *I Can See the Whole Room!* is, further, just one of several works of the early 1960s in which monocularity is represented by a depicted figure. That list would also include *Popeye*, one of the artist's first Pop canvases (see p. 60). Popeye is a character so well

known in American popular culture that it is easy for us to overlook one of his essential features: he is a *one-eyed* sailor. Yet his significance is not limited to his inherent monocularity; Michael Wassenaar has pointed out the extent to which the figure of Popeye (beginning particularly with the Fleischer Studio animated cartoons of the 1930s) has been linked to metaphors of engineering and the machine.[29] In this way Lichtenstein's *Popeye* can be read as an imaging of the relation between body and machine; according to Wassenaar's analysis, that open, empty can at lower left is a sign that Popeye has ingested his trademark strength-giving spinach, thus marking "a moment of increased efficiency of the organism. It is a dynamic change in that the level of energy within the human mechanism is maintained, if not increased, as it is put to work, often times by punching his nemesis, Bluto, repeatedly around the room."[30]

In one of his next canvases Lichtenstein turned to Popeye's hapless sidekick Wimpy, depicting him with a dark, hatch-marked circle—comic-book shorthand for a blackened eye—around his left eye. Taken together, *Wimpy (Tweet)* and *Popeye* demonstrate Lichtenstein's conflicted approach to the motif of monocularity. In both of these paintings, monocular vision is only referenced, not directly imaged. In the comics, Popeye is conventionally represented with one eye open and the other closed—usually denoted by a single dot (open) contrasted with a short horizontal line or dash (closed)—yet Lichtenstein depicts him with both eyes shut. Likewise, the blacked-out left eye of the title character in *Wimpy (Tweet)* suggests the monocular without a direct representation of that state. It's as if, in these paintings as in *I Can See the Whole Room!*, monocularity represented something so significant—yet so charged—to the artist that he would only allude to it rather than represent it directly. The same is true of one of Lichtenstein's most striking war-comic images, *Torpedo . . . LOS!* (1963), in which a submarine captain peers through a periscope, his exposed eye serving as the veritable focal point of the painting. Lichtenstein altered the image in a subtle way, depicting that exposed eye as open, rather than closed as in the comic book source panel. That panel had shown a German submarine commander peering with only one eye (his left) through a periscope viewer; the figure's direct embodiment of monocularity would ultimately be repressed in Lichtenstein's painting. That is to say that here, as in *I Can See the Whole Room!*, one side of the figure's face has been screened off from view. It is as if the artist introduced an undecidability into his depiction of vision, leaving the status of that hidden eye utterly in question. However, in the process he added a curious detail. Beneath the

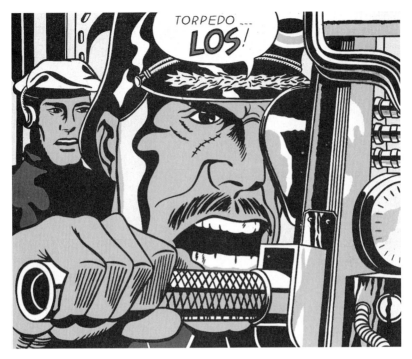

Torpedo . . . LOS!, 1963. Oil and
Magna on canvas, 68 × 80 inches.
Charles Simonyi Collection. © Estate of
Roy Lichtenstein.

foreground figure's exposed eye he added an arcing line crossed by several
short strokes, illustrational shorthand for a scar. Lichtenstein seems to have
derived that scar from one that appears on the figure's face in other panels
of the story, although he shifted the scar from the bridge of the nose to a
spot directly below the figure's now-opened right eye. That scar functions
as a veritable red flag, one that calls attention to the site of a significant
transformation he had effected on the image. I use the term "red flag"
intentionally, as it conjures an image invoked by Laura Mulvey in an essay
on fetishism. Mulvey notes that while the fetish is ostensibly a token of
disavowal, it operates simultaneously (and somewhat paradoxically) as a
red flag that calls attention to the site of pain and loss.[31] I am not offering
here a strictly psychoanalytic reading of Lichtenstein's work; rather, I am
suggesting that, like the fetish, the motif of monocularity was a means to
suture an ultimately irreconcilable structure of loss. And one that was
inextricably connected to the issue of sexual difference. For it is not just

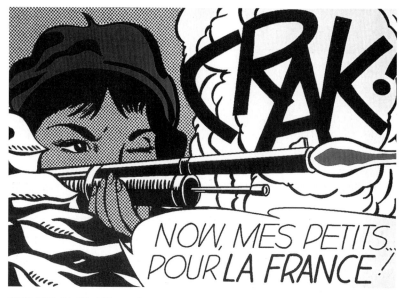

CRAK!, 1963–64. Offset lithograph on
paper, 19¼ × 27⅝ inches. © Estate of
Roy Lichtenstein.

that in these paintings Lichtenstein was thinking through the significance
of monocularity as an isolated motif; as noted earlier, his work proposes a
dialectical tension between monocular and binocular modes of vision, a
tension that operates on the level of gender as well.

In opposition to all those images that had merely pointed toward
monocularity, in this period Lichtenstein chose to depict one figure
that fully embodied the monocular. In 1963, to announce his second
one-person show at the Leo Castelli Gallery in New York, he executed
a screen-printed poster image (entitled *CRAK!*) that depicts a beret-clad
young woman, her eyes revealed above the barrel of a rifle that fires at
an unseen target. The previously unidentified source panel for the work
came from the April–May 1962 issue of the comic book *Star Spangled War
Stories*. Lichtenstein changed the image as was his wont by that time: he
replaced the earthen mound to the left of the figure with what looks like
a pile of sandbags; enlarged and recomposed the letters in that onomato-
poetic "CRAK!"; and cropped out the foreground and rearground, thus
isolating the figure. For our current analysis, though, the most significant
details in the image are those two eyes above the rifle barrel: one is open,
one closed. If it was only with a female figure that Lichtenstein would

directly represent an embodiment of monocular vision, then *CRAK!* points to the extent to which, in the signifying economy of his work at this time, the monocular had become a token of castration, of a kind of corporeal loss.[32] And not merely a corporeal loss but a loss to the imagined plenitude of the creative subject, a giving of oneself (and one's subjectivity) over to the automatism of the machine.

This linking of the monocular and the feminine in *CRAK!* may begin to explain a related set of images that appeared years later in Lichtenstein's oeuvre. Around 1977 the artist began to experiment with Surrealist imagery, borrowing mainly, as Diane Waldman has pointed out, from the work of René Magritte, Salvador Dalí, and Max Ernst.[33] Although Lichtenstein clearly appropriated certain stylistic conceits from those artists—the abrupt juxtaposition of incongruous objects and elements, the depiction of a veritable dream-landscape—many of his paintings contain a recurrent motif: the monocular female figure. Whether in *Girl with Tear I* (1977), in *Stepping Out* (1978), and even as late as 1992 in *Interior with Swimming Pool Painting*, Lichtenstein consistently imaged the monocular as feminine.[34]

Monocularity: Body and Machine

We have already seen how *I Can See the Whole Room!* (along with various other works from this period) stands for the possibility—impelled by Lichtenstein's immersion in Hoyt Sherman's theoretical program—of subjectivity being threatened through the experience of the human body approaching the automatism of the machine. Yet it also suggests another, parallel reading; if the painting imagines the viewer as erased by (or merged with) the photographic apparatus, it also depicts a figure interacting with a machine, inasmuch as the male figure peers out at the viewer through a primitive shutter mechanism. This is true as well of *Torpedo . . . LOS!* and *CRAK!*: in these paintings vision is directed through some sort of device that forces it into a monocular format.

Lichtenstein became known to the wider public in the early 1960s for three general categories of subject matter: consumer objects drawn from advertising sources, images from romance comics, and images culled from the war comics of the period.[35] The last group contains some of the artist's best-known paintings, including *Blam!* (1962), *Okay, Hot-Shot!* (1963), and *Whaam!* (1963). All three depict intense moments of aerial warfare, and show how Lichtenstein manipulated his source materials (especially details like explosions) to render highly abstracted shapes in

his canvases, another instance of his alteration of his sources to achieve the greatest formal effect in his work. While these images have been discussed at length in treatments of the artist's work, their significance to our current discussion relates to their depiction of interactions between body and machine. For instance, Diane Waldman has suggested that in *Okay, Hot-Shot!* Lichtenstein "updated the headgear of the pilot by substituting an astronaut's helmet for a World War II fighter pilot's helmet at a time when space-flight programs were under way in the U.S. and the U.S.S.R."[36] Waldman is, I believe, incorrect—the element she reads as an astronaut's helmet was meant to depict the canopy of a fighter plane—yet her misreading is understandable due to the way Lichtenstein compacted the pilot's physical form into the machine around it, so that the white surface just visible in the lower right seems more like an astronaut's fitted spacesuit than the metal skin of an airplane.

We have only to look to several other war-comic works to demonstrate how Lichtenstein's work in this period consistently returned to the interaction between machine and embodied vision. If *Okay Hot-Shot!* contains the figure of a pilot encased within the structure of his fighter plane, both the 1962 drawing *Jet Pilot* and the 1962 painting *Bratatat!* depict a seemingly half-human, half-mechanical figure: a fighter pilot inside the close confines of a cockpit, his eyes the only visible features of a body otherwise hidden by the helmet over his head and the oxygen mask covering his nose and mouth. A 1962 canvas entitled *Brattata* (not to be confused with the aforementioned *Bratatat!*) depicts a similar scene, a close-up view of the profile of a fighter pilot engaged in aerial combat, although in this work the unbuckled mask does reveal the lower portion of the pilot's face. And while this imaging of an almost "cyborgian" linkage between body and machine has significance in itself, the triangulation between body, vision, and machine is especially evidenced by the presence of a particular device in each of these images. Like *Torpedo . . . LOS!* and *CRAK!*, each of these works contains the image of a mechanical aid to vision. A reexamination of *CRAK!* highlights a relevant detail: a comparison of Lichtenstein's image with its source indicates that the artist took care to add a small sighting element at the end of the gun barrel. If he added a rather rudimentary aiming mechanism to that image, the aforementioned fighter-pilot works depict a more sophisticated device used for much the same purpose: a type of gun sight developed during World War II to help fighter pilots achieve better firing accuracy. A variation on this type of gun sight appears in each of these images: in the lower right of *Bratatat!*, and in the cockpit's lower right corner in *Jet Pilot*.

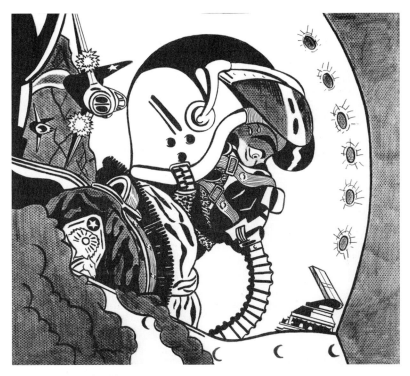

Jet Pilot, 1962. Pencil and frottage on paper, 15 × 17 inches. Private Collection. © Estate of Roy Lichtenstein.

A major problem in aerial gunnery involves the difficulty in accounting for how the combination of various factors—including range, aircraft speed, and angle of deflection—will affect the trajectory of the plane's gunfire. Additionally, the gun sight must be placed in the cockpit so as to minimize its interference with the pilot's line of vision. A certain type of sight developed during World War II—and depicted in the works by Lichtenstein cited above—provided solutions to those problems. Both Britain and the United States (among other nations) developed technology whereby the pilot or gunner could adjust an aiming mechanism according to a series of variables (speed, size of enemy aircraft, and so on) which would then be corrected for in the gun sight lens itself. It seems that one of the most common forms of these computing sights, especially for fighter pilots, was the reflector sight, in large part because it minimized intrusion into the pilot's visual field. The reflector gun sight is comprised of a small glass panel tilted down at about a 45-degree angle

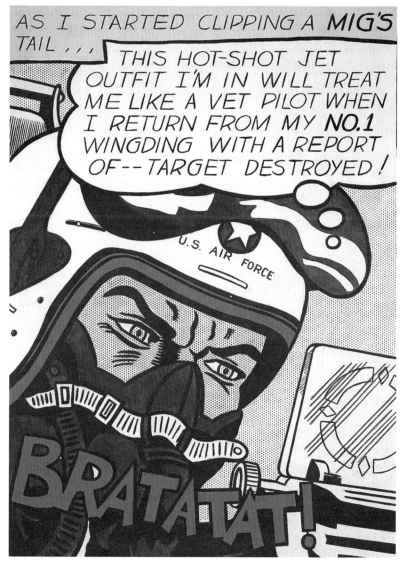

Bratatat!, 1963. Magna on
canvas, 46 × 34 inches. Charles
Simonyi Collection. © Estate of Roy
Lichtenstein.

that is fixed above the other cockpit instrumentation directly in front of the pilot's field of vision. An adjustable lamp and lens assembly inside the gun sight projects the image of a reticle or aiming schema—composed of some combination of circles, dots, or lines—onto the glass panel above. It is through this projected image of the reticle that the pilot targets the enemy aircraft.[37]

The works by Lichtenstein cited above image those very reticular schemata on the glass panels of their depicted gun sights. In *Jet Pilot* two thin horizontal lines cross a longer vertical one, while in *Bratatat!* a set of diamonds and semicircular bars mark off the aiming ring. A comparison of the artist's works and their source images seems to indicate that Lichtenstein made alterations that gave increased visual attention to these devices. For instance, in *Whaam!* (1963) he took care to delineate—in the cockpit close to the pilot's profile—a raised rectangular silhouette that signifies the interruption of the control panel's upper edge by a gun sight

Military aircraft cockpit interior with reflector gunsight at center. Photo: National Air and Space Museum (NASM WF-90848), Smithsonian Institution.

like the ones described here (in the painting's source that interruption is indicated barely, if at all). His adjustments to the image in *Jet Pilot*—in addition to his ninety-degree reorientation of the composition—direct visual attention to the depicted gun sight in an even more forceful way. Although he tended to simplify his images in the process of transcription, the gun sight in *Jet Pilot* is more carefully delineated than that in the source (a panel on the cover of *All American Men of War* no. 89, January–February 1962). His redrawing also allows more of it to show above the lower framing edge of the cockpit. In the comic book panel the line of bullet holes in the cockpit canopy was directed toward the pilot's broken air hose, providing a narrative intensity. A bullet had clipped the hose: would the pilot survive without his oxygen supply? Lichtenstein's editing out of this detail provides further insight into his approach to the comic book narratives he used as sources for his imagery. For his removal of this detail indicates that he may have wanted to suggest some, but not too much, narrative: while *Jet Pilot*—like so many of his other war paintings—depicts a figure engaged in a moment of intense affect, the broken air hose seems a detail that might have required too much narrative closure. Lichtenstein not only depicted that air hose as unbroken, but also redirected the line of bullet holes around the arc of the plane's canopy. That line of holes now points directly toward the reflector gun sight that seems almost to face off against the wide-eyed pilot.

That facing-off is key to my discussion because Lichtenstein's repeated treatment of this motif, and the visual attention his images draw to these gun sights, brings us back to the issue of monocularity. In the context of the analysis developed so far, a work like *Bratatat!* can be viewed as an image of the body's binocular vision played off against a seemingly monocular machine. And not just any machine: that very type of computing reflector sight was a machine used to correct the shortcomings of human perception. As an early account reported, "the gun sight automatically computes factors which previously the pilot had to estimate, such as the time lag between the bullets leaving the attacking plane and reaching their fleeting quarry, the effects of gravity and air density on the bullet, relative motion of the target and other factors."[38] In short, it was a machine that served as a corrective to the pilot's inability to effectively sight his target when faced with the speed and intensity of modern aerial warfare. According to Allan Kaprow it was that very problem of adapting vision to aerial combat that provided the impetus for Sherman's development of the flash lab:

Sherman had been instrumental in the military effort during World War II because of his experiments with perception. He found that most of us tend to see details of situations rather than overall configurations. This proved a rather serious problem when it came to aerial gunnery because gunners couldn't perceive modern enemy aircraft in motion. They moved too fast. Then men had been trained to identify insignia, tail and wing shapes, etc., in still pictures. Sherman's program proved effective.[39]

In this way Sherman's program was engineered toward solving the same problem as the computing gun sight: to augment the individual's visual perception by mechanical means. The machine is understood here as testing or training the subject's responses to the increased visual stimuli of modern life. And since Kaprow never had direct contact with Sherman or his teachings, he must have learned of the origins of Sherman's project from Lichtenstein himself. In fact, Kaprow's account provides insight into comments made by Lichtenstein when asked by the author about his first experience with the flash lab:

> Well, Sherman was developing it before I went to the army. In fact the Renshaw Recognition System, which had to do with the Navy, sort of happened through Hoyt [Sherman], who I guess was in the hospital and Renshaw took this to the Navy or something, I don't know, there was some story, they didn't get along very well after that. But anyway Hoyt didn't care about recognition, that wasn't the point, unifying was, and so forth. So he started working on it, and I knew what he was going to come up with, but then he had built the flash room—I believe, if I've got this straight, while I was away—and then when I came back I was teaching.[40]

Taken alongside Kaprow's account, Lichtenstein's version of events tells us this: that he understood Sherman's project to have originated in the problem of heightening visual perception through mechanical means in response to the demands of modern aerial warfare. Lichtenstein had his own brush with the possibilities of aerial combat; as he mentions in the above account, his undergraduate training was interrupted by his induction into the Army in 1943. After time spent in basic training and several semesters in an engineering training program at De Paul University in Chicago, in 1944 Lichtenstein arrived at Keesler Air Force Base in Biloxi,

Mississippi, for a pilot training program. But he received no training; soon after his arrival, the Army canceled the program due to the need for more troops in Europe after the Battle of the Bulge. In February 1945 he was sent overseas as a member of the engineer battalion of the 69th Infantry Division of the Ninth Army.[41]

Since Lichtenstein did not receive any formal training as a pilot, it is impossible to determine whether he knew much about the reflector gun sights that were used by fighter pilots in World War II and which he repeatedly depicted in works from the early 1960s.[42] We do know, however, that during his basic training at Fort Hulen, Texas, Lichtenstein trained with anti-aircraft guns that could be adjusted in much the same way as those of fighter plane computing gun sights. He recounted that those guns "were 40 millimeter I think at the time. I think they were guns of a type that got replaced after that by a higher caliber, and more automatic or something. But they had a separate range-finder box in which you would track the plane and it would automatically set the gun."[43] Regardless of Lichtenstein's specific knowledge of the details of gun sight technology, these instruments—and his imaging of them—provided another opportunity to consider the triangulation of body, vision, and machine, which would again be condensed into the motif of the monocular.

In closing, I return to the painting with which I began to suggest that, considering its confrontation with issues so central to Lichtenstein's project, it be taken as a kind of self-portrait. *I Can See the Whole Room!* is, after all, an image of a male figure pushing an extended digit through a circular opening—one much like the perforations in the dot-screen stencils the artist had just begun to use in his work. After experimenting in early cartoon paintings like *Look Mickey* and *Popeye* with various methods of applying regular patterns of dots to the canvas, Lichtenstein had manufactured his own rudimentary dot-patterned stencil by drilling holes in a piece of aluminum.[44] At the time he produced the painting, sometime in the summer of 1961, he had recently begun to apply paint in this distinctive way; the work can thus be read as an attempt at self-imaging, with that finger standing in for the brush the artist used to push pigment through the holes in his dot-stencil. The awkward, almost instrumental quality of the hand supports this interpretation.

If we consider *I Can See the Whole Room!* as a kind of self-portrait, then the play between monocular and binocular modes in the artist's work can best be brought out by comparing it with another image central to his project, namely *Image Duplicator* (1963). In fact, such a comparison

suggests that the latter canvas represents a veritable correction of the former. In both works a figure peers out at the viewer through an intervening surface plane, although the earlier representation of monocular vision gives way in the later work to the aggressive binocularity of those two glaring eyes. There is a formal element that lends further support to this reading: the arcing lines under the exposed eye of *I Can See the Whole Room!*, used to denote the shading of a cheekbone, are almost exactly repeated in the thick black outline of the mask in the lower right corner of *Image Duplicator*. We might even consider the aggression depicted in the later painting as compensating for its rejection of monocularity, in that a refusal of the terms of technologized vision was less than secure in Lichtenstein's practice. Monocularity was a fitting—albeit conflicted—vehicle for representing the relation between body, vision, and machine. Conflicted because it suggests both an intensification of vision (think of the common experience of closing one eye in order to fix an object in the gaze) and a cutting-off or loss of the ordinary experience of embodied vision. Nevertheless, the artist's experiences with visual technologies had demonstrated that something had to be sacrificed if the machine was to augment human perception. His paintings from this period bear the marks of a struggle between two irreconcilable positions: on the one side sits the idealism of Sherman's dream of pure, unmediated vision, couched in the technological language of the machine. On the other sits the belief in a perceiving subject whose imperfect corporeality denies access to such transcendence, yet provides an imaginary space of safety set away from the machine's erasure of subjectivity. In the end, it was the irresolvable space between these two possibilities that drove Lichtenstein's work at this time, as he began to experiment with the possibilities—and problems—inherent in his chosen approach to painting.

Notes

1. From early on the critics of Lichtenstein's work grappled with this problem; see, for example, Brian O'Doherty, "Lichtenstein: Doubtful But Definite Triumph of the Banal," *New York Times* (October 27, 1963), section II, p. 21; Robert Rosenblum, "Roy Lichtenstein and the Realist Revolt," *Metro* 8 (March 1963), pp. 38–45; and Erle Loran, "Cézanne and Lichtenstein: Problems of 'Transformation,'" *Artforum* 2, no. 3 (September 1963), pp. 34–35.

2. As a teenager Lichtenstein had some early, but not extensive, training in art. He took watercolor classes at Parsons School of Design, and attended a painting class taught by Reginald Marsh at the Arts Students League in New York; see Clare Bell's indispensable chronology in Diane Waldman, *Roy Lichtenstein* (exh. cat.) (New York: Solomon R.

Guggenheim Museum, 1993), pp. 364–375. David Deitcher has provided us with the most exhaustive critical account of Hoyt Sherman's project; see "Teaching the Late Modern Artist: From Mnemonics to the Technology of Gestalt," unpublished doctoral dissertation, Graduate Center, City University of New York, 1989, 2 volumes. Deitcher presents a condensed version of his analysis of Sherman's project in an essay entitled "Unsentimental Education: The Professionalization of the American Artist," in *Hand-Painted Pop: American Art in Transition 1955–62*, ed. Donna De Salvo and Paul Schimmel (Los Angeles: Museum of Contemporary Art, 1993), pp. 95–118 (reprinted in this volume). In *Roy Lichtenstein: Das Frühwerk 1942–1960* (Berlin: Gebr. Mann, 1988), Ernst Busche provides yet another extended account of Lichtenstein's training.

3. Hoyt Sherman, *The Visual Demonstration Center, Part 1: A Manual for Operation with an Emphasis on Vision in the Fine Arts* (Columbus, Ohio: Institute for Research in Vision, Ohio State University, 1951).

4. Deitcher, "Unsentimental Education," pp. 81–82, this volume.

5. See Hoyt Sherman, *Drawing by Seeing: A New Development in the Teaching of the Visual Arts Through the Training of Perception* (New York: Hinds, Hayden and Eldredge, 1947).

6. Bruce Breland, e-mail correspondence with the author, June 2, 1998.

7. Allan Kaprow, quoted in *Roy Lichtenstein at CalArts: Drawings and Collages from the Artist's Collection* (exh. cat.) (Valencia: California Institute of the Arts, 1977), p. 27.

8. Lichtenstein, interview with the author, March 6, 1997.

9. Lichtenstein, as quoted in Gene R. Swenson, "What Is Pop Art? Answers from Eight Painters, Part I," *Art News* 62, no. 7 (November 1963), pp. 25, 62.

10. Deitcher, "Unsentimental Education," this volume, p. 85.

11. Lichtenstein, quoted in Calvin Tomkins, "Brushstrokes," in Bob Adelman, *The Art of Roy Lichtenstein: Mural with Blue Brushstroke* (New York: Harry N. Abrams, 1988), p. 14.

12. Sherman, *Drawing by Seeing*, p. 66.

13. For a sustained analysis of the history of the camera obscura as both a device and a philosophical model, see Jonathan Crary, *Techniques of the Observer: On Vision and Modernity in the Nineteenth Century* (Cambridge, Mass.: MIT Press, 1990).

14. Of course, *camera* is Latin for "room" (as in *I Can See the Whole Room*).

15. Discussing the work of two students trained in the flash lab, Sherman wrote: "Both students were able freely to express their personalities through their drawing at the level at which their personalities would allow, *and this is one of the prized achievements the teacher is after.*" Sherman, *Drawing by Seeing*, p. 29.

16. This address to the viewer is made even more emphatic when we compare Lichtenstein's painting with its comic-strip source. The panel had been part of a story detailing the exploits of two characters, Mike Nomad and Trooper. It showed the former looking through a peephole and describing what he saw to his partner: "TROOPER!—I CAN SEE THE WHOLE ROOM!—**AND THERE'S NOBODY IN IT!**." By editing out the name of the text's original addressee, Lichtenstein provides the image a more direct address to the viewer.

17. Even before his move into Pop Lichtenstein had treated mechanical themes in his work, including a series of canvases that used mechanical diagrams as their subject matter. Ernst Busche links these to Lichtenstein's studies in basic engineering in Columbus, and to a short period during which the artist was employed as a mechanical draftsman in Cleveland. Significantly, in these works the machine is isolated; in other words there is no depicted

interaction between human body and machine. There are, however, certain pre-Pop works that image the interaction between human figures and machines, including Lichtenstein's 1951 version of Charles Willson Peale's *Exhuming the Mastodon* (which places more emphasis on the central mechanism than had Peale's canvas). See Busche, *Roy Lichtenstein: Das Frühwerk*, pp. 172–182.

18. I would like to thank Jonathan Weinberg for calling my attention to this aspect of Strand's photograph.

19. Ulrich Baer, "Photography and Hysteria: Toward a Poetics of the Flash," *Yale Journal of Criticism* 7, no. 1 (spring 1994), p. 67.

20. Ibid., pp. 53–55.

21. Sherman, *Drawing by Seeing*, p. 11.

22. For the Surrealist strategy of automatism, see Hal Foster, *Compulsive Beauty* (Cambridge, Mass.: MIT Press, 1993).

23. See John Ruskin, *The Elements of Drawing in Three Letters to Beginners* (London: George Allen, 1904), p. 5.

24. Hoyt Sherman, *The Visual Demonstration Center, Part 2: Cézanne and Visual Form* (Columbus: Ohio State University, 1952), p. 64.

25. Sherman, *Drawing by Seeing*, p. 2.

26. Sherman, *Cézanne and Visual Form*, p. 81.

27. My reading is heavily indebted to the work of Rosalind Krauss, who has described modernist visuality in precisely these terms, as structured by the repression of the corporeality of vision; see Rosalind Krauss, *The Optical Unconscious* (Cambridge, Mass.: MIT Press, 1993), esp. chapter 1.

28. Lichtenstein, quoted in Calvin Tomkins, "Brushstrokes," p. 15.

29. Michael Wassenaar, "Strong to the Finich: Machines, Metaphor, and Popeye the Sailor," *Velvet Light Trap* 24 (fall 1989), pp. 20–32.

30. Ibid., p. 23.

31. "Through disavowal, the fetish allows access to its own cause. It acknowledges its own traumatic real and may be compared to a red flag, symptomatically signaling a site of psychic pain." Laura Mulvey, "Some Thoughts on Theories of Fetishism in the Context of Contemporary Culture," *October* 65 (summer 1993), p. 6.

32. In describing this motif of monocular vision in Lichtenstein's work I do not mean any figure depicted with a single eye visible, as in the case of a figure shown in profile. I refer specifically to a figure that is depicted frontally in such a way as to expose both eyes to the viewer, yet which has one eye closed or otherwise obscured. In the other cases I've described—namely *I Can See the Whole Room!* and *Torpedo . . . LOS!*—the figure is frontal yet one eye is blocked by an intervening object, which I am suggesting was a way for the artist to represent monocularity indirectly or with some degree of ambiguity. It is only with *CRAK!* that we see a direct representation of monocular vision, with one eye depicted as open and the other closed.

33. Waldman, *Roy Lichtenstein*, pp. 241–249.

34. This linking of monocularity with the feminine—and even more pointedly with castration—is suggested in the title of *CRAK!*, which is a homonym for "crack," a colloquial term for the female genitalia.

35. Of course his output was a great deal more varied than this, and included works that ranged from imagery appropriated from earlier artists (such as Mondrian and Picasso) to a portrait of George Washington; nevertheless, for the wider public his work was most identified with these three general categories of imagery. For a more detailed categorization of his work of the time, see John Coplans, *Roy Lichtenstein* (New York: Praeger, 1972), pp. 37–47.

36. Waldman, *Roy Lichtenstein*, p. 97.

37. I have derived this information on reflector gun sights from archival materials in the National Air and Space Museum Library, Smithsonian Institution. These include H. S. Goldberg, "Reflector Gun Sights," *Army Air Forces Technical Report* no. 5179, Wright Field, Dayton, Ohio (January 2, 1945); R. Wallace Clarke, "Drawing a Bead," part 3, *Aeroplane Monthly* (April 1983), pp. 200–204; and R. Wallace Clarke, "Drawing a Bead," part 4, *Aeroplane Monthly* (May 1983), pp. 279–283.

38. "Robot Plane Sight Adapted," *New York World-Telegram*, October 18, 1944 (National Air and Space Museum Library, Smithsonian Institution).

39. Allan Kaprow, quoted in *Roy Lichtenstein at CalArts*, p. 25.

40. Roy Lichtenstein, interview with the author, March 6, 1997.

41. Much of this information on Lichtenstein's military service is again culled from Clare Bell's chronology in Waldman, *Roy Lichtenstein*, p. 365. Additional details are taken from Richard Brown Baker's 1963 interview with Lichtenstein in the collection of the Archives of American Art, Smithsonian Institution.

42. In contrast, many of the artists who illustrated war comics seem to have been military buffs who took care to faithfully render airplanes, guns, and other military equipment. In a similar vein, the war comic books often included letters pages that functioned as a kind of clearinghouse for information on military history and weaponry. For example, "Sgt. Rock's Combat Corner" in *All American Men of War* (from which Lichtenstein appropriated many source images) printed exchanges like this one: "Dear Sgt. Rock: Did the German Junkers carry any other armament besides its machine gun?—Bobby Stone, Toledo, Ohio. *Dear Bobby: The Junker also carried a 20-mm. cannon.—Sgt Rock.*" (*All American Men of War* no. 95 [January–February 1963], unpaginated).

43. Lichtenstein, interviewed by Richard Brown Baker (Archives of American Art), p. 16.

44. "Then I know that I made my own metal stencil out of a piece of aluminum and graph paper . . . I drilled through and it came out relatively uneven (laughing) . . . I can tell which were done that way." Lichtenstein, interview with the author, March 6, 1997.

Slide Lecture

Yve-Alain Bois

You are in the dark.[1] Two images come up on the large screen. The title is puzzling: *Imperfect Painting (Gold)*. Why imperfect? And why one title for two paintings? The speaker is eager to enlighten you. "This is actually one work, a diptych," he says, "just as the more accurately titled *Imperfect Diptych* painted the same year, 1987." (A second slide appears on the screen, now crowded with the projection of four canvases). "The diptych, let me remind you," he pontificates, "is an ancient format that was particularly favored in religious painting during the Middle Ages and at the beginning of the Renaissance—it pervaded a little longer in the Northern countries. Hanging two panels, each representing a different scene, allowed the artist to convey a sense of temporality in painting, something difficult to achieve within a devotional genre (the icon) that eschewed narrativity: Virgin Mary and her Child on one side, Man of Sorrows on the other, for example." Pointing to the gold paint that fills two triangles in both canvases of the first work, the lecturer adds that the artist might have been referring to the Byzantine tradition of icons and their gilded backgrounds.

Enjoying the suspense that was keeping his listeners attentive, the speaker had purposefully delayed releasing the artist's name. He finally lets it slip, offhand, somewhat proud in sensing the slight bafflement of his relatively well-informed public: "As for 'Imperfect,' it is a code word that Roy Lichtenstein has chosen for a series of paintings that occupied him for three years, from 1986 to 1988. They stand in contrast to the 'Perfect' paintings he started much earlier, in 1978. One does not quite know where the idea of 'perfection' came from—sounds a bit silly, doesn't it? But 'Imperfect' seems to mean here 'something that does not fit.' The diptychs you see on the screen involve both kinds of paintings at once: the geometric shapes painted on the 'perfect' left sides squarely stay put, while

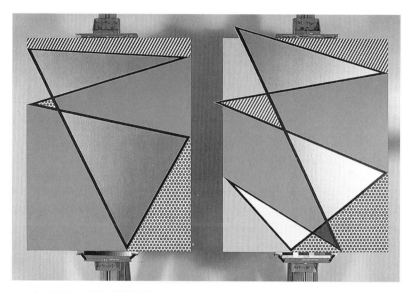

Imperfect Painting (Gold), 1987. Oil
and Magna on canvas, two separate
panels; left, 60 × 48 inches; right,
63 ⅝ × 50 ¾ inches. Private collection.
© Estate of Roy Lichtenstein.

the shapes of the 'imperfect' right sides extend beyond the stretchers' con-
fines. There is nothing really 'imperfect' about that, of course, and you
could say that Lichtenstein plays coy. For I am sure you have not forgotten
all the modernist experiments of 'exploding the frame' that we examined
last week. Actually, most *Imperfect Paintings* will remind you of the 1913
Gino Severinis we discussed, which is perhaps not entirely by chance,
given that Lichtenstein has been fascinated by the 'quirky' attempts of the
Italian Futurists to translate movement and thus time into painting. In
fact in 1974–75 he painted a whole group of parodic canvases based on
Severini, Umberto Boccioni, Carlo Carrà and Giacomo Balla."[2]

"Yes of course!" you say to yourself once the surprise has abated. You
have no difficulty in accepting the works projected on the screen as genu-
ine Lichtensteins, but you are irritated at yourself. What made you over-
look the signature combination of dots and parallel stripes, thick contours,
and the immaculate flatness of the color planes? You are also annoyed
by the religious connotation that was spelled out for you, but admit it
in the end for the sake of irony (much more efficient in its discretion,

you concede, than Warhol's late hoity-toity renditions of Leonardo's *Last Supper*). Mentally sending the key words "Abstract + Lichtenstein" through your own memory bank of images, your private little search engine quickly comes back with: "Non-Objectives" (1964), "Brushstrokes" (1965–1966), "Modern multipanel paintings" (1967). You try one more time, with "Diptych + Temporality," which yields precise titles: *Bread in Bag* (1961), *Step-On Can with Leg* (1961), and *Like New* (1962). Not much in common with what's currently on your plate, really. The works summoned in the first batch of answers all referred to identifiable (even if less and less nominal) targets: Mondrian, Abstract Expressionism, Art Deco. As for the early diptychs, their embodiment of narrative is straightforward: in *Bread in Bag*, the left panel displays a pair of hands bagging a piece of bread (or rather something that the title of the painting orders you to read as bread), and the right panel shows the same pair of hands holding the bag, now closed, parallel to the picture plane. In *Step-On Can with Leg*, the major difference resides in the lid of the trash can: closed at left, open at right. In *Like New*, "based on an advertisement for a screen door repair service," you remember reading, the sense of a "before and after," or rather of a "back to square one" in this case, is even more immediate: the hole

Like New, 1962. Oil on canvas, two panels, 36 × 28 inches each. Private collection. © Estate of Roy Lichtenstein.

that gashes the mesh of Benday dots most economically representing the screen, at left, is at right no more.[3]

Those links are not very satisfying. To which works of art do the geometric doodles of *Imperfect Painting (Gold)* refer exactly, you want to know? And what type of temporality is invoked? Is this work, and its neighbor on the screen, really a diptych? Unlike the predecessors just named, they are not hinged, are they?

The speaker comes to the rescue. He points to many other references that assuage your skepticism. One of them—"next slide, please"—is the *Cow Triptych (Cow Going Abstract)*, a large painting in three panels dating from 1974; he also shows several other preceding examples, such as a series of lithographs of a bull similarly "going abstract" (to the point of unrecognizability). You think that this alludes to Picasso's celebrated lithographic series of 1945–1946 (entitled *Bull*), but the lecturer tells you that the most likely source is Theo van Doesburg's 1925 Bauhaus book, in which the Dutch artist, with a sequence of photographs that began with that of a real cow and climaxed with one of his *Composition VIII* of 1918 (a painting acquired long ago by the Museum of Modern Art), had lamely attempted to ground his abstraction in nature.[4] Remembering being struck by the reproduction of a superb 1910 Kandinsky called *The Cow*, in which the eponymous animal's contours dissolved into the mountainous landscape, you fear for a moment that you are going to be submitted to a long development on "the bovine in modern art."[5] Noting that the foremost right panel of the *Cow Triptych* has a strong family resemblance to the works that were on the screen just a moment ago, particularly with the right canvas of *Imperfect Diptych*, you even wonder: "is there a cow underneath?" You privately smile at the grotesque echo this makes to Porbus's anxious cry to Poussin, at the end of Balzac's *The Unknown Masterpiece*, when gaping at the realistic foot poking out from under the thick coats of paint with which Frenhofer had irredeemably obliterated his figure: "Il y a une femme là-dessous!" You imagine for a moment that Lichtenstein would have liked the free association.

Now other images of things "going abstract" appear on the screen: Lichtenstein's *Portrait Triptych* and his *Pitcher Triptych*, both of 1974. You are still reticent (you are not so easily won over). You happily notice a difference between these works and the Perfect/Imperfect diptychs. In the earlier triptychs the linearity of time was more clearly discerned, mostly because three canvases rather than two were involved in order to ease the transition from figurative origin (a cow, a face, a jug) to abstract endpoint.

Notwithstanding his gentle mockery of van Doesburg's trite pedagogy, Lichtenstein had just as much taken you by the hand in the '70s triptychs: you went from A to B and from B to C. True, in the later diptychs the artist still respects the Western directional code of reading from left to right. But the connection between panel A and panel B seems pretty devoid of narrative value: neither simple event, as in the 1961–62 diptychs (the repair of a screen door, the opening of a lid), nor progressive erasure of a cow, face, jug. It goes from abstract 1 to abstract 2—big deal!

You are about to assume that the Perfect/Imperfect diptychs are just empty formalist exercises, when the ever resourceful lecturer pulls a new trump card from his sleeve. "Lichtenstein's method in these works is a form of montage," he says, "derived from film technique. It builds on the abrupt cut from one state to the other, without transition." And to prop his argument he comes up with an enticing text written late in life by S. M. Eisenstein, the great theoretician and practitioner of cinematographic montage, rediscovering the principles he had himself formulated in the juxtaposition of two Piranesi etchings, *Carcere Oscura* (Dark Room), the third plate of the *Prima Parte* of 1743, and the fourteenth plate of *Le Carceri* (The Prisons), an album dating from a few years later and considered a monument of early Romanticism.

Eisenstein's tale is fanciful: wrongly supposing that the first print belonged to the famous *Prisons*, he went through a lot of trouble to acquire it (by barter), only to be struck, once it was finally hung in his room, "by the degree of its balanced ... gentleness," and to find it "unexpectedly harmless, with little feeling. Unecstatic." Upon which he "ponder[ed] over what would happen to this etching if it were brought to a state of ecstasy, if it were brought out of itself." What follows is one of the most extraordinary pieces of *ekphrasis* ever written, in which Eisenstein, "step by step, element by element," as he says, "explodes" in thought all the specific features of the print. The virtual spectacle that he imagines turns out to be (surprise surprise!) ... the plate of the *Carceri* (which he only then admits having acquired at the same time by the same means): "The scheme which we devised—turns out to actually exist. ... Piranesi's second etching is actually the first one exploding in ecstatic flight."[6]

The lecturer has won a point: it is impossible to deny that Eisenstein's fantasy of "ecstatic explosion" is reenacted by Lichtenstein's 1987 diptychs. You are invited to inspect the transformations from A to B, the way the change in one element affects all the others. In *Imperfect Painting (Gold)*, for example, Lichtenstein slightly moved the longest oblique line of panel

A to the right in panel B, and further lengthened it in order to "bring it out of itself," or rather out of the confines of the rectangular frame of the canvas, thereby creating havoc. New subdivisions of the surface have come into play, new colors (red, white) have entered the fray in order to enliven the more dense population of triangles, and a shy triangle of Benday dots, now bulging out of the frame, has unexpectedly been converted into a more aggressive striped zone. The game is cool, engaging. You play along, apply the method to the *Imperfect Diptych* as well, and then, when slides of single Perfect or Imperfect paintings appear on the screen, you have no difficulty putting yourself in Eisenstein's shoes. How to explode this Perfect one and make it Imperfect, how to implode this Imperfect and revert it back to its state of "perfection"? You wonder why abstract film animation dwindled so fast, from the promises of Viking Eggeling and Hans Richter's early experiments to their devolution into Walt Disney's *Fantasia*.

But then after a while this charade wears thin: "What for?" you are beginning to wonder; "what is the historical relevance of this endeavor?" Is it really more than a futile game? Or was Lichtenstein, in the late 1980s, trying to say something about the vapidness of the decade to come? The kind of virtual alterations that you just made to his Perfect or Imperfect paintings is potentially infinite and yet perfectly predictable. You think of the tedium of this new folk genre, computer art: is Lichtenstein telling us that there is no difference between high and low, art and parody? That a genuine abstract art is no longer possible in our time? That it has become, at best, random decor? Haven't we already heard that long ago, most forcefully from Gerhard Richter, who always professed the greatest admiration for Lichtenstein?[7]

The lecturer is a master of his own art, or he already gave his talk once and had to deal with harsh rebuttals. At this juncture he sends you out onto yet another path of inquiry. "Lichtenstein," he says, "likes nothing better than rescuing discarded items from the trashcan of history. That was one function of the Art Deco paintings and sculptures of the late '60s. Twenty years later he returned to the same theme, this time indirectly. People have largely forgotten the intense debates of the period, but at the time Lichtenstein's *Modern* works, as they were called, were often compared to Frank Stella's *Protractor* Series.[8] What struck critics then was the near simultaneity of these two returns to Art Deco, one emphatically parodic, the other one, coming only a few months later, emphatically serious. Was it only pseudomorphism? The critical camps had been pretty

divided until then, with the notoriously anti-Pop Clement Greenberg at the helm. But the highbrow mapping of styles that had dominated art talk for more than a decade suddenly began to look suspect. The look-alike is a deadly weapon: pretty soon Kenneth Noland's *Circles* and Jasper Johns's *Targets* were put on the same side of the ledger, and well-established aesthetic criteria quickly crumbled. The Perfect/Imperfect paintings rewind us back to this era of ardent polemics, and somewhat solipsistically, to the critical reception of the Art Deco paintings."

You hope that you are not going to be treated to an endless iconological deciphering of the self-referential allegories that have filled many Lichtenstein paintings since the early 1970s. This has never been something for which you had a particular taste, even though you were able to appreciate the prank it plays on the art historian in quest of hidden significations, rendering him utterly redundant, or rather making him a robot programmed by the artist himself. Well, there is something of that here, but subtler than self-quotation: "What Lichtenstein does in these works," booms the lecturer, his tone almost vainglorious, "is to reopen a chapter that had been closed too fast by the expedient logic of the look-alike. Indeed, he is reexamining the relationship his Art Deco works entertained with those of his alter ego of the time, and particularly the manner in which they differed. The key concept is 'shaped canvas.' The *Protractor* paintings were irregularly shaped, as had been Stella's canvases for several years before that; the *Modern* ones were not. It is as if Lichtenstein had not been able to directly address the issue back then. After all, he had declared in one of his earliest—and most famous—interviews (with Gene Swenson, in 1963), that he was 'anti-contemplative, anti-nuance, *anti-getting-away-from-the-tyranny-of-the-rectangle*, anti-movement and -light, anti-mystery, anti–paint-quality, anti-Zen, and anti all of those brilliant ideas of preceding movements which everyone understands so thoroughly.'[9] That's a pretty exhaustive negative program, only topped, perhaps, by that of Ad Reinhardt's 'Twelve Rules for a New Academy' from 1957. And in this early stage of his sudden public success, Lichtenstein probably felt one had to stick to one's stated agenda. He did offer an ironic response to Stella at the time, but not to the shaped canvases per se. Rather, to what they had evolved from, the 'deductive structure' paintings (to use Michael Fried's label), which he mocked in his *Stretcher Frame* series of 1968."

Various proofs that the Imperfect paintings signaled Lichtenstein's renewed engagement with Stella's shaped canvases are piling up on the screen. The very first "imperfect" painting was the gigantic *Mural with Blue*

Brushstroke (1986) in the lobby of the Equitable building in Manhattan. The composition is replete with art historical allusions; some are obscure, but all are perfectly documented in the small monograph published on this work: there are the Léger, Matisse, Braque, and Arp areas—that's for the old modernist masters—and then, closer to home, the de Kooning, Johns, and Kelly quarters.[10] But the Stella portion is the most conspicuous. Not so much for what it depicts (a carpenter's triangle and French curve, whose shapes evoke, respectively, the *Polish Village* and *Brazilian Painting* series of the early to mid-1970s, and the *Exotic Birds* and *Indian Birds* that follow), but because it comes out of the frame. Then you are told that while Lichtenstein's studio technique had not changed one iota since his first Pop canvases, the Imperfect works were the first for which the artist ditched his standard technical apparatus. Previously he had approached a new painting in the same, highly ritualized, manner: a small sketch on paper was projected with an opaque projector on the surface of the canvas, the contours were then traced freehand, and so forth. But projecting an "imperfect" drawing would have been no great help indeed, since the out-of-the-frame area would have only registered on thin air. Graph paper, which Stella had been using to sketch most of his works for years, suddenly made an appearance in Lichtenstein's workshop.[11] Finally, back to gold (but silver is equally present in the Imperfect paintings): you are reminded of Stella's own use of metallic paint in his earliest shaped canvases, those of 1960, and how these responded both to Pollock's fondness for aluminum paint and to Greenberg's biased interpretation of it as a paean to a dematerialized opticality, as a "Byzantine parallel."[12]

You are glad, at last, to learn that the religious allusion that had annoyed you at the beginning was only a decoy. But you are still perplexed by the long meandering detour Lichtenstein (or is it just the speaker?) has taken to reach that point. An image popping up on the screen at this point reinforces your incredulous take. It shows the disarmingly simple nature of Lichtenstein's prosthetic device. As opposed to the intricate carpentry of Stella's stretchers, what you see is a mere triangular wedge of wood just nailed to a traditional stretcher, and then wrapped in canvas. Even you, for whom wrapping anything but a book is a total nightmare, could do it. That simple.

But the speaker had kept a gem for his conclusion: it's not that simple to be simple. A spoonful of *mise en abyme* will help the medicine go down. "During his formative years," you are told, "Lichtenstein's knowledge of art, back in Ohio, was mainly second-hand: the slide lecture was his main

Detail, back of *Imperfect Painting*,
1987. Oil and Magna on canvas,
30 × 31⅜ inches. Private collection.
©Estate of Roy Lichtenstein.

mode of encounter. Lots has been written lately of his mentor and teacher, Hoyt Sherman, whose precept of 'artistic unity,' no matter how utterly banal it was, Lichtenstein liked recalling, tongue-in-cheek perhaps, until the end of his life.[13] But more than what Sherman might have said in his slide lectures, it is the very form of this kind of performance that is relevant here. For the slide lecture had a fundamental role in the history of art history, notably the institution of the double screen comparison. Heinrich Wölfflin's fame as a speaker was based on the device, to say nothing of the elaboration of his 'fundamental principles of art history' as a set of binary oppositions: linear/painterly, plane/recession, closed/open form, and so forth. It is obvious that the Perfect/Imperfect diptychs—which could be termed, in Wölfflinian language, tectonic/atectonic—are a direct allusion to this pedagogic apparatus. As Robert Nelson has noted, the emergence of the slide lecture at the end of the nineteenth century as one of the main public vehicles of the professional art historian engendered a radical shift, a new division of labor, in the discourse on art: while a Reynolds or a Turner could only mesmerize their audience verbally when lecturing about works they had seen on their Grand Tour, any professor with a good projector and quality slides could make you swoon."[14]

But you won't swoon for much longer (does the lecturer realize how many of his listeners are fast asleep?). It is already obvious that this medium itself, the slide lecture, is on the wane, and that miles of slide cabinets will soon go down the drain, rendered obsolete by computerized "smart classrooms." Had Lichtenstein anticipated this turn of events? Could this be why, not long before he died, he decided to give the slide-lecture a try? As a nostalgic act? That's what the speaker had been driving at, you bet. He quotes the passage of Lichtenstein's Kyoto Prize acceptance speech (1995) that is devoted to the Perfect/Imperfect paintings:

I did both *Perfect Paintings* and *Imperfect Paintings*. In the *Imperfect Paintings* the line goes out beyond the rectangle of the painting, as though I missed the edges somehow. In the *Perfect Paintings* the line stops at the edge. The idea is that you can start with the line anywhere, and follow the line along, and draw all the shapes in the painting and return to the beginning. I was interested in this idea because it seemed to be the most meaningless way to make an abstraction. It is another way to make a painting that is a *thing,* and also a play on *shaped canvases,* a familiar genre of the 1960s.[15]

How can one achieve "meaninglessness," you wonder? Is it at all possible?

You agree that, right from the start, Lichtenstein understood his enterprise as one of desemanticization, as a flattening of affect. You now learn that the Perfect/Imperfect images appeared, long before they became autonomous works, as tokens of abstract art in interior scenes (the Perfect ones as easel paintings in 1974,[16] the Imperfect as free standing sculptures in 1977). At this juncture the speaker finally alludes to the *Brushstrokes* series of 1965–66, which had been in the back of your mind for some time. But he reveals something you ignored, and which you would not have been able to realize by yourself: how difficult it had been to create these images.[17] It makes sense, now that you think of it. Indeed, how could one engender a generic, depersonalized version of that which, at least since Impressionism and certainly to a paroxysmic point during the heyday of Abstract Expressionism, has been the paragon of signature style? Lichtenstein, you had forgotten but now remember, only managed to take this step when he found a vernacular source, a comic-book brushstroke. He only needed that crutch once, though, for the very first painting of the series; once he had found the recipe for producing an impersonal depiction of the sign of subjectivity itself, he was all set.[18]

And the same is true, you are told, for the Perfect/Imperfect compositions. A cartoon image now appears on the screen, showing a woman caught in a web of geometrical prisms modeled on Larionov's Rayonism and Moholy-Nagy's overused trick of transforming superimposed color planes into an illusion of transparency. The cartoon is no dumber than the lame versions of modernism it is based on, but it has no pretense: just what Lichtenstein needed. Excerpted from *Flash*, it dates from March 1963, which means that it had lain dormant for a while in the artist's trove of source images, pasted into a notebook perhaps, before he found a use for it. There does not seem to be any painting directly made from this cartoon, but the first Perfect paintings (which date back to 1978) as well as some of the most complex Imperfect ones derive indirectly from it—so the lecturer says. His argument is that the initial impetus was enough, that the brushstroke venture had taught Lichtenstein where to go from there.

You are not terribly convinced by the forensic find—all this "sources and influences" business has always seemed to you a perfect sham, a way for some art historians to cover up the fact that they have nothing much to say. If you had been invited to pitch in you'd have suggested the high kitsch of String Art, which American high school kids were taught in art

classes at least until the early 1970s (you were in the United States then, as an exchange student, and you were submitted to this torture). Whatever, it does not matter because you get the point: Lichtenstein needed a prop in order to find the dumbest way to make an abstract painting, and that you can certainly believe.

Notes

1. I would like to thank Harry Cooper, Jack Cowart, Don Kennison, and Scott Rothkopf for their editorial suggestions.

2. Speaking about Art Deco, Purism, Vorticism, and Futurism: "They all seem to be using a very important idea (an important perceptual change) for something a bit more trivial, only because the possibility was there to use it that way. Futurism does show motion, but it does not show motion very well; painting is not a *time* art. But I am interested in the quirky results of those derivatives of Cubism and like to push this quirkiness further toward the absurd. I am also interested in the relationship between depictions of movement in Futurism and in comic-strips." Roy Lichtenstein, "A Review of My Work Since 1961—A Slide Presentation," this volume, p. 66.

3. On these works, see Michael Lobel, *Image Duplicator: Roy Lichtenstein and the Emergence of Pop Art* (New Haven and London: Yale University Press, 2002), pp. 105–112.

4. See Theo van Doesburg, *Principles of Neo-Plastic Art*, trans. Janet Seligman (London: Lund Humphries, 1966), figs. 5–8.

5. See Jean Clay, *De L'impressionnisme à l'art moderne* (Paris: Hachette, 1975), p. 57. The painting is captioned as being in the Tretiakov Gallery, Moscow.

6. Sergei Eisenstein, "Piranesi, Or the Fluidity of Forms," ca. 1947, trans. Roberta Reeder, *Oppositions* 11 (winter 1977), pp. 84–110. The passages cited are from pages 85–86 and 91.

7. Richter insists, for example, that *Kitchen Range* (1961), which Konrad Fischer showed him in reproduction shortly after it was painted, was one of his starting points. See Benjamin Buchloh, "Entretien avec Gerhard Richter: Réception de l'avant-garde," in *Gerhard Richter* (Paris: Musée d'Art Moderne de la Ville de Paris, 1993), vol. 2, p. 93.

8. See, among others, Diane Waldman, *Roy Lichtenstein* (New York: Harry Abrams, 1971), p. 23.

9. This celebrated series of interviews with eight Pop artists, entitled "What Is Pop Art?" has been anthologized many times. The publication currently most accessible is Steven Henry Madoff, *Pop Art: A Critical History* (Berkeley, Los Angeles, London: University of California Press, 1997). The Lichtenstein quote is on page 107. Emphasis added.

10. See Bob Adelman and Calvin Tomkins, *The Art of Roy Lichtenstein: Mural with Blue Brush-Stroke* (New York: Arcade Publishing, 1987), pp. 30–31.

11. On Lichtenstein's studio practice, see the excellent "Notes on Technique" at the end of Lawrence Alloway, *Roy Lichtenstein* (New York: Abbeville Press, 1983), pp. 109–111. Apart from the use of graph paper, the elaboration of the Imperfect paintings differs in yet another way from the procedure described by Alloway, though this is more coincidental: starting with his large *Greene Street Mural* of 1983, which led to the commission of the Equitable mural, the artist and his assistants began to use masking tape.

12. On this issue, see Rosalind Krauss, *The Optical Unconscious* (Cambridge, Mass.: MIT Press, 1993), p. 248. "Byzantine Parallels" is the title of a 1958 article by Greenberg, reprinted in his classic *Art and Culture* (Boston: Beacon Press, 1961), pp. 167–170. In *Painters Painting*, Emile de Antonio's film on the New York art world released in 1972, Stella implicitly rejects Greenberg's interpretation of Pollock's use of aluminum paint when he speaks of his own fascination with this color as "fairly repellent," adding "I liked the idea, thinking about flatness and depth, that these [his metallic paint canvases] would be very hard to penetrate. All of the action would be on the surface, and that metallic surface would be, in effect, kind of resistant. You couldn't penetrate it, both literally and, I suppose, visually." See the book based on the film (and bearing the same title) published later by Emile de Antonio and Mitch Tuchman (New York: Abbeville Press, 1984), p. 140.

13. See Lobel's essay in the present volume and Bonnie Clearwater, *Roy Lichtenstein: Inside / Outside* (North Miami: Museum of Contemporary Art, 2001).

14. See Robert Nelson, "The Slide Lecture, Or the Work of Art *History* in the Age of Mechanical Reproduction," *Critical Inquiry* 26, no. 3 (spring 2000), pp. 414–434. I am indebted to Lobel's *Image Duplicator* for this reference. On page 433, Nelson writes: "Once, artists and genteel antiquarians wrote and lectured about art, which artists reproduced in engravings and lithographs. Then, from the late nineteenth century, art historians and photographers prevailed, as Reynolds and Turner and the makers of drawings and prints gave way to Warburg and Wölfflin and hosts of anonymous photographers. A division of labor and education eventually led to a distinction between the creation and the analysis of a work of art."

15. "A Review of My Work since 1961," p. 69.

16. In conversation, Lichtenstein referred to these paintings within paintings as "dumb paintings." See for example Adelman and Tomkins, *The Art of Roy Lichtenstein*, p. 80. He spoke in the same manner of the Imperfect canvases: "These paintings seemed to me like the dumbest abstraction you could think of, an abstract painting by someone without any motivation. It's about setting up rules and not obeying them. It's very simple-minded, but I loved the idea of being so literal." Ann Hindry, "Conversation with Roy Lichtenstein," *Art Studio* 20 (spring 1991), p. 16.

17. See Lobel, *Image Duplicator*, pp. 159–168.

18. Diane Waldman, who published the original comic-strip panel in her catalogue of the 1993 retrospective at the Guggenheim (p. 151), acknowledges Matthew Armstrong for locating it (page 163, note 3). The conclusion of Lobel's recent book provides a detailed analysis of the story.

Pop Pygmalion

Hal Foster

1

When it comes to Roy Lichtenstein, most of us still fix on the famous paintings of the early 1960s to the neglect of the inventive work that followed—and continued right up until his death in 1997.[1] That a good portion of this subsequent work is sculpture might also come as a surprise, given that Lichtenstein is known as a very graphic artist, concerned first and foremost to reconcile the relative flatness of high abstraction with the relative illusionism of lowly comics and advertisements. Why, then, was he drawn to sculpture at all?

Certainly it was not for any modernist reason of the physical integrity or spatial expressivity of the medium. On the contrary, Lichtenstein liked to dissemble his sculptural materials—his ceramic, bronze, aluminum, steel, and fiberglass are glazed, painted, and/or patinated, made to look other than they are—and, even more, he liked to play with illusionistic effects—volume is evoked pictorially, imagistically, far more often than it is shaped sculpturally, in the round. This indifference to medium-specificity is already clear from the early Pop objects, most of which are offshoots of the early Pop paintings. His ceramic heads and cups from the mid-1960s seem to have popped, literally, from his canvases, and most of his other Pop objects also exist somewhere between painting and sculpture, as though in transit from the one to the other or as a hybrid of the two. His jagged "explosions" in enamel and steel, from the same period, hyperbolize this transformation: cartoonish signs that appear to burst into three-dimensional space, they carry bits of two-dimensional imagery along with them.[2] Also relevant here are his still lifes (from the 1970s), precisely a pictorial genre rendered in object form, as well as his brushstrokes (many from the early 1980s on), the most painterly of

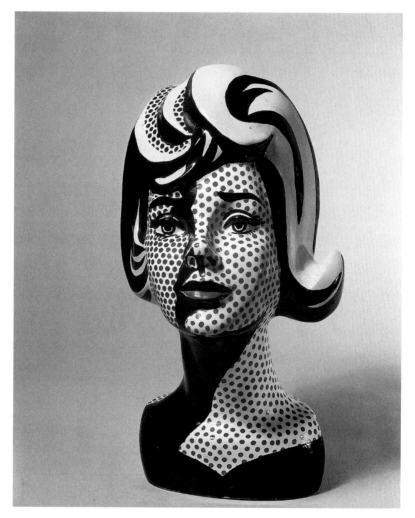

Head with Blue Shadow, 1965.
Glazed ceramic, 15 × 8¼ × 8 inches.
Raymond and Patsy Nasher Collection,
Dallas. © Estate of Roy Lichtenstein.

elements turned into upright figures, the most sculptural of genres. Even his schematic houses (from the mid-1990s on) exist in a no-man's land between the virtual and the actual, and his painted enamel plaques and layered planes with perforated screens are also hybrid forms.

It is as if Lichtenstein pursued his pictorial play with flatness and illusion, abstraction and figuration, into the realm of sculpture, in part to explore the effects of mechanical reproduction there as well. (For example, the mock Benday dots, his signature device to evoke the media processing of the modern world, often recur in his objects, which are also multiples.) These effects, Lichtenstein suggests, have transformed not only the definition of artistic mediums like painting and sculpture but also the appearance of everyday things like glasses, bowls, pitchers, lights . . .

2

Although his heads, brushstrokes, and everyday things are very Pop, they conform to the traditional genres of the bust, the figure, and the still life. In his paintings, too, Lichtenstein played on these genres, and others as well (e.g., landscape, seascape, interior, studio); he also played on such paradigms of painting as the window, the mirror, and the abstract surface—and, of course, he added a paradigm of his own, painting as screened image, as evoked by his faux Benday dots and primary colors. Moreover, his paintings abide by the traditional criterion of compositional unity, a criterion that still governed most modernist painting.[3] Yet Lichtenstein did not practice "good composition" simply for its own sake; he used it to set into relief his brash Pop elements—his trashy sources and subjects, his keyed-up colors and lines, and the other devices derived from comics, ads, and the like.

This collision of high and low modes is the strategy of his Pop painting, of course, and Lichtenstein extended it to his Pop sculpture as well: here classical bust meets painted mannequins, still life meets diner coffee-cups, interior scene is remodeled on a Yellow Pages ad, Abstract Expressionist gesture is redone as a comic-book version of the same, and so on. Crucially, however, the reference to traditional genres not only frames these collisions of high and low but, in doing so, *controls* them; Lichtenstein never opted for an outright desublimation of painting or sculpture à la Andy Warhol or Claes Oldenburg. On the other hand, he did not classicize his commercial images either (as Le Corbusier and Léger, with whom Lichtenstein is sometimes associated, were wont to do);

rather, he suggested how classical idioms—from a motif like a column to the criterion of compositional unity—had become clichés in their own right. And if there is a critical edge in Lichtenstein, it lies here: less in his *thematic* appropriation of comics and ads, and more in his *formal* juxtaposition of lowly contents with high modes—a juxtaposition that is never quite a reconciliation.

3

His Pop objects exist between painting and sculpture structurally, too: whereas minimalist objects are neither painting nor sculpture (at least according to the famous definition of Donald Judd), Pop objects tend to be both-and.[4] In effect, if representational painting is a two-dimensional encoding of a three-dimensional world, Lichtenstein reversed the process, and arrested it somewhere in between. Typically he pushed a two-dimensional image toward a three-dimensional thing, but retained bits of the pictorial illusion as the image-object was displaced into actual space.[5] Although this procedure is pronounced in the explosions of the 1960s and the still lifes of the 1970s, a programmatic example is the late piece *Wall Pyramid* (1996), which consists of two joined triangles—one solid yellow to signify a plane bathed in light, another yellow striped with black to signify a plane cast in shadow—pulled into a convex form. The result is at once funny—a pyramid, the most storied volume in world art, collapsed into a diagram—and ambiguous—an image-object suspended in a space akin to that of *relief.*

Lichtenstein had approximated the semipictorial order of relief well before his Pop objects: in the late 1940s he made a few mosaic tables as well as several ceramic plaques, and in the early 1950s he produced wood assemblages as well as carved figures inscribed with primitivist markings. In his Pop objects, however, the insistence on the frontality of relief is much stronger: some present a single profile (a few are quite flat, only as thick as the steel armature), and most favor a single point of view (a few are legible only *en face* and/or in perspective). Both attributes are essential to the effect of a semi-trompe-l'oeil sculpture that allowed Lichtenstein to bring his play with visual paradox to a new level of formal complexity.

Consider *Goldfish Bowl II* (1978) in this light. The motif is pictorial twice over, and so thrice removed from the world. Lichtenstein borrowed it from his own painting (e.g., *Still Life with Goldfish Bowl* and *Painting of a*

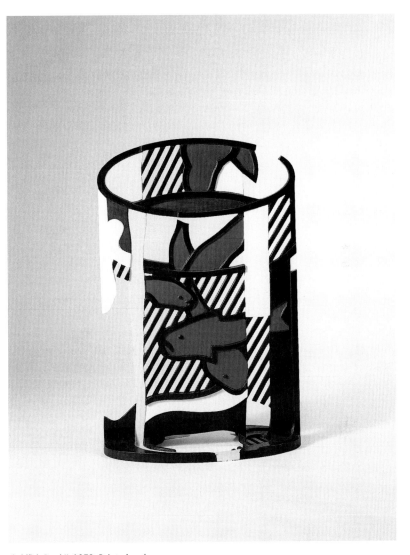

Goldfish Bowl II, 1978. Painted and
patinated bronze, 39 × 25 ¼ × 11 ¼
inches. Edition of three. Private
collection. © Estate of Roy Lichtenstein.

Golf Ball [1972]), where he had borrowed it in turn from a Matisse paint-
ing (e.g., *Goldfish* [1911]). And the sculpture sports other signs of his own
devising, both for light and shadow (again signified by yellow bands and
black stripes respectively) and for glass, reflection, and water (in different
places the black elements signify all three). Even more ambiguously pic-
torial are the fish: as in the related paintings, they appear as images, both
foreshortened in depth and distorted in refraction, despite the obvious fact
that they are objects (cast in bronze no less). With material things (like the
bowl and the fish) pushed toward the immaterial, and immaterial quali-
ties (like light and refraction) pushed toward the material, this piece is an
exemplary instance of the visual paradox that Lichtenstein could entertain
with his semi-relief, semi-*trompe-l'oeil* mode of sculpture.[6]

4

To a significant degree modernist sculpture developed, initially with Rodin
and further with Brancusi, in opposition to the model of sculpture-as-
relief, for this pictorial conception of the medium resisted the modernist
drive toward physical integrity and spatial expressivity (recall how Rodin
and Brancusi insisted on both). The principal theorist of the old paradigm
of sculpture-as-relief was the German sculptor Adolf von Hildebrand
(1847–1921), who exemplified it in his own practice. In *The Problem of
Form in the Fine Arts* (1893) von Hildebrand argued that sculpture in the
round offers too much variety of surface and shape as we walk around
it, and that this mutability threatens both the visual unity of the object
and the aesthetic contemplation of the viewer. Such prejudice against
sculpture in the round was not original to von Hildebrand (Diderot and
Baudelaire, among others, held this opinion), but von Hildebrand elabo-
rated it into a forceful brief for a pictorial sculpture set in relief and ori-
ented to a single point of view:

> All details of form must unite in a more comprehensive form. All
> separate judgments of depth must enter into a unitary, all-inclusive
> judgment of depth. So that ultimately the entire richness of a figure's
> form stands before us as a backward continuation of one simple plane.
> Whenever this is not the case, the unitary pictorial effect of the figure
> is lost. A tendency is then felt to clarify what we cannot perceive
> from our present point of view, by a change of position. Thus we are

driven all around the figure without ever being able to grasp it once in its entirety.[7]

Certainly, Lichtenstein sought a "unitary pictorial effect" in his painting—in this respect he was deeply influenced by his early training in the psychology of perception under Hoyt L. Sherman at Ohio State University—and, again, this visual unity served as a frame for his disruptive Pop elements.[8] But why did he revert to an old model of relief in his *sculpture*, a model that modernists had mostly opposed and minimalists had apparently overthrown (they famously attacked anything to do with "unitary pictorial effect")?

5

Perhaps Lichtenstein only appeared to conform to this old model of sculpture, in part to complicate it, even to refashion it to his own ends. Although his objects usually favor one plane and one point of view, any "unitary pictorial effect" collapses as soon as we walk around them, for, however shallow they might be, most are not, strictly speaking, reliefs at all. Von Hildebrand valued "unitary pictorial effect" as a way to reconcile optical and tactile perceptions of the sculptural figure in one impression of "plastic clarity."[9] In Lichtenstein, however, no such reconciliation is offered: he provides an illusionistic image and tricks the eye, but also breaks the illusion and exposes the trick, as our attention oscillates between image and object and as pictorial unity is contradicted by sculptural mutability.[10]

For von Hildebrand the sculptural figure must emerge from the ground of the relief as if naturally, for this emergence is an analogue for the coming-into-being of meaning as such—how material takes on form, intelligibility, life. Yet in Lichtenstein there is no stable *a priori* ground— the support of his sculptures is often, quite literally, a void, a negative space circumscribed by an armature—and meaning accrues through the image alone. Hence his evocation of relief is not a reversion to the old pictorialism of premodernist art so much as a turn to the new pictorialism of postmodernist culture, a turn through which Lichtenstein suggests that even sculpture might be reformatted as an image, indeed that *anything* might be—again, a glass, a bowl, a pitcher, a light . . . Already in the mid-1960s, then, as Marshall McLuhan touted the technological transformation of the human sensorium, Lichtenstein also intimated that "media"

had trumped "medium," that image-technologies had once again changed our perception of the visual arts utterly.[11]

6

We tend to read pictorial images in two ways, Walter Benjamin speculated in a short note of 1917: either as representational figures, if they appear in a vertical format (as in most paintings with a visual field oriented so that we can enter it imaginatively), or as symbolic signs, if they appear in a horizontal format (as in most mosaics where such fields are rare).[12] Lichtenstein worked in both modes, representational-figurative and symbolic-semiotic, and often combined the two; again, his early works in cast stone, clay, or wood, such as *Standing Figure* (ca. 1946–47), are inscribed with semi-pictographic lines. Many of his Pop objects can also be read as both figures and signs; again some seem to rise up, like horizontal signs in a pop-up book, to become vertical figures (the explosions and the brushstrokes are the best examples).[13]

The ambiguous status of such work between the iconic and the semiotic complicates its ambiguous location between two and three dimensions; typically Lichtenstein signifies volume and depth as much as he conveys them physically or illusionistically. This semiotic dimension is already activated in the first Pop objects: though already three-dimensional, his heads and cups are also covered with dots and stripes that signify light and shadow. Such signs for volume and depth are thus redundant, and this redundancy underscores the conventional status of such marks. On the other hand, as the heads occasionally flatten into near profiles in the 1970s and 1980s, there is also a semiotic use of voids as volumes. For instance, in *Sleeping Muse* (1983), his reprise of the famous Brancusi piece of the same title, Lichtenstein evokes the fullness of the head mostly through negative space. Another of his devices borrowed from the comics is a pattern of diagonal lines to signify "mirror." As Lichtenstein once remarked, "cartoonists have used diagonal lines and slash marks to tell us they are rendering a mirror and we have come to accept these symbols." Much of his art is concerned to explore this conventionality.[14]

7

In his celebrated *Course in General Linguistics* (1916) Ferdinand de Saussure articulated the basic principle that the same signifier can evoke different

signifieds. This principle applies to visual signifiers, too, as Lichtenstein knew well; for example, parallel lines might signify "mirror" if they are diagonal, as in *Mirror no. 1* (1971), and "motion," say, if they are horizontal, as in *In the Car* (1963). During the same years that Saussure gave his lectures, Picasso and Braque explored this arbitrary nature of the sign in their *papiers collés*, collages, and constructions. However, in this investigation the Cubists were cued not by the great Swiss linguist (whose work they did not know) but by certain African sculptures (which they studied closely). Some of their insights were later summed up by their gifted dealer Daniel-Henry Kahnweiler as follows:

> These painters turned away from imitation because they had discovered that the true character of painting and sculpture is that of a script. The products of these arts are signs, emblems, for the external world, not mirrors reflecting the external world in a more or less distorting manner. Once this was recognized, the plastic arts were freed from the slavery inherent in illusionistic styles. The [African] masks bore testimony to the conception, in all its purity, that art aims at the creation of signs. The human face "seen," or rather "read," does not coincide at all with the details of the sign, which details, moreover, would have no significance if isolated. . . .[15]

Again, like Picasso and Braque, Lichtenstein combined illusionistic bits with fragmentary signs in his sculptures. Both kinds of representation are evident, for example, in his *Ritual Mask* (1992), which, even as it images an African mask, also plays with its semiotic devices as Picasso and Braque might have done. The dots and stripes on the cheeks of *Ritual Mask* would indeed "have no significance if isolated"; in context, however, they signify both the scarification often represented in African masks and the modeling that the Cubists sometimes used these marks to evoke. *Modern Head* (1970), a piece that also riffs on African and Cubist art, plays with semiotic ambiguity as well. This black profile can be taken as a simple head, if we read the circular hole near the top as its "eye," or as a head with a headdress or a helmet, in which the "eye" becomes just an ornamental element; as often with Picasso, then, this "modern head" is two in one (or even three, if we agree that it also resembles a superhero mask).

Lichtenstein prized this kind of ambiguity, and it led him to elaborate on Cubist semiotics in a way that few other artists have. Of course, he did not develop this code of signs from Cubism alone; his language was

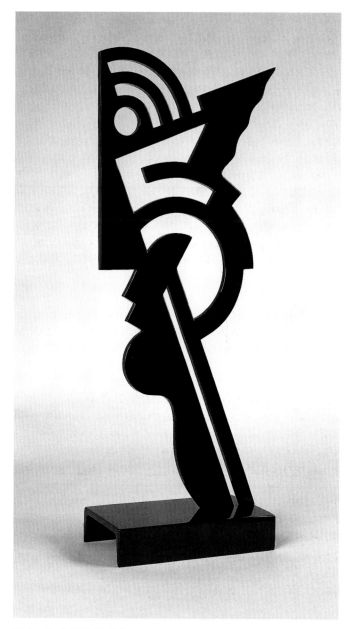

Modern Head, 1970. Black chromed
aluminum, 25 ⅝ × 10 ¼ × 5 inches.
Private collection. © Estate of Roy
Lichtenstein.

mediated, literally, by the comics. "Mine is linked to Cubism to the extent that cartooning is," Lichtenstein remarked in 1967. "There is a relationship between cartooning and people like Miró and Picasso which may not be understood by the cartoonist, but it definitely is related even in the early Disney."[16] One such relationship, exploited by Lichtenstein (indeed, all but copyrighted by him), is the shared conventionality of certain signs, such as diagonal lines to signify "mirror," vertical curves to signify "steam," and so on. Even his use of primary colors (plus the occasional green) is utterly conventional. As in Mondrian, they evoke a nonnatural world (Mondrian also avoided green for this reason); however, in Lichtenstein they further evoke a mediated world (the colors of the printing process), and, though not entirely arbitrary (yellow is often used to represent hair, for example, and blue to represent sky), his colors tend to signify only relative to one another, in their difference (i.e., one patch is yellow for no apparent reason other than other patches are blue or red).[17]

8

In the 1950s Lichtenstein undertook a catechism in modernist painting: he worked along Expressionist lines, then in a faux-naif style (to which he adapted Americana themes that anticipate his Pop art), and finally in an abstract mode. He also became adept in a range of techniques—the Cubist play with signs, the gestural version of the brushstroke, and other devices adapted from such modernists as Matisse and Léger. All of these elements soon reappeared in his Pop work, but as second-hand, held up, as in a review, along with techniques drawn from comics and ads. Lichtenstein followed a similar strategy in his sculpture: he worked through various styles in his early pieces (primitivist figures, assemblages, and so on), which sometimes reappeared, almost in quotation marks, in his Pop pieces.

Sometimes, especially in paintings where several styles are cited, this procedure borders on pastiche, which can appear cynical in its very eclecticism. Far more often, however, Lichtenstein practiced parody, as he indicated in an important conversation in 1964. "In parody there is the implication of the perverse," he comments, but not necessarily of the cynical: "The things that I have apparently parodied I actually admire."[18] "A parody," Oldenburg remarks in the same conversation, "is not the same thing as a satire"; rather, it is "kind of imitation ... [that] puts the imitated work in a new context."[19] And the critical edge of the Lichtenstein parodies is indeed directed less at the original styles than at what "new

contexts" have done to them. In a sense, then, the parodies follow the old Marxist maxim about historical repetition—"the first time as tragedy, the second as farce"—where the farcical reduction is tacitly blamed on us latter-day consumers of the culture industry.[20]

Thus, for example, *Expressionist Head* (1980) appears drained of feeling, as if to suggest that, in our world not only of mechanical reproduction but also of electronic simulation, expression can only be coded, never immediate (the piece dates to the rise of Neo-Expressionism, which it comments on wryly as well). Likewise, *Surrealist Head* (1986) is anything but uncanny, as if to suggest that, in a world where even the unconscious is subject to colonization, the disruptive disfigurations of Surrealism have become largely ineffective, indeed decorative.[21] Such works point to the historical absorption of much modernist art, indeed to its partial reification, and Lichtenstein presents entire categories in this guise, too, as clichéd and/or generic, as if they were so many listings in a home-shopping catalogue: "Modern Sculpture," "Ritual Mask," "Chinese Rock," "Amerind Figure." . . .[22]

9

In these ways Lichtenstein shows us inventions in modernist art that are not only paralleled by conventions in comics but also turned into gimmicks in commercial design. Consider how his "Archaic Heads" (1988–89) evoke archaic styles from the Egyptian to the Etruscan, as well as modernist adaptations of the same by Gauguin and Picasso, only to condense all such allusions into one stereotype-logo. Or how *Modern Head* recapitulates the streamlining of both African and Cubist art into a chic form of Black Deco (which, again, could pass as a superhero mask). Lichtenstein was often drawn to such moments when art and design converge: not only in Deco, as in his various "Modern Sculptures," but also in Brancusi, whose *Bird in Space* (1927) was once held for duty at U.S. customs as a manufactured thing (a kitchen utensil in fact), as well in Art Nouveau, in which the commingling of art and design was programmatic. *Surrealist Head*, for example, cites Art Nouveau as well as Surrealism: the "mediumistic line-language" of the former, which Benjamin once read as a desperate attempt "to win back the forms [of industry] for art," is in play here, as is the voluptuous line-language of the latter, which might be taken as an equally desperate attempt to win back the forms of eroticism for art.[23]

In *Surrealist Head*, however, both attempts appear almost comic, as if these contests were long since lost.

Above I speculated that Lichtenstein evoked a premodernist model of sculptural relief in a way that suggests that anything might be remade as an image; here he rehearses modernist styles in a way that suggests how they have become hardened as clichés. Resistance to this hardening of artistic means was already active in Art Nouveau and further developed in Surrealism (hence the aforementioned attempts "to win back" forms for art), but at the moment of Pop this reification became both more intensive and more extensive.[24] Indeed, Lichtenstein implies that no language, verbal or visual, is immune from this process; even the onomatopoeic words in his war paintings appear as clichés ("Brattata"), as do the expressive utterances in his romance paintings ("Oh Brad darling ... "). Of course, his key trope for this hardening is the gestural brushstroke: once a sign of subjective feeling, Lichtenstein displays it as a congealed decal, and it is all the more fetishized when it doubles as a sign for a blonde or a nude, as it does often in his sculptures. The signature of the artist is perhaps the least innocent of such marks, and Lichtenstein went so far as to sign a few early Pop paintings with a copyright symbol.

10

One can draw a dire conclusion from this commingling of art and commerce: that by the moment of Pop many devices of the prewar avant-garde had become gadgets of the culture industry; that, as a medium to explore subject–object relations, sculpture was overridden by the commodity, whose effectivity Pop objects could only attempt to mimic; that product and image, or commodity and sign, had become structurally equivalent and easily substitutable; and so on.[25] Or one can take the benign view that both art and commerce benefited from this exchange of forms, which is how Lichtenstein tended to see the matter. But he did more than adapt a Pollyannaish perspective here: not only did Lichtenstein point to the partial reification of styles and signs, but he also worked to *invent* within this condition, and, in so doing, to mitigate it a little as well.

In part this de-reification is a function of his process. As is well known, Lichtenstein did not copy any comic or ad directly in his paintings; at least initially, he would select one or more panels, sketch one or more motifs from these panels, then project his drawing with an opaque projector,

trace the image on the canvas (with various changes in the process), adjust it to the picture plane, and finally fill in his stenciled dots, primary colors, and thick contours—the light ground of the dots first, the heavy black of the outlines last (later, he would also use slides and collages). Thus, while a Lichtenstein painting might look industrially readymade, it is actually a layering of mechanical reproduction (comic or ad), handwork (drawing), mechanical reproduction again (projector), and handwork again (tracing, painting), to the point where distinctions between man and machine are impossible to recover. This paradox of "the handmade readymade" resists any final reification in the paintings, and much the same can be argued of the sculptures, too.

Another way that Lichtenstein mitigated reification is also paradox-ical—through its very exacerbation. For example, he did indeed inherit the gestural brushstroke as a reified sign—of Abstract Expressionism, of art as such—but his sculptural response was to take advantage of this fact, to stand the brushstroke up, make a figure of it, and so reanimate it a little; and several such pieces, like *Homage to Painting* (1983), do possess a lively Pop contrapposto as a result.[26] Here de-reification is focused on a single element, but Lichtenstein also attempted to enliven entire styles, even as he also presented them as clichés. Consider once more the evocation of Art Deco in the "Modern Sculptures." By the 1960s Deco had become a period style, "a discredited area, like the comics," as Lichtenstein once remarked; on the other hand, it had "become visible, even conspicuous again," as Lawrence Alloway also noted.[27] Even if Deco did not possess "the revolutionary energies" of "the outmoded," it still might produce the uneasy effects of the démodé, and Lichtenstein was keen to tap them.[28] "I am interested in the quirky results of those derivatives of Cubism," he once commented, "and I like to push this quirkiness further toward the absurd."[29] The touch of the quirky in these old styles, along with "the implication of the perverse" in his parodies, also works to unsettle reification.

A final example of this strategy. Lichtenstein cited Picasso more often than any other artist; in particular he was drawn to the manner of the early 1930s, which combines the semiotic inventiveness of Cubist forms with the "peculiar maneuverability" of Surrealist figures.[30] *Galatea* (1990) puts both qualities in play. This sinuous figure is described with one continu-ous line, in a way that recalls how Picasso, for motives erotic as well as aesthetic, sometimes drew his female bodies. Moreover, its different oval areas in identical red stripes signify belly and breasts depending on size

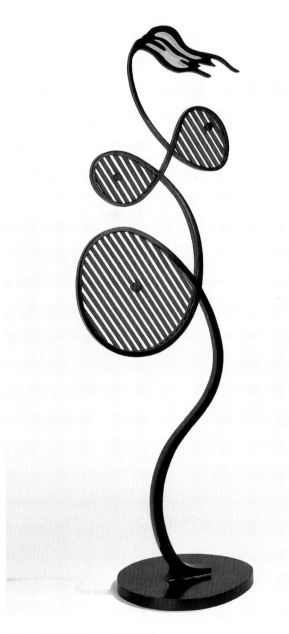

Galatea, 1990. Painted and patinated
bronze, 89 × 32 × 19 inches. Edition of
six. ©Estate of Roy Lichtenstein.

and location, while similar cylinders signify navel and nipples according to the same semiotic principle pioneered by Picasso. Lichtenstein tops his figure with a yellow brushstroke detailed in black that identifies her as a sprightly blonde—perhaps a lithe dancer on a stage or a bikinied girl on a beach (one Picasso that comes immediately to mind is *Bather with Beach Ball* [1932]). On the one hand, then, *Galatea* is a late incarnation of the ancient nymph that the great art historian Aby Warburg traced, as a recurrent spirit, throughout "the afterlife of antiquity"; on the other hand, she is also assembled from bits and pieces of received art styles and cartoon signs.[31] On the one hand, *Galatea* is brought to life by her Pygmalion, Lichtenstein inspired by Picasso; on the other hand, no artist is more alien than Lichtenstein to this classical myth about the immediacy of expression and the identity of art object and love object.

In such paradoxes Lichtenstein effects a double movement: even as he recovers aspects of the semiotic and the erotic in Picasso, he points to the onset of a reification already evident in his great predecessor.[32] Here and elsewhere Lichtenstein snatches expressive possibilities out of the jaws of reified signs, even as he registers them precisely as reified. As Marx wrote at the dawn of the modernist era, "Petrified social conditions must be made to dance again by singing them their own song."[33] Lichtenstein sang this song often, especially in his sculptures.

Notes

1. The present text is a revised version of an essay published in *Roy Lichtenstein: Sculpture* (New York: Gagosian Gallery, 2005). Thanks to Mark Francis for his original commission, Jack Cowart for his thoughtful assistance, and Graham Bader for his editorial advice. I have especially benefited from Jack Cowart, *Roy Lichtenstein: Sculpture and Drawings* (Washington: The Corcoran Gallery of Art, 1999), and Bonnie Clearwater, *Roy Lichtenstein: Inside/Outside* (North Miami: Museum of Contemporary Art, 2001).

2. In 1963–1964 Lichtenstein had pressed the faces of his women closer and closer to the picture plane, and, in his mural for the 1964 World's Fair of a woman leaning from her window, even out of it. His subsequent objects exploit this in-between status to evoke tense or contradictory states: not only explosions made permanent, but precarious cups made rigid, immaterial light made material, Calderesque mobiles made immobile, and so on.

3. On this criterion in Lichtenstein see Michael Lobel, *Image Duplicator: Roy Lichtenstein and the Emergence of Pop Art* (New Haven: Yale University Press, 2002). Donald Judd grasped its use in Lichtenstein already in his reviews of shows in 1962, 1963, and 1964 (reprinted in this volume).

4. See Donald Judd, "Specific Objects," *Arts Yearbook* 8 (1965). Pop objects are precisely not specific in the Juddian sense; they are ambiguous vis-à-vis dimensionality, originality, and so on.

5. "Even though I realize it is three-dimensional," Lichtenstein once remarked of his sculpture, "it is always a two-dimensional relationship to me—or as two-dimensional [a] relationship as a drawing is" (Constance W. Glenn, *Roy Lichtenstein: Ceramic Sculpture* [Long Beach: California State University, 1977], pp. 17–18). In some ways Lichtenstein recapitulated the development of Cubist objects out of Cubist painting (think, for example, of *Glass of Absinthe* [1914] of Picasso), more on which below.

6. Of course, this mixed space is also explored by other Pop artists, such as Richard Artschwager regularly and Oldenburg intermittently (e.g., *Bedroom Ensemble I* [1963]).

7. Adolf von Hildebrand, *The Problem of Form* (New York: Stechert, 1907), p. 95. This passage is quoted by Rosalind Krauss in her *Passages in Modern Sculpture* (Cambridge, Mass.: MIT Press, 1977), where she makes the argument that modernist sculpture emerged in opposition to the relief paradigm. For a recent translation and a helpful contextualization, see Harry Francis Malgrave and Eleftherios Ikonomou, eds., *Empathy, Form, and Space: Problems in German Aesthetics, 1873–1893* (Santa Monica: The Getty Center, 1994).

8. On this training see David Deitcher, "Unsentimental Education: The Professionalization of the American Artist," reprinted in this volume; Lobel, *Image Duplicator*; and Clearwater, *Roy Lichtenstein: Inside / Outside.*

9. For a helpful discussion of Hildebrand see Alex Potts, *The Sculptural Imagination: Figurative, Modernist, Minimalist* (New Haven: Yale University Press), pp. 124–129.

10. Some sculptures by David Smith and Anthony Caro also come into focus from one point of view, only to appear disjunctive from other perspectives. Seen through Lichtenstein, then, Smith and Caro might appear too pictorial to count as the exemplary modernist sculptors that they are often taken to be.

11. Only in Pop, it might be argued, is the predicament of art in the age of mechanical reproduction fully explored. On this historical lag see my "Postmodernism in Parallax," in *The Return of the Real* (Cambridge, Mass.: MIT Press, 1996).

12. Walter Benjamin, "Painting and the Graphic Arts," in *Walter Benjamin: Selected Writings, Volume 1: 1913–1926*, ed. Marcus Bullock and Michael W. Jennings (Cambridge, Mass.: Harvard University Press, 1996), p. 82.

13. Cowart calls these examples "pop-up art" in *Roy Lichtenstein: Sculpture and Drawings*, p. 10.

14. Roy Lichtenstein, "A Review of My Work Since 1961—A Slide Presentation," this volume, p. 62. For a semiotic account of a comic strip contemporaneous with early Pop, see Umberto Eco, "A Reading of Steve Canyon" (1964), reprinted in *Comic Iconoclasm*, ed. Sheena Wagstaff (London: Institute of Contemporary Arts, 1987). Eco also offered a semiotic account of Pop in "Lowbrow Highbrow, Highbrow Lowbrow," *Times Literary Supplement* (October 1971), pp. 1209–1211.

15. Daniel-Henry Kahnweiler, "Preface" to Brassaï, *The Sculptures of Picasso*, trans. A. D. B. Sylvester (London: Rodney Phillips, 1949). Also see Kahnweiler, "Negro Art and Cubism," *Présence africaine* 3 (1948), pp. 367–377. In "Kahnweiler's Lesson" Yve-Alain Bois explicates the semiotic dimension in Cubism brilliantly (see *Painting as Model* [Cambridge, Mass.: MIT Press, 1990]), as does Rosalind Krauss in such texts as *The Picasso Papers* (New York: Farrar, Straus, and Giroux, 1998). Yet Lichtenstein had already explored this dimension in his own art; on this connection see Lobel, *Image Duplicator*.

16. John Coplans, "Talking with Roy Lichtenstein," *Artforum* 5, no. 9 (May 1967), reprinted in *Pop Art: A Critical History*, ed. Steven Henry Madoff (Berkeley: University of California Press, 1997), p. 201. Lichtenstein was also interested in devices common to Futurism and

the comics. That such relationships might in fact be well understood by many cartoonists is suggested in Scott McCloud, *Understanding Comics: The Invisible Art* (New York: Kitchen Sink Press, 1993). On the relationship of Miró and Picasso (and others) to such forms see Kirk Varnedoe and Adam Gopnik, *High and Low: Modern Art and Popular Culture* (New York: Museum of Modern Art, 1991).

17. Lichtenstein often alluded to his diacritical way of working: e.g., "My emphasis was in forming the relationship of mark-to-mark" (Lichtenstein, "A Review of My Work Since 1961").

18. Bruce Glaser, "Oldenburg, Lichtenstein, Warhol: A Discussion," *Artforum* 4, no. 6 (February 1966), reprinted in Madoff, *Pop Art*, p. 145.

19. Ibid.

20. "A Picasso has become a kind of popular object," Lichtenstein remarked in 1967; "one has the feeling there should be a reproduction of Picasso in every home" (Coplans, "Talking with Roy Lichtenstein," p. 201). His parodies of other modernist masters like Matisse, Mondrian, and Léger suggest much the same.

21. The greatest emptying out occurs in his mirror pieces, which are mostly blank, with the presumed subject (sometimes the artist) usually absent.

22. Of course, these titles conflate the most disparate of objects, styles, and practices ("Amerind" also sounds like a corporate brand).

23. Walter Benjamin, "Paris, Capital of the Nineteenth Century," in *Reflections*, trans. Edmund Jephcott (New York: Harcourt Brace Jovanovich, 1978), p. 155.

24. On this historical process as revealed in postwar art see *The Return of the Real*, pp. 73–80.

25. These propositions can be extracted, respectively, from Peter Bürger, *Theory of the Avant-Garde* (1974), such movements as Nouveau Réalisme, and "the political economy of the sign" advanced by Jean Baudrillard. "One is no longer the truth of the other," Baudrillard wrote of image and object as treated in Pop; "they coexist *in extenso* and in the very same logical space, where they 'act' as signs (in their differential, reversible, combinatory relation)" (*La société de consommation: ses mythes, ses structures* [Paris: Gallimard, 1970], p. 175).

26. "Since myth robs language of something," Roland Barthes wrote, in a classic discussion of consumerist ideology at the dawn of the Pop era, "why not rob myth?" (*Mythologies* [1957], trans. Annette Lavers [New York: Hill and Wang, 1972], p. 135). In both verbal and visual registers Ed Ruscha also plays with reification and reanimation, "myth" and "myth-robbery." For modernist instances of this strategy see my "Dada Mime," *October* 105 (summer 2003).

27. Lichtenstein quoted in Lawrence Alloway, "Roy Lichtenstein's Period Style: From the Thirties to the Sixties and Back," *Arts Magazine* 42, no. 1 (September–October 1967), reprinted in Coplans, *Roy Lichtenstein* (New York: Praeger, 1972), p. 145.

28. Walter Benjamin, "Surrealism: The Last Snapshot of the European Intelligentsia," in *Reflections*, 181.

29. Lichtenstein, "A Review of My Work Since 1961," p. 66. In the process a flash of historical insight might also be extracted from a style like Deco that, as "a kind of Platonism of the production line," worked precisely against such awareness. Alloway described one such insight as follows: "The forms of the thirties are symbols of an antique period with a naïve ideal of a modernity discontinuous with our own" (Alloway, "Roy Lichtenstein's Period Style," p. 145).

30. Leo Steinberg, "The Algerian Women and Picasso at Large," *Other Criteria* (London: Oxford University Press, 1972), p. 128.

31. Ernst Gombrich discusses this fascination in his *Aby Warburg: An Intellectual Biography* (Chicago: University of Chicago Press, 1986), pp. 105–127. See the relevant papers collected in Warburg, *The Renewal of Pagan Antiquity*, trans. David Britt (Los Angeles: The Getty Research Institute, 1999).

32. For more on this reification see Krauss, *Picasso Papers*.

33. Karl Marx, "A Contribution to the Critique of Hegel's Philosophy of Right, Introduction," in *Early Writings*, ed. T. B. Bottomore (New York: McGraw-Hill, 1964), p. 47 (translation modified).

Roy Lichtenstein consistently identified 1961's *Look Mickey* as his "first" pop work, recounting through decades of interviews the painting's seminal place in his oeuvre.[1] How curious, then, that already by 1966 the artist appeared uncertain about the very subject of his then only five-year-old image. As he recounted to David Sylvester in an interview of that year:

> The first one, I think, was Mickey and Donald on a raft. Mickey Mouse had caught the back of his coat with his own fishing rod and said: "I've caught a big one now" or something like that. I forget exactly how it went.[2]

Lichtenstein had, indeed, misremembered: *Look Mickey* (without question the painting referred to here) shows Donald, not Mickey, having hooked his coat, and portrays this scene as taking place on a jutting dock, not a raft. The artist had not only forgotten his inaugural pop image, in other words, but reversed the very terms around which it is built.

Lichtenstein's fuzzy memory is understandable. Exhibiting in and collected by museums in both the United States and Europe, working to satisfy an eager waiting list of enthusiastic collectors, discussed in media outlets from *Artforum* to *Life* to *Newsweek* (which would feature an original Lichtenstein design on its April 25, 1966 cover, accompanying a feature article on "The Story of Pop"), and having moved away from comic book iconography altogether in his most recent paintings, Lichtenstein in 1966 was certainly far removed from the aesthetic and financial struggles he had faced at the decade's outset. And despite *Look Mickey*'s seminal status, the painting was repeatedly linked by the artist to insinuations of inadequacy, of failure. In what has emerged as a standard account of the work's genesis, for instance, Lichtenstein claimed that he decided to paint

Look Mickey, 1961. Oil on canvas,
48 × 69 inches. National Gallery of
Art, Washington, D.C., Gift of Dorothy
and Roy Lichtenstein in Honor of the
Fiftieth Anniversary of the National
Gallery of Art. © Board of Trustees,
National Gallery of Art, Washington,
D.C.

his duck-and-mouse scene as a favor to his youngest son Mitchell, who
had been embarrassed at school by the incomprehensibility of his father's
occupation as a (then) abstract artist. Such a comic book image, so the tale
goes, would prove to both Mitchell and his elementary school classmates
that the elder Lichtenstein was a skilled craftsman, not, as his son's friends
had claimed, "somebody who paints abstracts because he's no good at
drawing."[3] In a second well-known story, that of Lichtenstein's unveil-
ing of *Look Mickey* to Allan Kaprow in the summer of 1961, the paint-
ing's emergence is similarly tied to a declaration of incapacity. As Kaprow
recounted:

> Roy and I were sitting in his converted bedroom, which was a studio,
> talking about pedagogy. For example, how do you teach art from
> Cézanne? I said you don't. That was my opinion. I said, "What you
> do—" and the kids had just come back with a bag full of Double

Bubble chewing gum. They always had little cartoons inside, wrapped around the bubble gum. I said, "This is the way you teach color, and volume, and composition." . . . Roy sort of looked at me with a slight grin. [. . .] I said, "Cézanne's much too complicated. You'll never really teach Cézanne. It's just ninety-nine percent intuitive. This collapsing of space, and several viewpoints at the same time, will go right over the heads of the students. This is the way to do it. Teach them how to make cartoons," and he smiled at me. A half smile. [. . .] So he flipped through a couple of [canvases tacked to the wall] and up came Donald Duck.[4]

I cite this passage in its entirety not just because nearly all of Kaprow's memories of that day have become fixtures of Lichtenstein lore, but also because so many of them are crucial to understanding the status of *Look Mickey*—its "firstness," real or imagined—in the artist's pop oeuvre. For in addition to the bubble gum comics and pedagogical context it shares with the story of Mitchell Lichtenstein's classroom woes, Kaprow's account introduces the figure of Cézanne and the issue of deskilling; indeed, it weaves these two together, situating the latter as a necessary response to the former's massive accomplishment. *Look Mickey*'s importance, I think, lies in its status as an examination of just this situation: one not so much of failure as of loss, of a kind of impotence in the face of both Cézanne and art history itself. The painting marks Lichtenstein's realization, as he recounted in 1996, that he could only create an original work of art "by doing something completely unoriginal."[5]

Just what was involved in this recognition, and how can we understand its place as the hinge between Lichtenstein's "pre-pop" and "pop" careers? I want to approach these questions in what follows both by reconsidering the artist's creative milieu circa 1960–61—years he spent on the art faculty of Douglass College at Rutgers University, with colleagues and students including Kaprow, Robert Watts, Geoffrey Hendricks, and George Brecht—and, especially, by looking again at *Look Mickey* itself, as both pictorial narrative and historical artifact. Lichtenstein's seminal 1961 painting, I want to argue, is *about* just the issues raised above: about beginnings, history, and painting and the (im)possibility of originality. And it is through these concerns that we can better situate Lichtenstein's faulty memories of the work in his 1966 discussion with Sylvester; for these memories betray a desire to forget not just the precise iconographic ordering of his inaugural pop work, but also—and above all—the precarious representational stakes that had determined its creation just five years before.

1 Art and Objects

First, to Rutgers. Lichtenstein joined the university's faculty in the autumn of 1960, teaching design and introductory drawing. Having already taught for two years at the State University of New York at Oswego and exhibited annually in New York galleries for the better part of a decade (his most recent paintings consisting of tightly locked ribbons of viscous color, the final stop in what would prove to be a frustrating three-year detour through abstraction), he came to the school as a mildly successful, if aesthetically somewhat conservative, thirty-seven-year-old artist.

Or rather, a mildly successful and aesthetically conservative *painter*. For Lichtenstein in 1960 remained adamantly committed to both painting as a medium and the understanding of this he had formed under his teacher at Ohio State University in the late 1940s, Hoyt Sherman. Sherman's pedagogy, Lichtenstein explained to the critic Gene Swenson in 1963, had done nothing less than explain "what art is all about" for him—the answer to this, he continued, being "organized perception."[6] Sherman's preferred phrase for the same was "perceptual unity," what he described in his 1949 treatise *Drawing by Seeing* (written while Lichtenstein was his teaching assistant) as the "satisfactory pictorial organization [of a work of art] . . . in such a way that all points are related to a focal point."[7] Rooting his thought in both Gestalt psychology and John Dewey's conception of the "felt unity" of aesthetic experience, Sherman understood such satisfactory organization to result from the fusion of normally distinct sensual "channels," above all vision and touch, in the production of works of art. Or, as Lichtenstein himself put it in one of the poems that opened his 1949 MFA thesis (for which Sherman served as primary advisor), "You must first feel, then see./You must feel until you see./You will see what you feel."[8] To foster such integrated perception, Sherman designed an elaborate pedagogical program around what became known as the "flash lab," a light-sealed classroom in which students would sketch after slides projected by a tachitoscope in rapid-fire succession at the front of the hall. This facility, a crude version of which was built by Lichtenstein immediately upon his arrival at Rutgers, was to serve as a kind of pure aesthetic space—one in which "drawing by seeing" would be free from both disharmonious optical intrusions and what were dismissed as the corrupting "verbalisms" of art historical chatter.[9] In such isolation, Lichtenstein and Sherman equally believed, aesthetic vision could best be fostered and the central artistic goal of "perceptual unity" achieved.

This certainly sounds a far cry from Kaprow, Watts, and the rest of Lichtenstein's Rutgers colleagues, nearly all of whom were enthusiastically allied not just against painting's hegemony, but *for* modes of artistic practice that were explicitly fragmented and diffuse. As Kaprow had concluded his seminal 1958 *Art News* article on "The Legacy of Jackson Pollock," "[a]n odor of crushed strawberries, a letter from a friend or a billboard selling Draino, three taps on the front door, a scratch, a sigh or a voice lecturing endlessly, a blinding staccato flash, a bowler hat—all will become materials for . . . new concrete art."[10] This vision, if not exactly a shock for Lichtenstein (who surely would have known Kaprow's article and work before coming to Rutgers), certainly must have put the new professor in an odd place: he suddenly found himself, just three years after having left Ohio and eight years after his drawings had unleashed a minor Cleveland art scandal, by far the most conservative artist in his milieu.[11]

In the autumn of 1960, Lichtenstein's sense of his own relative conservatism would have been particularly acute. That season, both Kaprow and Brecht, as well as recent Rutgers graduates Whitman and Lucas Samaras (and, incidentally, Lichtenstein's earlier OSU student Tom Doyle), exhibited works in the second installment of the much-discussed show *New Forms—New Media* at New York's Martha Jackson Gallery. The exhibition—comprised, in its two installments, of the work of nearly 100 artists including Claes Oldenburg, John Chamberlain, Bruce Conner, and Dan Flavin, as well as more established figures including Alberto Burri and Kurt Schwitters in an "Historical Section"—attempted both to introduce and establish a historical genealogy for what Lawrence Alloway, in his accompanying essay, termed "New York Junk Culture." Though Schwitters was perhaps the closest historical precedent for such work, Alloway argued, the contemporary artists in the show rejected the German's "album and locket aesthetic" and chose instead to pursue more "factual" means of presentation (or at least what appeared as such at the time). "[These artists'] objects are assembled factually," wrote Alloway, and "their original identity stolidly kept."[12]

Despite the explicit historical genealogy at the center of the *New Forms—New Media* show, nearly all commentary on the exhibition, both pro and contra, focused on the fundamental challenge posed by the work it included—incorporating materials from ping pong balls to garter belts to coffee grounds—to then-current aesthetic models. Hilton Kramer, in *Arts*, discussed what he saw as its regressive celebration of the "journalistic mind"; Thomas B. Hess, in *Art News*, wrote of "a new collective dive into

sociology, into the streets"; and Kaprow, in a statement in the exhibi-
tion brochure adopted from his forthcoming *Paintings, Environments, and
Happenings*, described "a shift ... to the work of art as a situation, an
action, an environment or an event."[13] All of these commentaries pointed
to models of activity beyond the simple making of objects, to the *extension*
of the work of art (the word is stressed in Kaprow's essay) to include new
materials, activities, spaces, and audiences. Concomitant with this move,
as again both supporters and detractors agreed, was a shift of attention
away from the primacy of artistic "transformation" to the straightforward
presentation of objects, actions, and situations.

Such ideas had been circulating in contemporary art discourse for
several years, as evidenced by Kaprow's influential Pollock essay of late
1958. But for Lichtenstein—having just recently moved to the New
York City area and begun working with Kaprow and the other Rutgers
participants in the Martha Jackson show—the critical debates surround-
ing *New Forms—New Media* must have been startlingly resonant.[14] Here
was work that was not just noticed, but heatedly argued about, desig-
nated as nothing less than revolutionary by the editor of *Art News*. And
the source of this attention was precisely its opposition to everything
Lichtenstein had understood art "to be all about" up to that point: here
the "harmonious relations" of perceptual unity were superseded by an
urge "to reach out ... [and] give the spectator's hand a good shake or
nudge him in the ribs" (Hess); the move to fuse the essential creative acts
of drawing and seeing had regressed to a celebration of "mass-produced
objects, just because they are what is around" (Alloway); and the absolute
differentiation between "verbalisms and drawing reactions" so central to
Sherman's pedagogy was emphatically blurred by what Kramer, the lone
detractor of my sampling here, termed "the effort to turn rhetoric itself
into a substitute for experience."[15]

And yet, this same work could just as easily be seen as a realization—if
in completely unexpected form—of the very same aesthetic principles so
vigorously championed by Lichtenstein's mentor. For the rhetoric of order
and integration that filled Sherman's pedagogical writings was accompa-
nied by a call—obliquely stated but apparently crucial for Lichtenstein's
understanding of his teacher's thought—for just the kind of "extension"
heralded by Kaprow in his Jackson Gallery text. This was what Sherman
described as the artist's "letting himself go": the generation, through the
pursuit of pictorial integration, of "a harmony ... among the many parts

of oneself and between oneself and the universe."[16] As Sherman described this in *Drawing by Seeing*:

> [In artistic production] one . . . lets *himself* go, while responding to a concourse of kinesthetic, tactile, psychological, auditory, and optical sensations which somehow take order without the ego being there to boss it. They discover a new center of focus in themselves which allows all of themselves to blend in a harmonious relation with the universe around them.[17]

Just as this process was linked by Sherman and his allies to a furthering of democratic principles (for it was held to be accessible to all, not just trained artists, and thus to serve the cause of broader social integration), so the work that filled *New Forms—New Media* was explicitly, even adamantly, populist, seeking as it did to expand the definition of art beyond established "expert" boundaries, while still maintaining connections to a distinguished lineage reaching back to earlier European avant-gardes (thus evidencing an essential rootedness in history, another of Sherman's essential criteria for successful artistic work).

Of course, Lichtenstein remained resolutely committed to painting even after his Rutgers appointment, and there is no reason to believe he ever wavered in his commitment to the medium. But by the time he joined the university in late 1960, he clearly was at an impasse as to what, and how, to paint—uncommitted to his recent forays into abstraction, he found himself consumed by thoughts, as he later remarked, of the most elementary books on "how to draw."[18] This was still the question Lichtenstein had not answered—as he well knew—by the fall of 1960; he remained trapped between an abstraction in which "there were no spaces left," as he told John Coplans in 1963, and a figuration in which the only apparent option was to lurk endlessly in the shadow of the still magnificently productive—and innovative—Picasso.[19] It was through the lens of this inability that he would have examined the "new forms" at the Martha Jackson Gallery, and seen their connections to his own artistic training, and understood the new aesthetic directions they opened up— directions that at first glance appeared to lie outside the bounds of painting altogether.

If the wholesale dismissal of the painted canvas in favor of less traditional objects and actions failed to draw Lichtenstein on board, however,

the objects chosen by Kaprow and other "junk" artists certainly gained his attention—both in their "American-ness" and straightforward facticity. [20] And what he appears to have realized, at some point in early 1961, was that the place of the simple object in his oeuvre would be not as the substance of the work of art itself, but in the most straightforward and "objective" representation of things in the world—and specifically, of objects (including tires, socks, and spent cigarettes) chosen precisely for their tawdry ubiquity. What Lichtenstein would henceforth attempt was to transfer the populist and nontransformative aesthetic of the new art he was then encountering into the medium that was, and had been, his only real aesthetic concern: painting. This was the motivation behind his many deadpan single-object paintings of 1961 and 1962, the contents of which frequently appear directly borrowed from Kaprow's environments and happenings (such as in 1962's *Tire*, which recalls Kaprow's seminal *Yard* of just a year before), or even from Alloway's 1960 list, in the *New Forms—New Media* brochure, of "suits, shoes, razor blades, radios, records, friends" as appropriate materials for works of art; all of these items, save records, would become the exclusive subject matter of subsequent Lichtenstein images. The artist's two early radio paintings of 1961 and 1962 even included a leather strap and metal antenna, situating them as the closest Lichtenstein would come to actively blurring the boundaries between painting as discrete representational space and as a physical object among others in its environment.

As the number and strength of the paintings Lichtenstein executed in 1961–62 testify, the artist's recognition that he could build his work around the simple, dead-pan presentation of what he termed "American rather than School of Paris objects" was clearly a liberation, allowing him both to return to central elements from his earlier oeuvre—above all figuration and an explicitly American subject matter—and to escape, it seemed, the long shadow of Picasso that had plagued him throughout the 1950s. As Kaprow later commented, the Rutgers artists' interest in untransformed everyday objects "served as a kind of permission note" for Lichtenstein, indicating to him that "you don't have to [produce what looks] like art to be an artist."[21] Indeed, if Lichtenstein's 1950s oeuvre had been plagued precisely by looking too much like "art," his response to this new permission note was to produce work so inartistic that he felt compelled to hide it away in the depths of his studio—until, of course, his fortuitous conversation with Kaprow in the summer of 1961.

Tire, 1962. Oil on canvas, 68 × 58 inches. The Museum of Modern Art, New York, Fractional gift of Mr. and Mrs. Donald G. Fisher in honor of Kirk Varnedoe. © Estate of Roy Lichtenstein.

Radio (with leather strap), 1962. Oil
on canvas with leather strap and
aluminum stripping. 17¼ × 20 inches.
Private collection, San Francisco.
©Estate of Roy Lichtenstein.

In *Look Mickey*, the "object" Lichtenstein presents is an image itself.
A semiotic cousin of the painted target by Jasper Johns that had graced
the cover of *Art News* in January 1958, Lichtenstein's painting is both a
comic *and* a picture of one—the joke of Donald Duck's catching his own
behind is no less effective painted on canvas than printed on the cheapest
comic book pages. In fact, *Look Mickey* evidences more "transformation"
than nearly all of the artist's early-'60s comic paintings for which source
images are known.[22] As a recently discovered children's book illustra-
tion on which Lichtenstein based his 1961 painting reveals, he not only
removed extraneous figures and radically flattened the pictorial space of
his model, but rotated the dock on which its central action transpires by
ninety degrees, directing this away from, rather than toward, his beholders
(while positioning Mickey Mouse and Donald Duck, despite this new axis,
almost precisely as in the original image).[23] There is no denying that he
created a more unified image through these changes, one even Sherman

could praise: we see this in his reconfiguring of the diffuse space of the original picture into streamlined bands of blue and yellow; his rotating of the dock's planks to guide, rather than cross against, its extension into the water; his redesign of Donald's body and taut rod into a perfectly balanced egg-like ellipse; his eradication of such particulars as wrinkles or marks of exertion; his shifting of Mickey's fishing pole to continue the vertical extension of the pylon beneath it; or, finally—for such a list could surely continue—his careful rhyming of this same pole's excess wire with the outline of Donald's rear immediately to its left. *Look Mickey*, in short, is a meticulously composed image—even as it wears the guise of its opposite, posing as a simple-minded mimicry of industrial mass culture.

Illustration by Bob Grant and Bob Totten from Carl Buettner, *Donald Duck Lost and Found*, 1960. ©Disney Enterprises, Inc.

Lichtenstein's painting in fact appears more the product of industrial manufacture than the very pulp image on which it is based. And therein, I think, lies the work's primary significance: it marks Lichtenstein's realization that he could only approach the aesthetic ideals that had driven his earlier oeuvre by simultaneously opposing them—that the pursuit of Shermanesque aesthetic integration necessitated an embrace of precisely the everyday commercial detritus, mechanized forms, and corrupting "verbalisms" to which the program of perceptual unity was ostensibly opposed. This was a fundamental paradox, and an equally fundamental realization for Lichtenstein himself in 1961: that being an artist meant producing what didn't look like art, just as being original would mean questioning the very notion of originality itself.

2 Lichtenstein's Narcissus

Look Mickey is not just (or even) an image of an image. It is, rather, an image *about* image-making, and, specifically, about Lichtenstein's own medium of painting. What it ultimately presents us, I want to argue, is a self-portrait: a statement and study of the conditions defining Lichtenstein's own practice as a painter circa early 1961.

Why not start at the beginning, then, with the birth of painting itself? For curiously enough, this is just what Lichtenstein's painting shows us, in its none-too-strange retelling of the story of Narcissus—the figure who has "haunted" Western painting since its modern inception in Renaissance Florence, when he was named as the father of the medium by none other than Leon Battista Alberti. "What is painting," Alberti asks in his seminal *De pictura*, "but the act of embracing by means of art the surface of the pool?"[24] And just as Narcissus gazes in his pool and unwittingly falls in love with his own image ("and found a substance," Ovid recounts in his *Metamorphoses*, "[i]n what was only shadow"), so Donald stares in the water before him and exclaims that he has finally snared a catch—which, we know, is only himself.[25] Lichtenstein even forms the duck's elliptical circuit of body, pole, and jacket as if to echo the central libidinal channel of what is perhaps the greatest pictorial representation of Narcissus' fate, Caravaggio's canvas of circa 1597–99 at the Palazzo Barberini in Rome.

If the analogy between Narcissus and Donald is more immediately evident in Lichtenstein's source image, in which the latter's blurry reflection hovers on the surface of the water and appears to be the immediate object of his intense gaze (something Lichtenstein, a careful student of

Caravaggio (Michelangelo Merisi da),
Narcissus, ca. 1600. Galleria Nazionale
d'Arte Antica, Rome. Oil on canvas,
43¼ × 36¼ inches. Photo: Alinari/Art
Resource, New York.

images if ever there was one, surely did not miss), *Look Mickey* explicitly situates the painting's maker himself within the self-enclosed narcissistic circuit at its center. For while Lichtenstein simplifies Donald's reflected visage to a subtly stylized and barely noticeable ripple on the water below, he also places his own signature—a simple blue "rfl"—squarely in the duck's field of vision. And even beyond his plight's parallels to that of poor Narcissus and his unfocused gaze at the initials in the water before him, Donald is figured here as a kind of surrogate for the image's creator. For does his fishing rod resemble anything so much as a painter's brush, ending here in a flat, unmodulated field of blue of precisely the sort that would become, very shortly, "classic" Lichtenstein? (Indeed, this field is even filled here with two large yellow dots.) And does Lichtenstein not balance the clean white form of Donald's body and word balloon with an amorphous and equally white splotch (accompanied by two drips) in the lower-right corner, one that more closely resembles spilt paint than the water we can assume it is meant to represent? As if to direct our attention to this connection over a decade later, the first of Lichtenstein's *Artist's Studio* paintings, of 1973, is presided over by none other than the Donald Duck of *Look Mickey*, which the artist has carefully cropped to exclude all of Donald's more famous partner save for his hand, fishing pole, and foot. In thus positioning his image within an image, Lichtenstein both situates Donald as the primary figure in his "artist's studio," and presents an interior composed of earlier Lichtenstein works as the explicit object of the duck's (narcissistic) gaze—just as was Donald for Lichtenstein himself in making his 1973 image. In cropping out all of Mickey but his hand, foot, and pole, furthermore, Lichtenstein focuses his viewers' attention on these elements' place in the reflection on artistic production that *Artist's Studio* presents—and, by extension, on their metaphorical place in the story of painting's origin (as well as Lichtenstein's own) provided by *Look Mickey* twelve years before.[26]

The origin that *Look Mickey* presents is in fact of painting as an act permeated by textuality, and one that through this permeation effects a negation of precisely the integrated bodily experience that Lichtenstein, following Sherman, had understood to be the essence of aesthetic activity. For however big Donald feels his catch to be, he apparently senses nothing of the yanks at his own back side. This fact, all but ignored in discussions of the painting, is the very engine of its narrative. Donald is an explicitly *divided* subject, all sensory experience on one end and, literally, numbness on the other (and, visually, all depth and all flatness—for Donald's face is

Artist's Studio: "Look Mickey," 1973.
Oil, Magna, and sand on canvas,
96 ⅛ × 128 ⅛ inches. Walker Art
Center, Minneapolis, gift of Judy
and Kenneth Dayton and the T. B.
Walker Foundation. © Estate of Roy
Lichtenstein.

by far the painting's most spatially illusionistic element, while his caught jacket, merged with the schematic waves behind it, is emphatically one of its flattest).[27] Indeed, Donald is a portrait of precisely the *separation* of sight and feeling, vision and touch—of the very fissure Sherman's flash lab, as the broader perceptual unity project of which it was a part, had been committed to eradicating. And what divides vision and touch in *Look Mickey*, what marks this shift between them, is text: the words that Donald (and Lichtenstein) introduces to the scene, and which the duck's pole-cum-brush passes through before snagging his own back end.

Donald's words in the painting take looking as their explicit subject and, within this, foreground the necessary slippage between the iconic and symbolic functions of both word and image.[28] In "look" as in "hooked," we see Donald's double-o's hovering as parts of words *and* as visual echoes of their speaker's own two eyes, as elements to be both seen and read (and

that themselves, we could say, both speak and see).[29] This equivocation is reinforced by the nervously delineated underwriting, only visible up close, that hangs on Donald's terms (most conspicuously the two I have specified here) like a nagging ghost, dividing them from themselves. Just as Donald's spoken words animate the sudden numbness of their speaker, then, so they blur the boundaries between looking and seeing, and conflate the organs of vision with the symbols of writing—while, at the same time, transforming Lichtenstein's viewers' perceptual experience (that of looking at an image) into one of, quite literally, reading a text. Is it any wonder that Donald's eyes (together with Mickey's red face) mark the introduction of Benday dots to Lichtenstein's oeuvre? They are thus both marked as an import from the printed page, and represented as a screen—the very figure, for psychoanalyst Jacques Lacan, of the cultural discourses that saturate perceptual experience (what Lacan terms "the gaze"), subsuming the notion of unmediated vision within the differential logic of signs, of *visuality* as a social construct.[30]

Lacan's conception of the discursivity of vision—and of our emergence as subjects within this discursive field, through the mediation of the screen—is not far from the concerns I am sketching here for Lichtenstein's image, concerns that surround the move from painting as a confluence of vision and touch to one of vision and textuality. We should note, in this connection, that Donald's exclamation in *Look Mickey* is absent from Lichtenstein's original source image; there, words are missing from the scene entirely, with Donald's utterance only recounted in the accompanying narrative text. Rather than maintaining this original separation, Lichtenstein chose to build his painting around precisely the combination of word and image as an integrated unit. Beyond this single image, however, Donald's textual exuberance marks the inauguration of the written word as a primary compositional and semiotic component within Lichtenstein's oeuvre. Though text did occasionally appear in the artist's images of the 1950s, such as *Weatherford Surrenders to Jackson* (1953), it was almost always as mere accessory label—small, pushed to the perimeter, and wholly subservient to other visual elements. In *Look Mickey*, by contrast, Donald's words are dominant: they provide the image's title, clarify its narrative, and animate its formal organization, all elements that would continue to be true of Lichtenstein's use of words for years to come. Most significant, however, beyond the particular text *Look Mickey* includes, is the image's prioritizing of the differential logic of the linguistic sign, of discursivity itself, as a constitutive element of the practice of painting. For

Donald's predicament not only tells us a joke about his own specific failure to "reach out and seize" the world—what Sherman had declared to be the central task of the painter—but, as represented by Lichtenstein, demonstrates the impossibility of such a goal for the painting's creator himself.

Look Mickey is, Lichtenstein knew, most powerful in its abdication of any such claims to sensual experience. In its disembodied flatness, emulation of the effects of mechanical reproduction, and desire to appear both unoriginal and inartistic, *Look Mickey* points to aesthetic significance as a product not of the integration of vision and touch, self and world, but of reference to other representations and signs, of an image's own discursive position within a spectacular culture in which claims to authenticity, originality, and intuitive experience were being dismissed as themselves nothing more than simple convention—nowhere more so than in the New York art world.[31] And yet, as we have seen, the image is

Weatherford Surrenders to Jackson,
1953. Oil on canvas, 42 × 50 inches.
Private collection. © Estate of Roy
Lichtenstein.

clearly *composed*, motivated by the same imperatives of unity and good aesthetic form—and, related to these, of the very redemption of sensual experience in the face of modern mass culture's levelling force—that had driven both Lichtenstein's art education and his earlier work as a painter. It is this paradox, the slippage between these two seemingly opposed projects, that we see in Donald's hapless plight—which is, I mean to say, Lichtenstein's own.

What of Donald's partner in Lichtenstein's image, the equally prominent (and, after all, much more famous) mouse of its title? If Donald is the image of self-delusion, Mickey is that of self-assurance, firmly grasping his fishing rod with one hand and holding his mouth shut (and containing a certain howl—or at least squeak—of laughter) with the other.[32] Indeed, just the hands of these two figures make this opposition clear: the former's are puffy stumps, seemingly barely capable of even the lightest grasp, much less the intense struggle Donald declares them to be engaged in (the schematic marks of which—evident in Lichtenstein's source image—have been completely eliminated in *Look Mickey*); the latter's, all but human save for an absent fifth finger, are oversized and utterly firm of grasp, obscuring Mickey's mouth almost entirely and squeezing his rod, it appears, to near nothingness.

Narcissus may be helpful again here, though this time in a slightly more modern guise. For in Sigmund Freud's retelling of Ovid's tale—perhaps, by now, the best-known version of all—its self-loving protagonist is forced to turn his desire inward only because of the repression of his attachment to external objects. And the force of this repression is the subject's own cultural and ethical ideas, manifested in what the founder of psychoanalysis, in his 1914 essay "On Narcissism: An Introduction," terms the "ego-ideal"—the formation of which, Freud writes, is prompted by:

> the influence of parental criticism (conveyed to [the subject] by the medium of the voice), reinforced, as time [goes] on, by those who trained and taught the child and by all the other persons of his environment—an indefinite host, too numerous to reckon (fellowmen, public opinion).[33]

Now, I don't want to dwell here on Freud. My point is simply to suggest an analogy between his basic sketch of the narcissistic scenario and the shared plights of both Lichtenstein and Donald—and through this, to

speculate on the place of Mickey in Lichtenstein's inaugural pop work. For like the subject of Freud's 1914 essay, Lichtenstein's story to 1961 was one of repressed cathexes, of disallowed attachments to external objects (as a figurative practice would make possible) and materials (through a historically viable abstraction) alike. And Lichtenstein's response to this was, precisely, to turn his erotic attachments inward—that is, to build his aesthetic project out of the self-referential imaging of other representations, of pictures known above all for their cheapness, falsity, and lack of connection to the world "out there." This was just the criticism thrown at Lichtenstein's early pop pictures themselves: that they were "not transformed by aesthetics [. . . but replaced] aesthetics," or that they revealed just "how terrorized [Lichtenstein] is of being a real artist."[34] This rhetoric—the central tropes of which have become standards of much art criticism over the past half century—rehashes the terms of Freud's discussion above: it is one of displacement and fear, of a subject held captive by a disciplinary gaze regulating both actions and desires alike.

Lichtenstein himself, in discussing his move into a pop idiom, consistently referred to the foreclosed aesthetic avenues that had led him to *Look Mickey*'s industrialized pictorial syntax. To John Coplans, for instance (in a comment noted above), he named "desperation" as his central motivating force, a desperation brought about by the perception that "there were no spaces left between Milton Resnick and Mike Goldberg."[35] And to John Jones, in a discussion of the dearth of "plastic innovation" initiated by pop artists, he commented that "at this moment . . . every kind of direction—Realism, and all kinds of abstraction from the strictly geometric to automatic writing—has been explored. . . ."[36] These are typical laments of any advanced late-twentieth-century artist, and they are those out of which, against all odds, aesthetic innovations have always emerged. But for Lichtenstein these frustrations had, by 1961, become a kind of albatross, presided over by those figures he saw as the current title-bearers of the modernist lineage: Picasso and (as the dominant figure in contemporary abstraction) Willem de Kooning. It was these two twentieth-century masters—whose shadows Lichtenstein had already spent the good part of a decade trying to move beyond—who filled the role of Freud's "fellowmen" for the artist circa 1960–61. And it is they, as the most recent and resonant embodiments of the historical continuum constituting "the way of art," whose accomplishments had formed Lichtenstein's ego-ideal and—through the modernist myth of nonrepeatability—established such a far-reaching set of proscriptions that the artist turned to a mode of

painting that he himself considered "brutal," "antiseptic," and "completely unoriginal."[37] Indeed, the artist described this turn as one whose motivation escaped his own conscious understanding, telling Alan Solomon in 1965 that he had "no idea why" he had chosen such a formal direction.[38] Likewise, he repeatedly referred to his works as utterances over whose significance he ultimately had little authority, telling Bruce Glaser in 1964 (referring to his adaptations of Picasso and Mondrian) that "the things I have apparently parodied I actually admire, and I really don't know what the implication of that is," or remarking to a German interviewer ten years later that his work "has to be read" as "symbolic of commercial art sanitizing human feelings"—even though, he continued, "I don't know it's purposeful on my part."[39]

If Donald can be read as Lichtenstein as Narcissus, then, I am suggesting we see Mickey as Cézanne/Picasso/de Kooning, and understand all of these together as constituting the art historical superego looming over Lichtenstein at the moment of *Look Mickey*'s creation. The mouse's firm and upright straddling of the image's white "paint splotch," his tight grasp of his fishing-rod-cum-paint-brush and control over the flow of his speech, even his premiere place vis-à-vis Donald in the Disney pantheon of characters (particularly in 1961, when *The Mickey Mouse Club* was still a television sensation on ABC): all of these position him not just in a position of authority and knowledge where his companion lacks both, but, precisely, in one of *symbolic* authority, of control over signs, images, and utterances.[40] And it is in this context that Lichtenstein's confusion about *Look Mickey* in his 1966 interview with David Sylvester becomes particularly telling. Coming at a point when the artist was moving definitively beyond the pulp imagery of his early-'60s oeuvre, and at which he had already produced successful reappropriations of the work of all three masters noted above, his reversal of the roles of Donald and Mickey in his 1966 recollections betrays a desire to revise the terms of the self-portrait I am arguing the image represents.[41] By 1966, Lichtenstein was ready to move beyond the thwarted object attachments and slapstick textual exuberance that characterize the hapless Donald, to occupy Mickey's position of epistemological and symbolic control.[42]

3 Bodies and Machines

Let's remain for now with Narcissus and 1961. For if there were ever a time and place in which the name of Ovid's tragically deluded young

lover spoke to a range of contemporary concerns and desires, it was the United States just around that year. And indeed, it was Freud's Narcissus that carried such cultural resonance, though not the repressed figure of his 1914 essay discussed above. Rather, it was the notion of *primary Narcissism*—that pure, undifferentiated libidinal state prior to the separation of ego and external world and the concomitant onset of the repressive apparatus—that, through the popularizing efforts of cultural critics Herbert Marcuse and Norman O. Brown (among others), had become a cultural phenomenon arguably to rival even Mickey Mouse himself.[43] Central texts in this process were Marcuse's *Eros and Civilization*, first published in 1955, and Brown's *Life Against Death: The Psychoanalytical Meaning of History*, of 1959.[44]

In these widely discussed, even period-defining, books, Brown and Marcuse sought to rethink the operation of repression within both Freudian theory and the broader cultural field in which both authors were writing, that of the late-'50s United States.[45] Above all, Brown and Marcuse aimed to challenge Freud's dictum that civilization was necessarily founded on, and rooted in, repression—instead calling for a "resurrection of the body [as] a social project facing mankind as a whole."[46] The first step in this process was a recognition of what Marcuse, betraying his Frankfurt School origins, termed "surplus repression"—the excess restrictions beyond those necessary for the advancement of the social whole, and serving merely the exercise of domination by power itself ("the apparatus").[47] For Marcuse, the conditions producing this surplus repression had also brought about the opportunity for its subversion; for the same technological innovations enabling greater repressive control of daily life had also generated, through increased mechanization of productive processes and the overcoming of material scarcity, a situation in which the ever-increasing productivity of labor had ceased to be a central imperative, and in which the "the antagonistic relation between pleasure principle and reality principle" could thus "be altered in favor of the former," enabling nothing less than the emergence of a non-repressive civilization.[48] The result of this would be that the body, "no longer used as a full-time instrument of labor, ... would be resexualized"—a resexualization encompassing "not simply a release, but a *transformation* of the libido: from sexuality constrained under genital supremacy to erotization of the entire personality."[49]

Narcissus, for both Marcuse and Brown, was the figure of this transformation. Brown wrote that "narcissism, like Narcissus, would be a

fountain of play and of erotic exuberance," while Marcuse, discussing
Freud's description in *Civilization and Its Discontents* of the primary narcis-
sistic state as one of "limitless extension and oneness with the universe,"
commented:

> The striking paradox that narcissism, usually understood as egoistic
> withdrawal from reality, here is connected with oneness with the uni-
> verse, reveals the new depth of the conception: beyond all immature
> autoeroticism, narcissism denotes a fundamental relatedness to real-
> ity which may generate a comprehensive existential order. In other
> words, narcissism may contain the germ of a different reality prin-
> ciple: the libidinal cathexis of the ego (one's own body) may become
> the source and reservoir for a new libidinal cathexis of the objective
> world—transforming this world into a new mode of being.[50]

This new mode of being, Marcuse and Brown both concluded, would be
guided by aesthetic, rather than performance, imperatives—the former
term being understood in the sense of the ancient Greek *Aisthetikos*, for
that which is "perceptive by feeling," or what Terry Eagleton has described
as "nothing less than the whole of our sensate life together—the business
of affections and aversions, of how the world strikes the body on its sen-
sory surfaces, of that which takes root in the gaze and the guts and all that
arises from our most banal, biological insertion into the world."[51] Both
Brown and Marcuse, in turn, looked back to Friedrich Schiller, and spe-
cifically his *Letters on the Aesthetic Education of Man* of 1795, for a concep-
tualization of what this "aesthetic turn" might mean, finding in Schiller's
identification of the play-drive as a mediator between form and sense an
early proposal for the "abolition of the repressive controls that civilization
has imposed on sensuousness," "the possibility for a new reality principle,"
a way "to regain the lost laughter of infancy."[52]

It's impossible to say whether or not Lichtenstein had read Marcuse or
Brown, or if he shared even the slightest interest in their proposals. He
was, it's fair to assume, at least vaguely aware of their arguments, which by
the early 1960s had spread far beyond the academic confines out of which
they had sprung.[53] What I want to suggest here is that the terms of both
thinkers' cultural analyses overlap, to an extraordinary degree, with a range
of cultural discourses informing Lichtenstein's aesthetic thinking, and ani-
mating his practice, in these years, and that in this, we can see something

of the complex field of issues at play in both *Look Mickey* and much of the artist's subsequent oeuvre.

Marcuse's and Brown's calls for a renewed reality principle, for instance, strikingly resemble Sherman's claims that aesthetic activity constituted a fundamental reordering of the relationship between subject and world. As Lichtenstein's teacher had argued that the artistic act was built of a "concourse of . . . sensations which somehow take order without the ego being there to boss it" and resulted in a "special kind of happiness which comes when a harmony is established among the many parts of oneself and between oneself and the universe," so Marcuse and Brown hailed the narcissist's "fundamental relatedness to reality" and called for a new aesthetic attitude to emerge from this. Indeed, Sherman's pedagogy was driven by precisely the same dialectic as that at the heart of Marcuse's *Eros and Civilization*—that of machine and body, mechanization and liberation, reason and sensuousness. Just as Marcuse saw the growth of automation as opening the possibility for a transformation of human bodily experience rooted in a renewed cathexis to the objective world, so Sherman utilized mechanistic means, above all the flash lab's tachitoscope, to reconnect his students with "the universe around them" and integrate what he saw as destructively separated sensual drives.[54] For both theoreticians (as for Brown), these projects were to be realized in aesthetic activity, and were understood as enabling a metaphorical return to the innocence of childhood—one made possible through the unlearning of "verbalisms" (Sherman), or the willed "regression" involved in rejecting the institutions of civilized rationality (Marcuse)—in which the realization of true liberation and integration would become possible.

To the words of Sherman, we can add those of another important figure for Lichtenstein's practice of the late 1950s and early 1960s: Walt Disney, the father of Mickey Mouse and Donald Duck. Here is Disney in a speech of the early 1950s, commenting on his animators' preference for drawing animals rather than humans, a fact he attributes to the excessive physicality of the former:

> Often the entire body comes into play. Take a joyful dog. His tail wags, his torso wiggles, his ears flop. He may greet you by jumping on your lap or by making a circuit of the room, not missing a chair or a divan. He keeps barking, and that's a form of physical expression, too; it stretches his big mouth.

But how does a human being react to a stimulus? He's lost the sense of play he once had and he inhibits physical expression. He's the victim of a civilization whose ideal is the unbotherable, poker-faced man and the attractive, unruffled woman. Even the gestures get to be calculated. They call it poise. The spontaneity of the animals—you find it in small children, but it's gradually trained out of them.[55]

These comments, it is not difficult to notice, mimic almost precisely Marcuse's above. Indeed, the tropes employed by Disney and his more intellectually esteemed counterpart are almost identical: of adult repression versus childhood freedom; of excessive physical containment versus bodily openness and connection to the external world; and finally, accompanying both of these, of "play" as a means of achieving the freedom and openness thus praised. These parallels are real, and hardly a coincidence. For just as Sherman and the broader aesthetic discourse with which he was engaged in the 1940s and '50s, Marcuse and Disney shared a concern for, and partly a vision of, the future of Western society in an era marked by both unparalleled material wealth and the apparent uprooting of previously fixed cultural and political divisions—what Daniel Bell, writing at precisely the same historical moment, famously referred to as a period characterized by "the end of ideology."[56]

But despite their rhetorical parallels, of course, we know that Marcuse and Disney could not have been further apart in their ideological alignments, and that it was the latter's vision of postwar cultural transformation that ultimately reigned triumphant. Indeed, the growth of Disney's empire exemplifies the degree to which the one pole of Marcuse's dialectic—that of mechanization, repression, and the industrial management of everyday life—had come to dominate American culture by the early 1960s. Beginning already with the opening of Disneyland park and television premier of *The Mickey Mouse Club* on ABC in 1955 (the same year in which Marcuse's *Eros and Civilization* was published), Disney built what is arguably the world's premier cultural organization around precisely these principles. Not only did (and do) Disney's theme parks, television shows, movies, consumer products, stores, journals, and comic books sell a vision of happiness grounded in the reinforcement of precisely the repressive norms Marcuse so excoriated, but they achieved this through a seamlessly integrated industrial apparatus that would quickly become a model for both American corporate development and cultural life alike (embodied in the nearly complete integration of just these two spheres).[57] For all

his praise of the uninhibited physical expression of animals and children, Disney created a symbolic world in which God, country, and paternal authority reigned supreme, in which human bodies were literally transformed into machines and the world made into a plastic copy of itself: in which not "play" was the final goal, but rather the maximization of profit within an ever-more-integrated corporate network.

My point here is not to attack Disney or claim that Lichtenstein even thought much about the nature of his empire (though it would have been difficult, given the overwhelming cultural presence the Walt Disney Corporation had become by the late 1950s, not to do so). Rather, I am interested in Disney's practice and discourse—along with those of Marcuse, Sherman, Brown, and even Kaprow—as symptoms of the state of American culture at the end of the 1950s. The easy slippages between the cultural and aesthetic prognoses of these diverse figures— their shared desire (in however wide a form) for a renewed connection between human beings and the world around them, and, related to this, for a return to the free bodily play of childhood—betrays a tension at the time surrounding the body and its place in the broader culture. At the root of this, I think, were the terms that occupied the opposite pole, dialectically or not, in nearly all of these discussions: mechanization and the machine. Marcuse and Brown's ebullient optimism, Disney's calculated business program, Sherman's uneasy negotiation between art and industry: all of these are saturated by a particularly postwar specter of mechanized bodies, of bodies manipulated, managed, and programmed within a culture increasingly rooted in a logic of simulacrum and integrated corporate control—and for which Disney, by 1961, was perhaps the key representative.

Look Mickey, I ultimately want to argue, is part and parcel of just this discourse: it is a work *about* bodies, signs, and the promise—and eclipse— of sensate experience. Indeed, Disney's continuation of the early 1950s speech cited above—in which he isolates Donald Duck as the prime exemplar of the bodily freedom shared by animals but lost in the repressive march of civilization—reads as if a visual description of the painting:

> Look at Donald Duck. He's got a big mouth, a big belligerent eye, a twistable neck and a substantial backside that's highly flexible. The duck comes near being the animator's ideal subject. He's got plasticity plus.[58]

Lichtenstein's painting, we can notice, is built around just these elements—Donald's mouth, eyes, and "substantial backside"—and focuses on precisely the exemplary plasticity of Disney's character. But the artist's Donald is also, as we have seen, *numb* to his own touch. It is precisely this tension—between heightened sensation and absolute numbness, bodily exuberance and the deadening of sensory experience—that animates *Look Mickey*. The painting, finally, is about the movement between just these terms, about the ease with which Marcuse's vision would be transformed into Disney's (or the expansive Narcissus of Marcuse and Brown overwhelmed by the repressed figure of Freud's 1914 essay). And by telling this story through the figure of the artist, Lichtenstein creates an image that is ultimately one of his own fate, and that betrays the imbrication of the specific discourses of painting within the broader cultural tensions of which they are a part. For the return to the figure that Lichtenstein marked with this inaugural Pop work was, after all, predicated on a renunciation of the materiality of the very bodies thus portrayed—these are flat, schematic *signs* for bodies—just as it was rooted in a mimicking of the techniques of industrial image manufacture by the artist himself. Lichtenstein was acutely aware of these contradictions. They would, in the following years, come to structure the entirety of his Pop oeuvre—an oeuvre for which *Look Mickey*, in this case, was very much a "first image" indeed.

Notes

1. Yve-Alain Bois, Jordan Kantor, and Lida Oukaderova are all warmly thanked for their editorical comments.

2. Roy Lichtenstein as quoted in David Sylvester, *Some Kind of Reality* (London: Anthony d'Offay Gallery, 1997), p. 7.

3. Hans Richter, *Dada: Art and Anti-Art* (London: Thames and Hudson, 1965), pp. 204–205. For a consideration of this story as told by Richter and others, see also Michael Lobel, *Image Duplicator: Roy Lichtenstein and the Emergence of Pop Art* (New Haven: Yale University Press, 2002), pp. 34–35.

4. Allan Kaprow as quoted in Avis Berman, "The Transformations of Roy Lichtenstein: An Oral History," in *Roy Lichtenstein: All About Art*, ed. Michael Juul Holm, Poul Erik Tøjner, and Martin Caiger-Smith (Humblebaek, Denmark: Louisiana Museum of Modern Art, 2004), p. 124. Kaprow's account also provides an explanation for the many inaccurate claims that *Look Mickey*'s original source image was a bubble-gum wrapper (as Lobel has recently established, no bubble-gum comics including Mickey Mouse and Donald Duck were even produced at the time; see Lobel, *Image Duplicator*, p. 34). In reporting this fact over the years, Lichtenstein appears to have been confusing the production of the image and the circumstances of its unveiling to Kaprow in the summer of 1961.

5. Lichtenstein as quoted in Joan Marter and Joseph Jacobs, "Interview with Roy Lichtenstein (New York City, March 27, 1996)," in *Off Limits: Rutgers University and the Avant-Garde, 1957–1963,* ed. Joan Marter (New Brunswick, N.J.: Rutgers University Press, 1999), p. 138.

6. Lichtenstein as quoted in Gene R. Swenson, "What Is Pop Art? Answers from Eight Painters, Part I," *Art News* 62, no. 7 (November 1963), p. 62.

7. Hoyt Sherman, *Drawing by Seeing: A New Development in the Teaching of the Visual Arts through the Teaching of Perception* (Hinds, Hayden, and Eldredge: New York, 1947), pp. 1–2. Sherman's pedagogy has been discussed at length in a number of recent publications, most notably David Deitcher's and Michael Lobel's essays included in the present volume and Bonnie Clearwater's 2001 exhibition catalogue *Roy Lichtenstein: Inside / Outside* (North Miami: Museum of Contemporary Art, 2001).

8. Roy Lichtenstein, *Paintings, Drawings, and Pastels* (unpublished MFA thesis, Ohio State University, 1949), p. 5.

9. Sherman, *Drawing by Seeing,* p. 14.

10. Allan Kaprow, "The Legacy of Jackson Pollock," *Art News* 57, no. 6 (October 1958), p. 57.

11. Louise Bruner, art critic for the *Cleveland News*, had derided Lichtenstein's drawings in the paper in 1952 as "truly like the doodling of a five-year-old," a judgment that invited a number of letters to the *News* both defending and further attacking the artist's work. See *Cleveland News*, 1 March 1952; follow-up letters appeared in the paper on 13 March and 12 April of that year.

12. Lawrence Alloway, "Junk Culture as a Tradition," in *New Forms—New Media I* (Martha Jackson Gallery: New York, 1960), unpaginated.

13. See Hilton Kramer, "Month in Review," *Arts* 35, no. 2 (November 1960), p. 50; Thomas B. Hess, "Mixed Mediums for a Soft Revolution," *Art News* 59, no. 4 (summer 1960), p. 62; and Allan Kaprow, "Some Observations on Contemporary Art," *New Forms—New Media I*, unpaginated.

14. Indeed, *New Forms—New Media* is perhaps the only exhibition cited by Lichtenstein as having been important for his aesthetic development at the time. See his remarks in Bruce Glaser, "Oldenburg, Lichtenstein, Warhol: A Discussion," *Artforum* 4, no. 6 (February 1966), p. 21.

15. Hess, "Mixed mediums," p. 62; Alloway, "Junk Culture," unpaginated; Kramer, "Month in Review," p. 50.

16. Sherman, *Drawing by Seeing*, p. 54

17. Ibid., p. 54.

18. Lichtenstein as quoted in Diane Waldman, *Roy Lichtenstein* (New York: Abrams, 1971), p. 25.

19. As Lichtenstein remarked to Waldman in a discussion of Picasso's importance for his 1950s work, "what I was doing wasn't a play on Cubism, it was Cubism." Ibid., p. 25. For Lichtenstein's comments on the limited options available to contemporary artists circa 1961, see John Coplans, "An Interview with Roy Lichtenstein," *Artforum* 2, no. 4 (October 1963), p. 31.

20. As Lichtenstein recounted in 1996, "But the thing that probably had influence on me was the American rather than the French *objects*, the School of Paris *objects*. But, of course,

the Abstract Expressionists had already bypassed the School of Paris *objects*. . . . " (Emphasis added.) See Marter, *Off Limits*, p. 137.

21. Allan Kaprow as quoted in an unpublished interview by Avis Berman for the Roy Lichtenstein Foundation Oral History Project, pp. 46–47. (Excerpts from Berman's interviews with Kaprow and others are included in "The Transformations of Roy Lichtenstein: An Oral History," in *Roy Lichtenstein: All About Art*, pp. 114–133.)

22. The issue of "transformation" became central to discussions of Lichtenstein's work almost immediately with his first Castelli exhibition in 1962. In the most infamous critical salvo regarding the term, University of California art professor Erle Loran threatened—in a pair of coordinated articles appearing in the September 1963 issues of *Artforum* and *Art News*—to sue Lichtenstein for what he claimed was an outright copying of his work. See Erle Loran, "Cézanne and Lichtenstein: Problems of 'Transformation,'" in *Artforum* 2, no. 3 (September 1963), pp. 34–35, and "Pop Artists or Copy Cats?" in *Art News* 62, no. 5 (September 1963), pp. 48–49, 61.

23. Lichtenstein's source image for *Look Mickey*, discovered in the course of research for this essay, comes from a 1960 Little Golden Book entitled *Donald Duck Lost and Found*, written by Carl Buettner and illustrated by Bob Grant and Bob Totten. Atypically for Lichtenstein, the image is from a children's book rather than a comic, and is thus painted rather than drawn and without both voice balloons and panel borders. Lichtenstein adapted Donald's exclamation from the narrative text accompanying this original image, which reads:

> First they went fishing at Catfish Cove. "Look Mickey," cried Donald. "I've hooked a big one." "Land it," laughed Mickey, "and you can have it fried for lunch."

My profuse thanks to Michael Kades for his help in locating this image.

24. Leon Battista Alberti, *On Painting*, trans. Cecil Grayson (London: Penguin, 1991), p. 61.

25. Ovid, *Metamorphoses*, III.21–22. This and following citations are from Rolfe Humphries' translation (Bloomington, Indiana: Indiana University Press, 1983).

26. Lichtenstein suggested a connection between himself and *Look Mickey*'s central protagonist in several later interviews. Discussing the painting and its significance for his subsequent production, he told Milton Esterow in 1991 that "even the quote in the painting, 'Look Mickey, I've hooked a big one!!,' seems so appropriate in retrospect." Bradford R. Collins has recently written that Lichtenstein claimed in an unpublished 1995 interview that "the subject of [*Look Mickey*] is me," though he provides no further details about this statement or its context. See Roy Lichtenstein, "How Could You Be Much Luckier Than I Am?" (interview with Milton Esterow), *Art News* 90, no. 5 (May 1991), p. 90, and Bradford R. Collins, "Modern Romance: Lichtenstein's Comic Book Paintings," *American Art* 17, no. 2 (summer 2003), pp. 64–65.

27. Is it any surprise, within this context, that Narcissus' name derives from the Greek *narcosis*? Marshall McLuhan seized upon this connection in his much-discussed 1964 book *Understanding Media*, arguing that the "extension or self-amputation of our physical bodies" brought about by rapid technological development "puts us in the Narcissus role of subliminal awareness and numbness" in which "[w]e have to numb our central nervous system . . . or die." See Marshall McLuhan, *Understanding Media: The Extensions of Man* (Cambridge, Mass.: MIT Press, 1994), pp. 45–47. For a riveting discussion of the dialectic of sensory alienation and renewal within modernity that touches on the Narcissus/*narcosis* connection, see Susan Buck-Morss, "Aesthetics and Anaesthetics: Walter Benjamin's Artwork Essay Reconsidered," *October* 62 (fall 1992), pp. 3–41.

28. It is worth noting in this context that it is precisely language—and specifically, the division between what is said and what is seen—that ultimately enlightens Narcissus as to the true identity of the object of his desire in Ovid's account. Listing his observations of the natural reciprocity between his own visage and that of the face in the pool, Narcissus then notes: "Your lips, it seems, answer when I am talking/Though what you say I cannot hear. I know/The truth at last. He is myself! I feel it,/I know my image now. I burn with love/Of my own self; I start the fire I suffer." See Ovid, *Metamorphoses*, III.461–465. For a discussion of vision and speech in Ovid's poem, see Kenneth J. Knoespel, *Narcissus and the Invention of Personal History* (New York: Garland, 1985), pp. 15ff.

29. These visual suggestions are made particularly resonant by Lichtenstein's alterations in transferring his source image's accompanying text to the word balloon of his painting. His change of the original text from Times Roman to a simple sans serif font, integration of bold lettering, and exclusive use of capital letters all serve to emphasize Donald's words' dual function as both verbal utterance and visual passage within the image.

30. Though the rough Benday dots in *Look Mickey* were created with a plastic-bristle dog-grooming brush dipped in oil paint, Lichtenstein would shortly turn to the use of an actual metal screen for the same effect—and it is, indeed, a screen that the blue eyes of Donald most resemble in the picture at hand. For Lacan's discussion of screen and gaze, see Jacques Lacan, *The Seminar of Jacques Lacan Book XI: The Four Fundamental Concepts of Psychoanalysis*, trans. Alan Sheridan (New York: Norton, 1981), pp. 106ff.

31. This is evident with even the most cursory glance at art journals from the period, which are filled with discussions of the conventionality of so many contemporary attempts, both abstract and figurative, to muster the visual rhetoric of "authenticity." See for instance Irving Sandler, "Is There a New Academy?" *Art News* 58, nos. 4–5 (summer–September 1959), pp. 34–37, 58–59 (no. 4) and 36–39, 58–60 (no. 5); William Rubin, "The International Style: Notes on the Pittsburgh Triennial," *Art International* 5, no. 9 (20 November 1961), pp. 26–34; Manny Farber, "New Images of (ugh) Man," *Art News* 58, no. 6 (October 1959), pp. 38–39, 58; and P[hilip] L[eider], "Recent Painting, USA: The Figure," *Artforum* 2, no. 4 (October 1963), p. 11.

32. Mickey's suppressed laughter calls attention to the central trope of dumbness in *Look Mickey*. For not only are both of the image's protagonists "dumb" (if in different senses of the word), but the painting itself, as Lichtenstein well knew, equally so—although, as Lichtenstein also recognized, it is precisely the work's "dumbness" that makes it so smart.

33. Sigmund Freud, "On Narcissism: An Introduction," trans. James Strachey, in *General Psychological Theory*, ed. Philip Rieff (New York: Macmillan, 1963), p. 76.

34. N[atalie] E[dgar], "Roy Lichtenstein," *Art News* 61, no. 1 (March 1962), p. 14; S[idney] T[illim], "Roy Lichtenstein and the Hudson River School," *Arts Magazine* 37, no. 1 (October 1962), p. 56.

35. Lichtenstein as quoted in Coplans, "An Interview with Roy Lichtenstein," p. 31.

36. Lichtenstein as quoted in John Jones, "Tape-recorded Interview with Roy Lichtenstein, October 5, 1965, 11:00 AM," this volume, p. 32.

37. The first two words are taken from Lichtenstein's comments as quoted in Alan Solomon, "Conversation with Lichtenstein," *Fantazaria* 1, no. 2 (July–August 1966), p. 39. Lichtenstein's description of his work as "unoriginal," as cited above, appears in Marter, *Off Limits*, p. 138.

38. Lichtenstein as quoted in Solomon, "Conversation with Lichtenstein," p. 39.

39. Lichtenstein as quoted in Glaser, "Oldenburg, Lichtenstein, Warhol," p. 23; and as shown in *Roy Lichtenstein*, dir. Michael Blackwood, Suddeutsche Rundfunk (W. Germany), 1975.

40. Mickey's dryly sadistic response to Donald's exclamation in the text accompanying Lichtenstein's source image—"Land it and you can have it fried for lunch"—similarly stresses the lopsided power relations between the two characters.

41. If Lichtenstein's reversal of the roles of Donald and Mickey in his comments to Sylvester remain curious—and, as I am arguing, telling of his shifting attitudes vis-à-vis the aesthetic tensions embedded in *Look Mickey*—his location of the painting's setting as a raft rather than a dock is partly explained by the work's recently discovered source image. On the cover of the Golden Book from which Lichtenstein took his model for the painting, Mickey and Donald are shown steering a raft toward a distant island, almost certainly the scene Lichtenstein had in mind when making his remarks to Sylvester.

42. Following the logic sketched in this paragraph, we can read Lichtenstein's decisive cropping of Mickey from his 1973 *Artist's Studio* as a statement of his independence from the historical pressure I am arguing the mouse embodies in *Look Mickey*. Produced nearly a decade after the artist had initiated his move away from his "classic" pop idiom with the series of landscape paintings he began in 1964, *Artist's Studio* exemplifies (through the mediation of Matisse) Lichtenstein's awareness of—and confidence in—his own secure place in the history of art. Not only had he already been the subject of two major retrospective exhibitions (in Pasadena in 1967 and at New York's Guggenheim Museum in 1969), but his *Big Painting no. 6*, of 1965, had recently brought the highest auction price ever paid for a work by a living American artist, selling to German art dealer Rudolf Zwirner for $75,000 in November 1970.

43. As Freud writes near the beginning of *Civilization and Its Discontents*, commenting on the "oceanic feeling" of the primary narcissistic state, "Our present ego-feeling is, therefore, only a shrunken residue of a much more inclusive—indeed, an all-embracing—feeling which corresponded to a more intimate bond between the ego and the world around it." See Sigmund Freud, *Civilization and Its Discontents*, trans. James Strachey (New York: Norton, 1961), p. 15.

44. Herbert Marcuse, *Eros and Civilization: A Philosophical Inquiry into Freud* (Boston: Beacon Press, 1955); Norman O. Brown, *Life Against Death: The Psychoanalytical Meaning of History* (New York: Vintage, 1959).

45. Morris Dickstein discusses the period-defining status of Marcuse's and Brown's texts in *Gates of Eden: American Culture in the Sixties* (Cambridge, Mass.: Harvard University Press, 1977), pp. 67ff.

46. Brown, *Life Against Death*, p. 317.

47. Marcuse's examples of the operation of this apparatus—including the perpetuation of the monogamous patriarchal family and public control over private behavior, both carried out through social forces including institutionalized education and the pervasive influence of mass media—anticipates Louis Althusser's conception, formulated a decade and a half later, of Ideological State Apparatuses as those forces concerned with reproducing existing social and productive conditions. See "Ideology and Ideological State Apparatuses (Notes Towards an Investigation)" in Louis Althusser, *Lenin and Philosophy*, trans. Ben Brewster (New York: Monthly Review Press, 1971), pp. 127–186.

48. Marcuse, *Eros and Civilization*, p. 154.

49. Ibid., p. 201.

50. Brown, *Life Against Death*, pp. 50–51; Marcuse, *Eros and Civilization*, p. 169.

51. Terry Eagleton, *The Ideology of the Aesthetic* (London: Blackwell, 1990), p. 13.

52. Marcuse, *Eros and Civilization*, pp. 190 and 180; Brown, *Life Against Death*, p. 60.

53. Though many who referred to them surely had not read much of their actual arguments, Marcuse and Brown appear in nearly every sort of discussion, both popular and expert, of cultural matters in the 1960s—including occasional appearances on the pages of *Artforum* and even *Art News*.

54. Lobel's essay in the present volume (adapted from chapter 3 of *Image Duplicator*) includes a particularly intelligent discussion of the mechanistic means and implications of Sherman's pedagogy, though one that I think inadequately considers the dialectical nature of Lichtenstein's mentor's project as touched on here.

55. Walt Disney, as quoted in Jack Alexander, "The Amazing Story of Walt Disney," *Saturday Evening Post* 226, no. 19 (7 November 1953), p. 27.

56. See Daniel Bell, *The End of Ideology: On the Exhaustion of Political Ideas in the Fifties* (Glencoe, Ill.: Free Press, 1960). For an important analysis of the significance of Disney's characters for Marcuse's German colleagues Walter Benjamin and Theodor W. Adorno, see Miriam Hansen, "Of Mice and Ducks: Benjamin and Adorno on Disney," *South Atlantic Quarterly* 92, no. 1 (January 1993), pp. 27–61.

57. For an account of Disney's growth and influence during the cold war, see Steven Watts, *The Magic Kingdom: Walt Disney and the American Way of Life* (Boston: Houghton Mifflin, 1997), pp. 283–445, as well as Richard Schickel, *The Disney Version: The Life, Times, Art, and Commerce of Walt Disney* (New York: Simon and Schuster, 1968). As Watts illustrates, Disney quickly became a model for what the *Wall Street Journal*, writing on "Walt's Profit Formula" in 1958, described as "diversifying into a wide variety of activities, then . . . dovetailing them so all work to exploit one another" (Watts, *The Magic Kingdom*, p. 362). This "formula" was the almost universal focus of media discussions of the rapidly growing Disney empire in the late 1950s and early 1960s (among both admirers and detractors), as evidenced by such articles as "How to Make a Buck," *Time* 70 (29 July 1957), pp. 76–77, and Julian Haveley, "Disneyland and Las Vegas," *The Nation* 186 (7 June 1958), pp. 510–513.

58. Alexander, "The Amazing Story of Walt Disney," p. 28. Sergei Eisenstein, writing on Disney's characters in the early 1930s, identified almost precisely this same quality—what he termed "plasmation *par excellence*"—as their defining characteristic. For Eisenstein, Disney's plasmation was understood as a form of protest against "American mechanization in the realm of life, welfare, and morals"; this protest, however, failed to "look . . . beneath to the origins, at the reasons and causes, at the conditions and pre-conditions" of such mechanization. See *Eisenstein on Disney*, ed. Jay Leyda (Calcutta: Seagull Books, 1996), pp. 69, 33, 23.

Page numbers in boldface indicate illustrations.

3. March 8
Amazon 12-21 1064468